JOHN SIMPSON

THE QUEEN'S GALLERY
BUCKINGHAM PALACE
AND OTHER WORKS

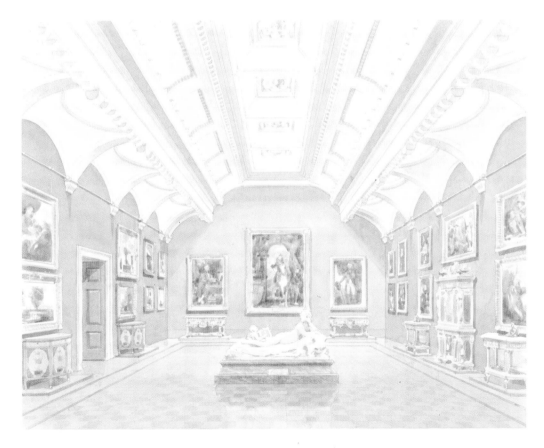

Watercolour of the Nash gallery by Ed Venn

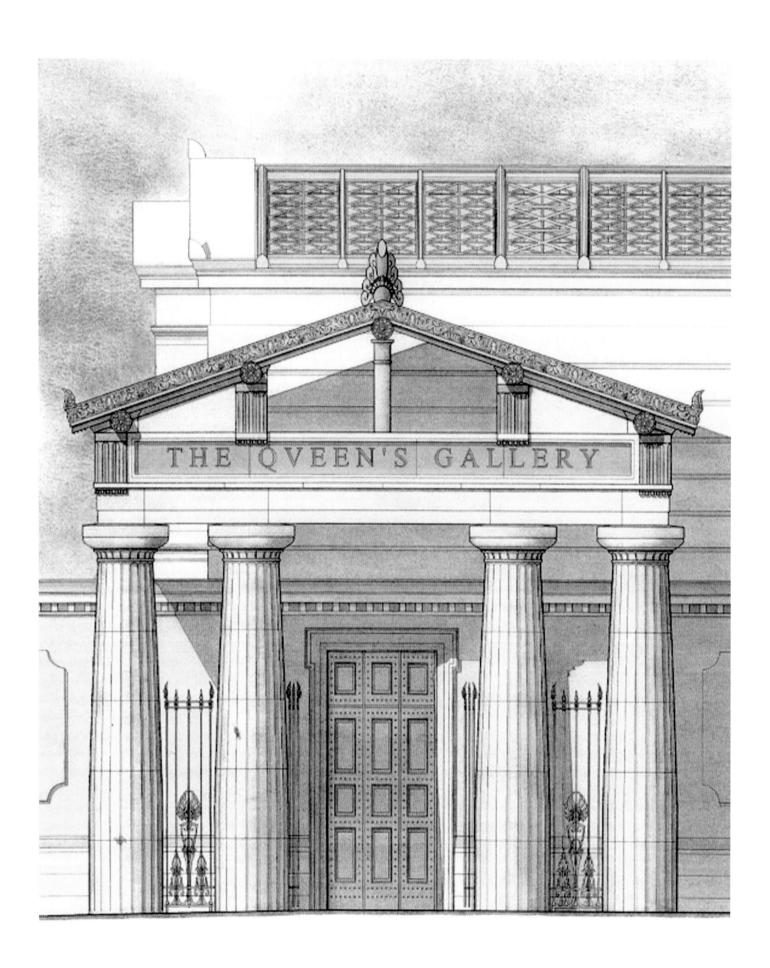

THE QVEEN'S GALLERY

JOHN SIMPSON

THE QUEEN'S GALLERY

BUCKINGHAM PALACE

AND OTHER WORKS

Richard John

David Watkin

ANDREAS **PAPADAKIS** PUBLISHER

PUBLISHERS' NOTE

The publication of a monograph on the work of John Simpson is long overdue but it is fitting that it should appear now when he has just completed one of his most important commissions to date: the new Queen's Gallery at Buckingham Palace, commissioned to celebrate the Golden Jubilee of H.M The Queen, who will perform the opening ceremony later this year. This volume was produced to a demanding schedule and I would like to thank all those who have helped to make timely publication possible and especially the authors, Richard John and David Watkin, for responding so quickly and the staff at John Simpson and Partners who prepared the material for publication. At New Architecture, I am especially grateful to Alexandra Papadakis for taking charge of the project and seeing it through the press. Finally my thanks to my printer of more than twenty years, Mr Phang Jee-Nam whose support has enabled us to meet deadlines with his usual excellent quality. For me, this volume is proof that high quality buildings in the classical tradition can be built today when the project is in the hands of a gifted architect.

Cover: The Queen's Gallery, Buckingham Palace
Frontispiece: Watercolour showing the elevation of entrance to the Queen's Gallery facing the new square
Overleaf: Watercolour showing the elevation of the new Gallery facing Buckingham Palace Road

First published in Great Britain in 2002 by
ANDREAS PAPADAKIS PUBLISHER
An imprint of New Architecture Group Limited
16 Grosvenor Place, London SW1X 7HH

ISBN 1 901092 38 0 hardback
ISBN 1 901092 39 9 paperback

Printed and bound in Singapore

CONTENTS

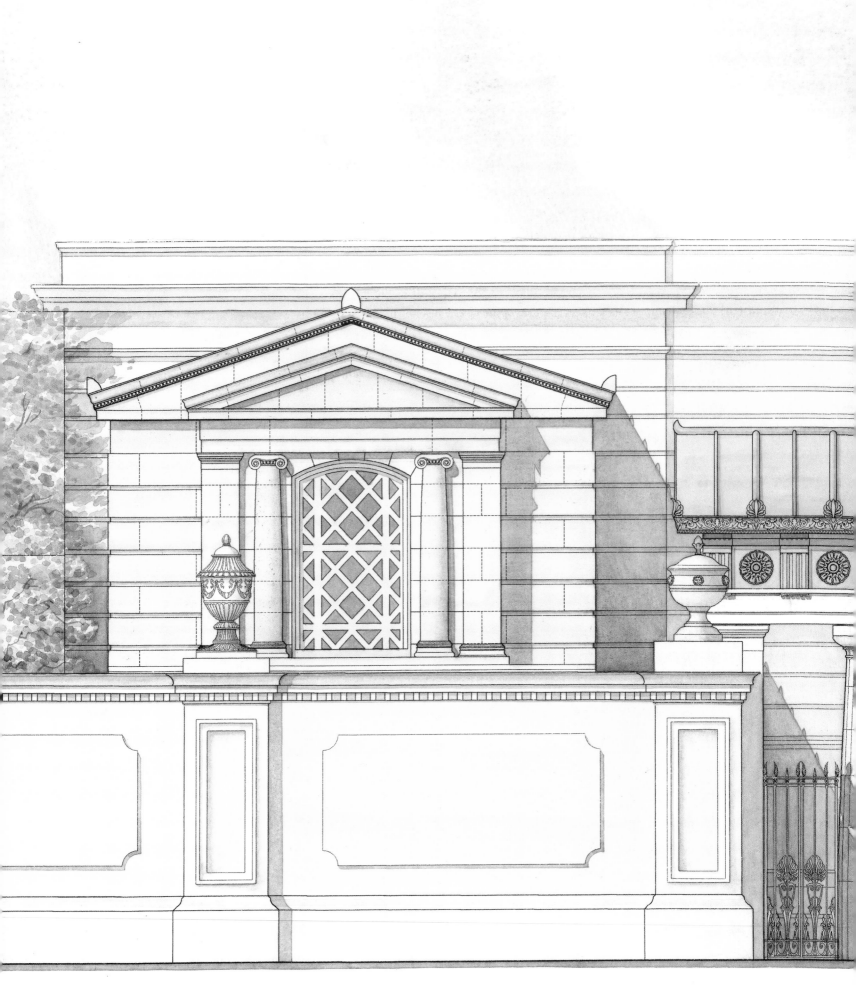

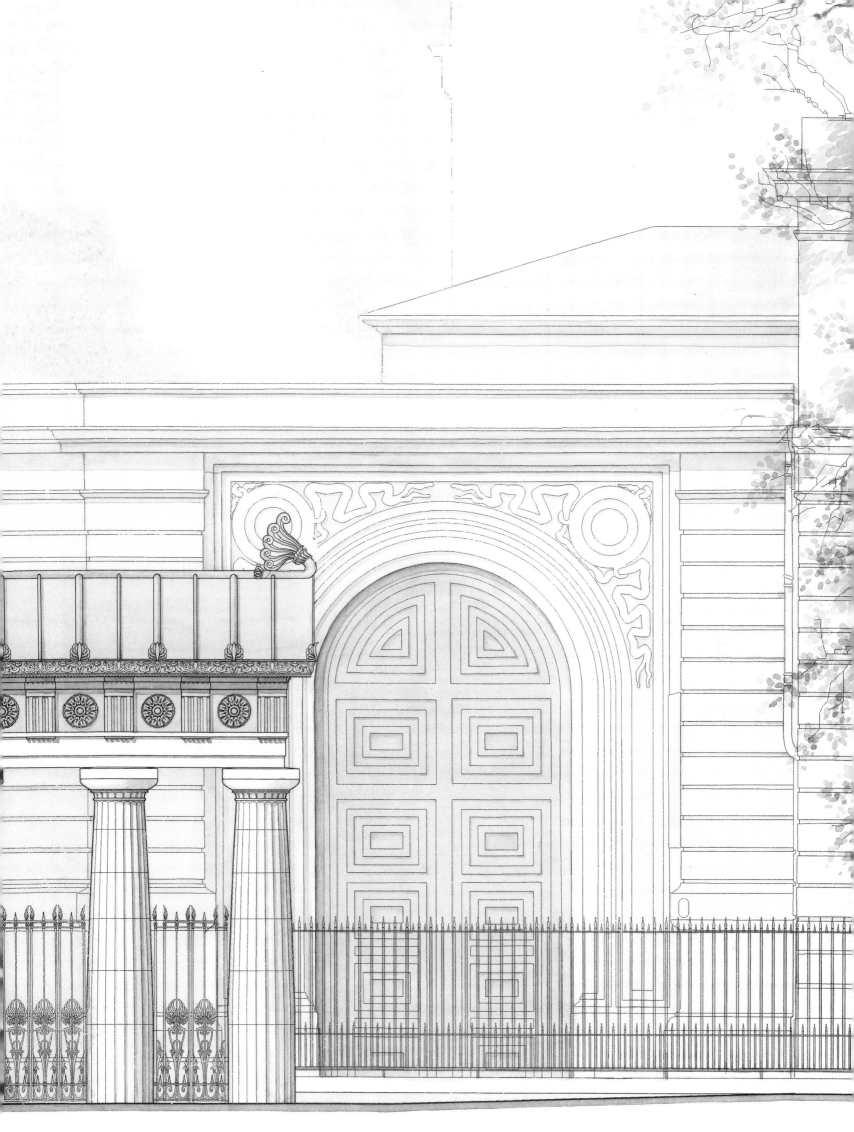

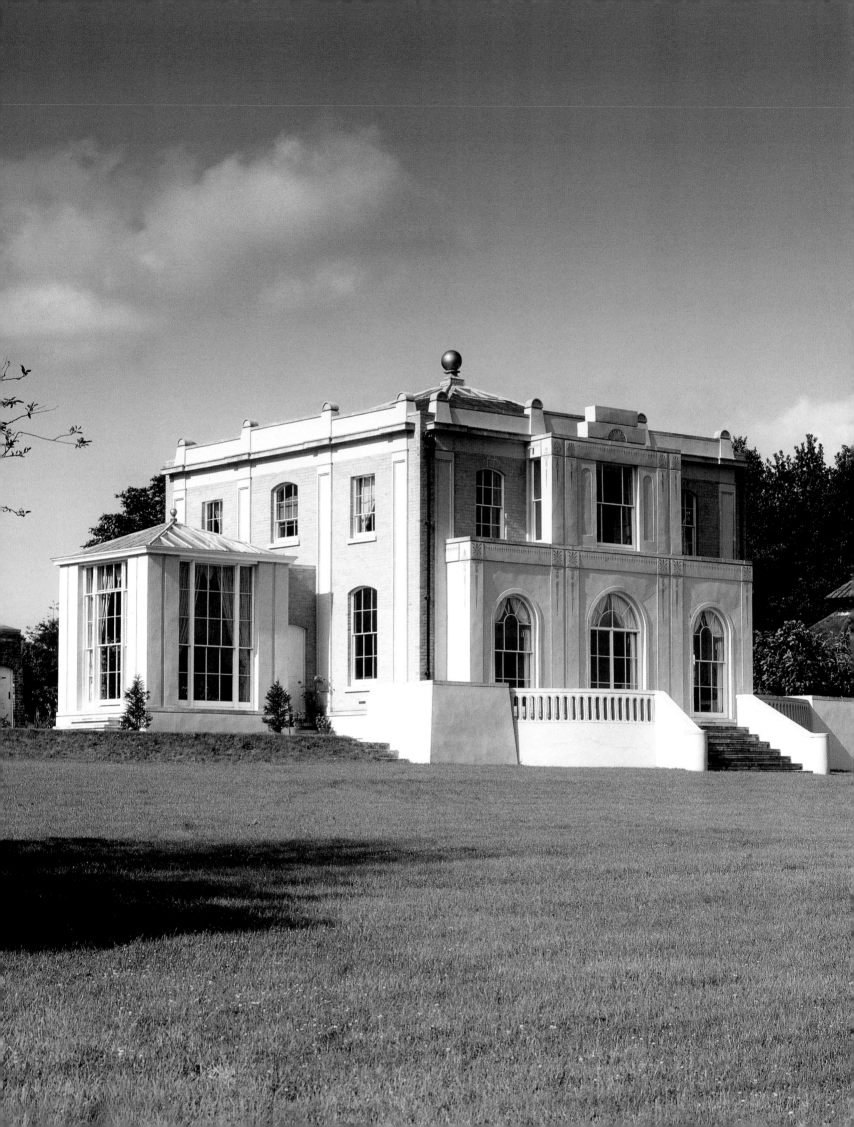

INTRODUCTION

Ionic capital designed for Heritage Stone
Right: Ashfold House in Sussex showing conservatory and terrace

How much more sensible would it be if we united Architecture, Painting and Sculpture? Who could then resist this triple magic whose illusions make the mind feel almost every sensation which is known to us?" *Sir John Soane*[1]

Soane was drawn to this passage by the architect and theorist of the French Enlightenment, Le Camus de Mézières, because he had pursued in his own architecture precisely this unity of the arts for the sake of heightened sensations. For instance, in his own house and museum in Lincoln's Inn Fields begun in 1792, he employed a combination of dramatic lighting effects and daring spatial experiments to provide a rich and invigorating setting for his eclectic collection of paintings, sculpture and objets d'art. One of the themes we shall explore in this book is the striking kinship which exists between Soane and Simpson as innovative and poetic architects. Simpson's most substantial work to date, the Queen's Gallery at Buckingham Palace, seems a perfect realisation of Le Camus de Mézières' ambition of uniting the arts of architecture, painting, and sculpture into a stimulating and beautiful whole. Like Soane, Simpson is also a master of space and light who explores and reinterprets the language and ornament of the classical orders to create powerful buildings of novelty, poetry and association. In this, both Soane and Simpson follow a tradition by which, for over two and a half thousand years until about the mid-twentieth century, the orders of architecture, principally Doric, Ionic and Corinthian, were constantly being rediscovered and renewed by architects as varied as Iktinos in the ancient world, Michelangelo in the sixteenth century, Borromini in the seventeenth century, Adam in the eighteenth century, Cockerell in the nineteenth century, and Plecnik in the twentieth century. From the 1970s on both sides of the Atlantic, and particularly in North America, a growing number of architects came to believe that it was inherently improbable that something at once so ancient and so vital as the classical tradition in architecture should have been brought to an end.

Architects such as Robert Stern, Allan Greenberg, Thomas Beeby, and Thomas Gordon Smith, in the United States, and John Simpson, Quinlan Terry, Robert Adam, and Demetri Porphyrios in Great Britain, are part of an international movement in architecture which has restored to buildings order, colour and ornament, as well as reinstating a traditional approach to urban design. Their

world is enriched by the resonances of the ancient legends recorded by Vitruvius, including the origins of the Doric order in the tectonics of the primitive wooden hut, and the anthropomorphic parallels between the orders and the human body so that Doric is seen as reflecting the strength of the body of a man; Ionic, the beauty of that of a woman; and Corinthian that of a girl. The timeless beauty of the repertoire of classical ornament also derives from its origin in nature and in plant forms such as the acanthus and the palm.

EARLY INFLUENCES ON JOHN SIMPSON

John Simpson, who was born in 1954, had his interest in architecture naturally cultivated at an early age by the architectural practice of his father. During holidays from Marlborough College, he would help in his father's office and see work in progress on building sites. His father's work was mainly traditional, most buildings being constructed of stone or other traditional materials. Completing his training before the Second World War, he remained after the war as Command Architect with the War Office for the British Land Forces Overseas. As a result, he escaped the drive in post-war Britain to eradicate traditional architectural thought and practice in the profession and the schools of architecture. When he did set up his own practice, he continued to design outside mainstream modernism and commercial architecture, retaining a traditional style with reminiscences of both the 1930s and the 1950s. He thus counted among his friends architects of an older generation such as Lord Bossom and Sir Albert Richardson, both of whom put him forward for his Fellowship at the RIBA. The building that is most representative of the work of Simpson senior is the Ophthalmic Hospital in Jerusalem, commissioned by the Knight Hospitallers of St. John of Jerusalem and completed in 1960. Though thoroughly modern as a hospital, performing more than six thousand major operations a year, it reflects the earlier buildings of the Order with its fort-like towers and internal arcaded cloister, all built of local stone.

John Simpson was trained from 1972 at the Bartlett School of Architecture and Planning in the University of London. He welcomed the fact that the Bartlett School was then reacting against High Modernism and in particular the concrete New Brutalism of architects such as Denys Lasdun. Thus, while it was very much a Modernist school, Simpson found that, "there did seem at least a superficial search for a more humane approach to architecture, which suited me." Today, he recalls little specific in his teaching there, except for an inspiring series of lectures on Palladio, delivered, ironically, by Reyner Banham, the undeviating propagandist for the Modern Movement.

As an undergraduate, Simpson could understand the attempts in the 1920s to harness the methods of industrial production

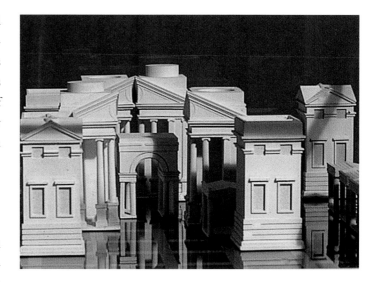

Chessmen as buildings, creating streets and squares

to house the urban poor. He also felt that, in view of the state of heavy industry at that time, it was not surprising that simple repetitive forms, devoid of any ornament, were promoted in these new buildings. However, seeing that this process had led to social housing projects and tower blocks in which no one wanted to live by the 1970s, he felt that there could therefore be no justification for creating any more buildings of this graceless and inhuman type. While he believed that it would become possible to deliver much more sophisticated results with new technology, he was also aware of a growing appetite for craft-based work.

While at the Bartlett School, he spent his year in practice in 1975 in the office of DLGW (Duffy Lange Giffone Worthington, from 1976 known as DEGW, Duffy, Eley, Giffone, and Worthington), cataloguing and surveying existing buildings in Covent Garden with a view to find new uses for those which had become redundant following the move of the fruit and vegetable market to Nine Elms in South London. It was here that he discovered the merits of traditional architecture and urban planning. It was particularly relevant that this should have been in Covent Garden, for vast swathes of historic buildings in this area, in Tavistock Street, Burleigh Street, Southampton Street, Henrietta Street, and Bedford Street, were to have been swept away in a nightmare scheme of comprehensive redevelopment proposed in 1970 by the Greater London Council, the City of Westminster, and the London Borough of Camden. The last-minute reprieve of this area enabled the buildings to be restored and rehabilitated so that it is now one of the most delightful and vibrant parts of modern London. It is the envy of the French who at this time destroyed a comparable market area at the heart of historic Paris, Les Halles.

Simpson also became involved at this time with the conversion by DLGW of the redundant Highgate Methodist church and hall, built in 1905. It was completely transformed to create the Jackson's

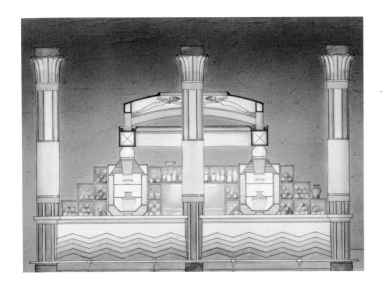

Bar built under London Bridge

Lane Community Centre with a theatre and facilities for the local area. It was carried out with government job-creation funds that were intended to fund worthy projects and to train the unemployed young who were interested in a career in one of the building trades or crafts. It served as the model for subsequent community centres. Simpson felt that, though he was still a student at the Bartlett, through his involvement with these projects he had discovered how much could be learned from studying old buildings. He had begun to appreciate the advantages of working within a tradition and the benefits of accumulated knowledge which acted as a fail-safe to ensure that buildings were both handsome and well built.

Simpson thus appreciated at a relatively young age the importance of studying older buildings so as to benefit from the experience of other architects in dealing with situations similar to those which might confront him. At Covent Garden, he was "struck by the consistency, the order, and the hierarchy, of the materials used, which had clearly evolved out of a commonly accepted wisdom that was prevalent at the time. In this context, buildings had been designed first and foremost, not in response to function, but as pleasant places to be in; this is what made them so essentially flexible to different uses, and thus so timeless. Whereas function and circumstances change from generation to generation, people do not, for they have the same senses, the same appreciation for space, forms, and materials, and are proud of their cultural lineage and their link with the past. The conclusion to which I had come was that architecture was essentially a language for the art of building. As with any language, it was necessary to understand its intricacies and the canon of work associated with it, before you could produce lasting and significant works."

Returning to the Bartlett for his Postgraduate Diploma, he found a less hostile atmosphere with Reyner Banham's departure for the United States and his replacement by Robert Maxwell as Professor of Architectural History. Maxwell promoted the theories of Robert Venturi, first evinced in *Complexity and Contradiction in Modern Architecture* (1966) and subsequently developed in *Learning from Las Vegas* (1972), in which Venturi questioned the solemnity and simplicity of Modern architecture as well as its lack of meaning and ornament. The Bartlett School at this time also encouraged Post-Modernism, the Venturi-inspired movement that emerged as a reaction to Modernism. Simpson felt that the position Post-Modernists were taking against Modernism was valuable because it fostered debate, but that their stand remained largely symbolic as they were unwilling, or perhaps unable, to understand the significance or the benefits of working with a tradition. It was also becoming acceptable to discuss traditional approaches to town planning, mainly through the published schemes and polemics of Léon Krier, as in his plans of the 1970s for his native Luxembourg, as well as for Paris, Berlin, and Barcelona, which sought to repair the damage inflicted by Modernist planning policy.

Simpson recalls the late 1970s as an exciting time. He was encouraged by a new climate in which twentieth-century traditional architecture, like that of McMorran and Whitby, was being promoted by Gavin Stamp and the newly-founded Thirties Society, while David Watkin, in *Morality and Architecture* (1977), was challenging the supposed philosophical basis of the Modernist orthodoxy promoted by Pevsner and his followers such as Reyner Banham. Simpson now began to admire the lonely field of classical architecture being ploughed from the 1950s to the 1970s by Raymond Erith and thereafter by his disciple, Quinlan Terry. As a result, Simpson decided, in his own words, "to take my architectural education into my own hands. I thus studied eighteenth- and early-nineteenth-century buildings that I liked, especially Sir John Soane's house and museum in Lincoln's Inn Fields."

THE ESTABLISHMENT OF JOHN SIMPSON & PARTNERS AND EARLY WORK

In 1980, Simpson set up in independent practice in Bloomsbury, in an office opposite that major essay in the Greek Revival, Sir Robert Smirke's British Museum. His early work included a restaurant called *Ptolemy's* in the vaults below London Bridge on the South bank of the River Thames where, with only a modest budget to hand, he created a dramatic sequence of subterranean dining rooms and a bar. He deployed a polychromatic decorative scheme with Egyptian motifs and painted palm columns created from drain-pipes within an otherwise untouched existing vaulted space so as to recreate the atmosphere of an underground pharaonic burial chamber. Unexecuted works during this early period included designs for houses for Mr and Mrs Beeching in Sussex and for Group-

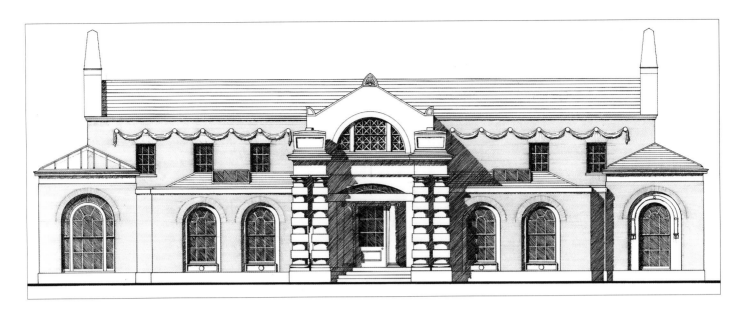

House in Sussex for Mr & Mrs Beeching

Captain Seyfried in Warwickshire, and a new building for Guy's Hospital, Southwark, to be placed on land at the base of the thirty-storey tower block, known as Guy's Tower, designed in 1963. Simpson's aim was to demonstrate that the damage done to the urban fabric by Modernism could be repaired, for his new buildings would enable the tower to be demolished so as to reinstate the street pattern in the area. This approach, while it might have seemed rather polemical at the time, has in fact since been adopted in a number of European cities, such as Brussels at the rue de Laeken.

Simpson carried out various small commissions in and around London as well as a remarkable design for a chess set, based on classical buildings, commissioned by Mr Brindsley Black and exhibited at the Royal Academy. Ashfold House, Sussex, designed for his parents in 1985, was an early demonstration of his brilliant handling of the classical vocabulary as well as his mastery of space and light. Around this time he made designs for a new village at Donnington Grove, near Newbury, Berkshire, for Mr James Gladstone. It was the first modern village development to be proposed on entirely traditional lines, but unfortunately remained unexecuted because it was considered incompatible with the planning laws. These, ironically, are based on the correct assumption that the intrusion of Modernist buildings would wreck the countryside, but Upper Donnington showed that traditional buildings would fit in perfectly well. This point was appreciated by the Prince of Wales who was shown Simpson's project before work began on his own village of Poundbury in 1988.

In 1984, Simpson organised an exhibition, *Classical Survival, Classical Revival*, at the Building Centre in London. Funded by a small grant from the Greater London Council, it made an unexpectedly big impact. Encouraged by this, he mounted a further exhibition at the Building Centre in 1987 called *Real Architecture*, again including his own designs as well now as those of Léon Krier who had by now declared his support for the traditional classicists. The Prince of Wales wrote to John Simpson asking to be shown the exhibition. It was following this that the idea of an alternative design for Paternoster Square arose. This led to the Prince's famous speech on city planning at the Mansion House and to the planning submission that, with support from the Evening Standard, was later made for Simpson's scheme for Paternoster Square, of which he was master-planner from 1988-92. His scheme, involving the replacement of some of the most hostile tower blocks of the 1960s, respected the traditional patterns of urban development in this historic part of London next to St Paul's Cathedral. It attracted wide support from the general public, though not from the professional architectural establishment, still entirely Modernist. Though the designs were not eventually executed, his battle for traditional urbanism was successful, for the buildings that from 2001 have been erected on this site followed the spirit of his plans.

The practice moved in 1992 to an early-Georgian house in Great James Street, Holborn. Work at this time included a vast project called London Bridge City, on the South Bank of the Thames, opposite the Tower of London. He used the watery setting as an excuse for a composition with a strikingly Venetian flavour. He also built a new classical house at Ascot for the King and Queen of Jordan; and began the Coldharbour Farm development, a new garden city on the Hartwell House estate, near Aylesbury, for the Ernest Cook Trust.

SOANE AND SIMPSON

To understand Simpson's work fully, it is necessary to consider his sense of kinship with Soane who was, in a way, his master at the

Above: Masterplan for Paternoster Square next to St Paul's Cathedral, London (Painting by Carl Laubin)
Below: Model for the Market Hall Building at Paternoster Square in the City of London

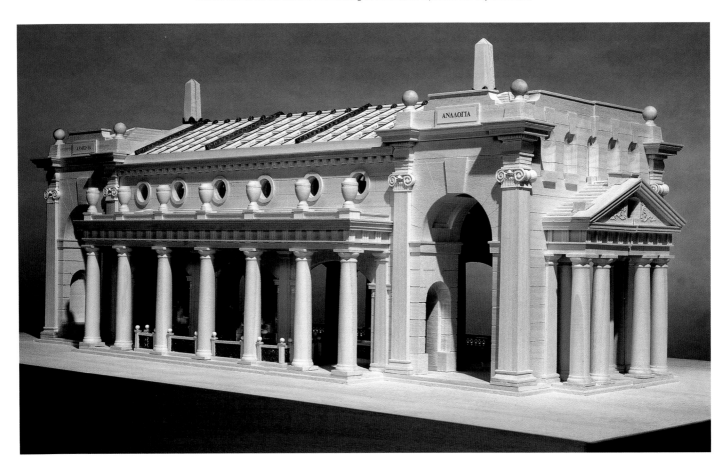

Bartlett School. He explains: "As well as the inspiration provided by Soane's house in Lincoln's Inn Fields, there were the drawings and his own museum where I could trace in the architectural fragments he collected some of the sources for his own designs. This, in particular, proved invaluable for understanding how he worked. I travelled to study and measure a number of his surviving buildings to which I could gain access. Invariably, I was amazed at how much Soane always managed to pack into one space, for when I measured I found that the dimensions were always smaller than I expected, despite their apparent monumentality. Also, discovering the tricks he used to create apparent symmetry out of such irregular shapes, I found especially instructive the way in which he fitted new rooms within the constraints of existing buildings."

Simpson further explains: "Another aspect of Soane's work that proved most intriguing was his detailing which at Dulwich Gallery might appear economic. However he invariably used relatively expensive materials as well as, on occasions, elaborate and time-consuming techniques to achieve the effect he wanted. As a result, the stucco-fronted buildings of Nash were probably cheaper than those of Soane who despised Nash's work and refused to show examples of it to his students at the Royal Academy. What Soane was passionate about was a crisp, sharp, appearance, which he went to great lengths to achieve. This was also a preoccupation of his when detailing his more elaborate and architecturally embellished buildings such as the Bank of England. This is why he chose to adopt the rich Corinthian order from the so-called Temple of Vesta at Tivoli, one of the most sculptural of the Corin-thian orders with the most sharp and prominent detail." As Soane proclaimed to his students, "Art cannot go beyond the Corinthian order."[2]

We have seen in the last decades of the twentieth century the rise of the prima donna architect who is hired specifically to create a "signature building" which has the desire to shock as its primary function and unsurpassed novelty as its primary goal. This has led to the undervaluing of the architect who can work with skill and subtlety within the framework of an existing building so as to transform it like a conjuror. Such a process is wholly alien to Modernists who always seek as a starting point a tabula rasa from which all vestiges of the past have been expunged thus allowing every commission to be approached as though no such building had ever been designed before. Simpson, by contrast, shows that piety towards the past can be compatible with the most fertile invention. Architects such as Alberti, Michelangelo, Bernini, Adam, Nash, and Soane, often displayed their greatest genius when they were forced to work within or to transform existing buildings. Of no one is this more true than Sir John Soane at the Bank of England and at the Law Courts where, astonishingly he succeeded in inserting the new courts that were required between the mediaeval buttresses of Westminster Hall.

Working within existing buildings of many different periods at Gonville and Caius College, Cambridge, Simpson mastered the complex art of manipulating space so as to create a variety of interlocking new interiors on many different levels. Both Soane and Simpson have had to operate within huge constraints that seem to liberate rather than restrict the exercise of their architectural imagination. One of the tasks with which Simpson was confronted at Gonville and Caius College was the recreation of a major but long-lost room by Soane. It is no exaggeration to say that there was really no other architect in England who could have brought to this challenging task the same skill, knowledge, and sympathy with the work of Soane. In his first major work, Ashfold House, Simpson had already displayed his understanding of the essence of Soane's individual achievement and paid it a worthy homage.

In recognising the way in which Soane stood at the cusp of classicism and the modern world, Simpson was in kinship with the most distinguished classical architect at work in post-war England, Raymond Erith (1904-73). Erith, like Simpson, had alighted on Soane as a sure guide in the modern world, though Erith confessed that, "To contemporary architects especially Soane is difficult because, although he shares their progressive outlook, he is opposed to their utilitarian conception of architecture. Soane is in fact a very rare bird, and unique among the great architects in being a progressive classicist."

Erith claimed that, "What Soane tried to do was to guide the great classical Renaissance tradition into a new age and to adapt it to an expanding knowledge of the means of construction and of comfort." He recognised that, despite the brilliance of Soane's own work, he did not succeed in this wider ambition of influencing the path of modern architecture. If he had, Erith argued, "not only architecture but art generally, might have been very different today." Erith saw that "Soane believed in progress. But unlike so many people who believe in progress, he didn't believe that progress always meant destruction first in order to progress afterwards. Soane's aim was to make classical architecture progress and absorb itself in the needs of a new age. He thought it could be made to absorb the expanding means of construction. Even the idea of shell construction, or something like it, was not beyond his vision." It is impossible not to see in Simpson's subtle incorporation of modern technology within the classical language, the fulfilment of the kind of progressive classicism for which both he and Erith found an inspiring model in Soane.

FROM GONVILLE AND CAIUS COLLEGE TO BUCKINGHAM PALACE

In a rare published statement about his design philosophy, Simpson explained in connection with Gonville and Caius College that,

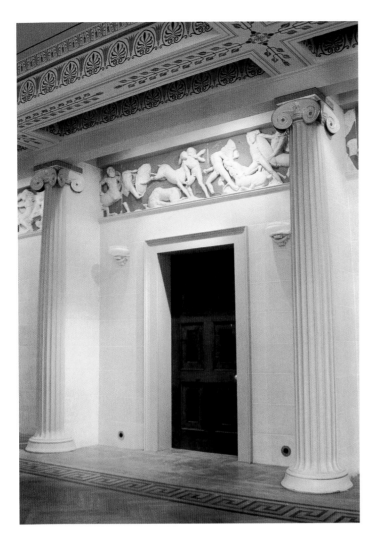

View of one bay of the new dining room at Gonville and Caius College, Cambridge

"perhaps one of the most fascinating aspects of working with an old building is the opportunity one gets to piece together its history and unravel the many complex layers of building that occurred over its lifetime. It is part of the process an architect needs to go through in order to understand the nature of the building he is dealing with, not unlike a doctor getting to know a patient and his problems before he can make a diagnosis and suggest a remedy. Perhaps because buildings are created by human beings, like their creators they can be complex and often are not quite what they appear to be on the surface – just when you think you have pieced together a plausible history something new reveals itself."[3] In the design process at Gonville and Caius, as in all his commissions, he was constantly open to suggestions as to disposition, planning, and circulation, from those who were actually going to use the building.

The commission at Gonville and Caius College was thus the ideal apprenticeship for the similar, though far more extensive, task of remodelling and extending the buildings forming the southwest angle of Buckingham Palace, Simpson's most important work so far. The attention to detail, especially to the importance of ornament and mouldings, which Simpson showed at Gonville and Caius, enabled him to bring much employment at Buckingham Palace to the kind of craftsmen and artists who have appeared since the fires at Hampton Court Palace, Uppark, and Windsor Castle. Though the destruction of interiors at these buildings seemed initially wholly disastrous, their brilliant recreation has changed the popular view as to what it is possible to create in the field of ornament and decoration. In this new and positive climate, there is no longer any room for the familiar explanation for the bareness of twentieth-century work that "you can't get the craftsmen nowadays." One of the most striking fruits of Simpson's belief in the unity of architecture and sculpture is the magnificent frieze and free-standing figures carved by Alexander Stoddart for the new entrance hall to the Queen's Gallery at Buckingham Palace.

We shall survey in this book Simpson's remarkable and varied achievement in public buildings and private houses, noting his exceptional attention to the design of appropriate furniture, fittings, and ornament. Full attention will also be given to his innovative approach to urban design where, with Léon Krier, he was a pioneer in attempting to repair the damage inflicted on towns and cities in the twentieth century. He has been able to put his principles into practice in new urban developments in places as different as Chelsea and Solihull, always showing his particular awareness of the genius loci of every individual commission. His brilliant designs are thus the product of a rare combination of knowledge and modesty, for he is constantly sensitive to the environment, both historical and physical: that is, the general cultural inheritance from the past of which he sees us as the privileged heirs.

August Schmarsow (1853-1936), one of the founders of modern architectural history, claimed in his inaugural lecture at Leipzig University that, "Architecture prepares a place for all that is lasting and established in the beliefs of a people and of an age; often, in a period of forceful change when everything else threatens to sway, will the solemn language of its stones speak support."[4] The works of John Simpson express the truth of this claim though they have an intense beauty which does not require the theoretical justification provided by German aesthetics. For many, his work will stand by itself as a joyous celebration of the forms and details of the architectural language which unites us with the roots of our civilisation in the achievements of ancient Greece and Rome.

[1]MS translation in 1807-08 from Nicolas Le Camus de *Mézières, Le Génie de l'architecture, ou, l'analogie de cet art avec nos sensations* (The Genius of Architecture or the Analogy of this art with our sensations) (Paris 1780).

[2] David Watkin, *Sir John Soane*, 1996, p. 509.

[3] *The Caian*, November 1996.

[4] *The Essence of Architectural Creation*, 1893.

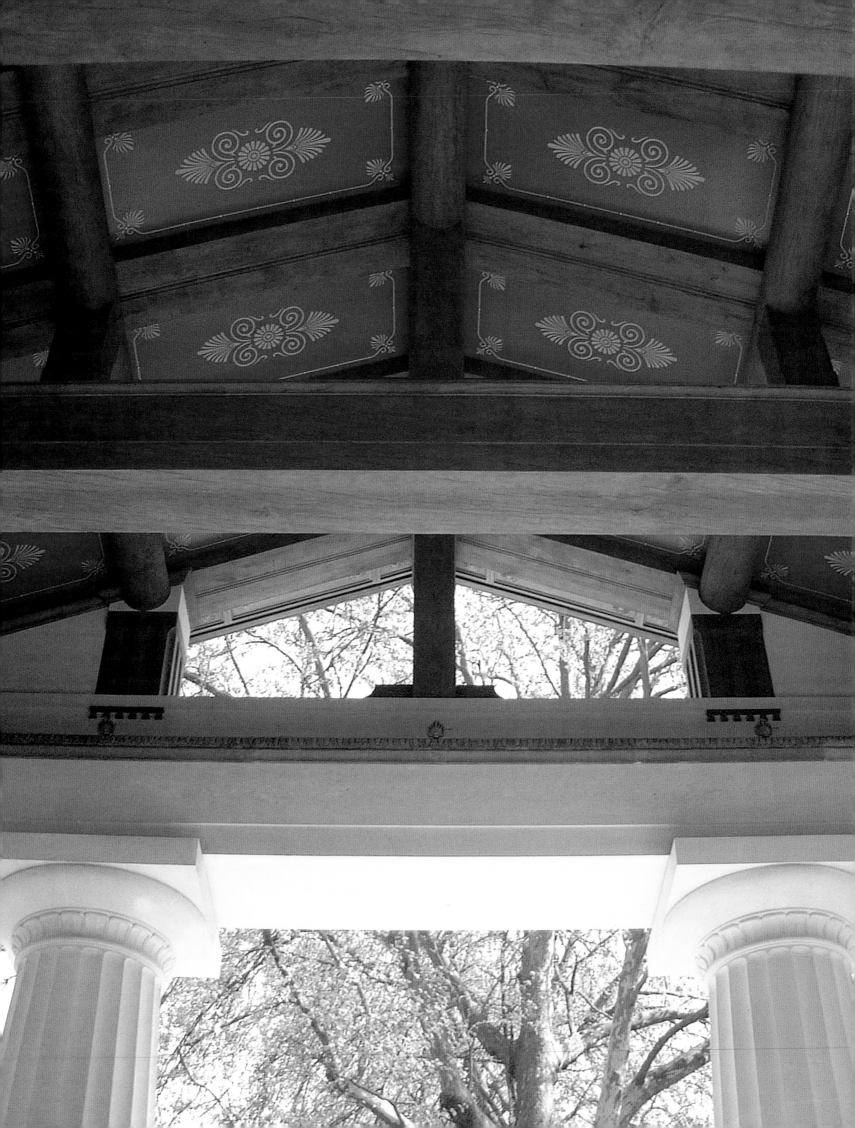

THE QUEEN'S GALLERY
BUCKINGHAM PALACE

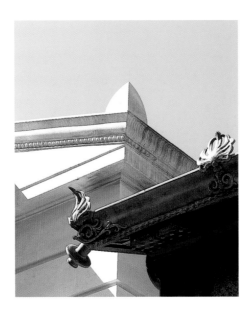

Detail of copper and stone acroteria
Left: View looking into roof of entrance portico showing solid oak beams and rafters

The New Queen's Gallery at Buckingham Palace and its attendant spaces, built to mark the Golden Jubilee of Her Majesty The Queen in 2002, effect the cultural transformation of a building which is one of Britain's greatest focuses of national identity and a magnet for tourists. It does not merely replace the former Queen's Gallery which had been built in 1962, but is an entirely new creation providing three and a half times as much gallery space as before, as well as establishing a major new centre for the visual arts in the heart of London, provided with the most up-to-date museological services for the conservation and display of works of art of all kinds.

A limited competition was held in 1997 to provide designs to replace the existing Queen's Gallery, for its exhibition spaces, air-conditioning and other services had, not surprisingly, become inadequate and outdated, while there was no access for the disabled, no proper kitchen, and no serving areas for functions and parties. It was also important to provide a more flexible and intelligible series of exhibition spaces with the capacity to show a far wider range of objects from the Royal Collection. Even more significantly, it was felt necessary to respond to the way in which the expectations of the exhibition-going public had expanded since

1962. During the last decade there has been a transformation in the world of museum design away from the advocacy of minimalist interiors with neutral colours and an absence of ornament to an appreciation of how much more effective a setting for great works of art is provided by a richer, more historically appropriate architecture. In Britain this was perhaps first illustrated in a new building by the interiors of Venturi Scott Brown's National Gallery Sainsbury Wing (1991) where the simple decision to use pietra serena mouldings and architraves gave the galleries a Quattrocento air appropriate for the hanging of early Renaissance paintings. In 1980 Timothy Clifford restored the 1840s interiors at Manchester City Art Galleries paving the way for the re-instatement of many nineteenth-century decorative schemes in British museums and galleries. The mid Victorian interiors of the National Gallery by E.M. Barry and others were also restored to a polychromatic splendour during the 1990s and by the end of the decade even galleries in the 1975 Northern Extension were being redesigned to give them a nineteenth-century flavour. National Lottery funding has also vastly improved the experience of visitors to London galleries, allowing the restoration of sumptuous historic interiors at the Tate Gallery, the Victoria and Albert

Museum and the British Museum. Alec Cobbe, in particular, has pioneered a revival of traditional methods of hanging pictures in clusters on richly coloured silks in his imaginative recreations at houses such as Petworth, Harewood, Burleigh, and Kenwood, as well as in his work at the Walker Art Gallery in Liverpool and the Courtauld Gallery in London. Perhaps the most notable example of this new historically-informed approach to gallery design is to be found in the costliest new museum in the world, the Getty Center in Los Angeles (1997), where the French architect Thierry Despont was commissioned to create a sequence of rich period interiors appropriate to the objects on display within a monochrome modernist shell designed by Richard Meier.

Those invited to submit designs for the new Queen's Gallery in 1997 were Jeremy Dixon, Piers Gough, who declined, Michael Hopkins, Sidell Gibson, John Simpson, and Bowyer Langlands Batchelor. With the exception of Simpson's, the designs tended to be somewhat bland, whether in a modernist or traditional direction. This may have been because, since the signing of the Venice Charter at the Second International Congress of Architects and Technicians of Historic Monuments in 1964, historic buildings have come to present a problem for modern architects. This highly influential document required that "additions cannot be allowed except in so far as they do not detract from the interesting parts of the building" and that "the valid contributions of all periods to the building of a monument must be respected, since unity of style is not the aim." The charter further insisted that any new work "must be distinguishable from the original so that restoration does not falsify the artistic or historic evidence." The result of this has been to favour the preservation of all parts of historic buildings, regardless of aesthetic merit or practical value, as a faithful record of their historical development, and to discourage additions or at the very least to ensure that any additions that are built are easily distinguishable by being in a different style or materials from the original building. This approach is, of course, contrary to what has often happened to historic buildings in past centuries, where additions might consciously be in the same materials and idiom as the original in an effort to enhance its character and produce a seamless whole. Simpson believed that if an architect were prepared to work with the grain of the existing building, he could afford to be quite bold. He had been well prepared for this task, for, as we shall see, he had just carried out a scheme of similar complexity though of smaller scale within the historic buildings at Gonville and Caius College, Cambridge.

In creating Buckingham Palace in the 1820s, John Nash skilfully incorporated Buckingham House, built in 1702-06 and altered by Sir William Chambers in the 1760s. In adding new galleries and associated spaces, John Simpson has similarly had to work within the complex building remodelled after Nash by Edward Blore in

Right: Entrance to the new Gallery. The Portland stone of the entrance portico contrasts with the Bath stone of the entrance hall behind

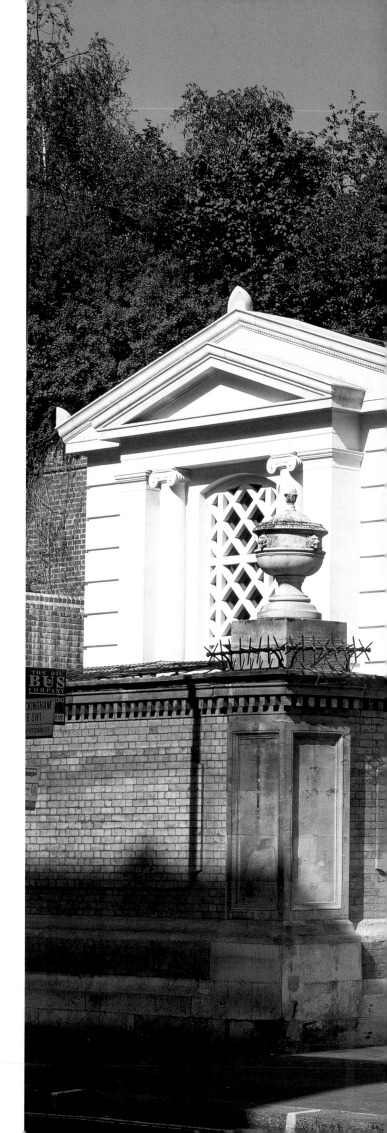

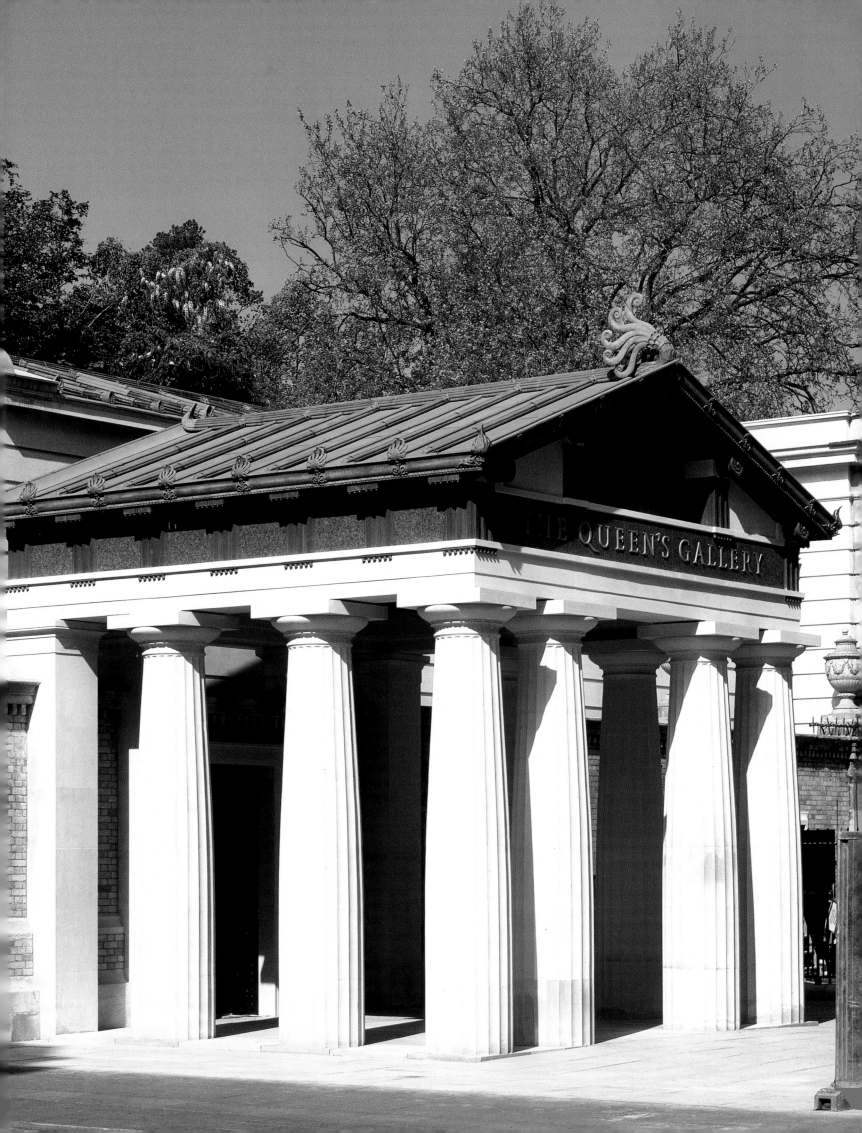

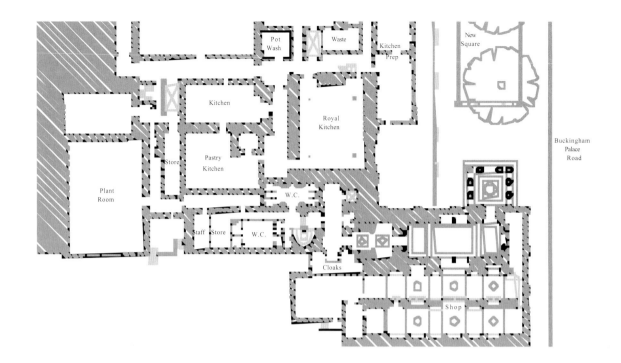

Plan of entrance floor of Gallery
Below: Model showing the relationship of the new building to Pennethorne's ballroom
Right: View of ceiling above entrance door

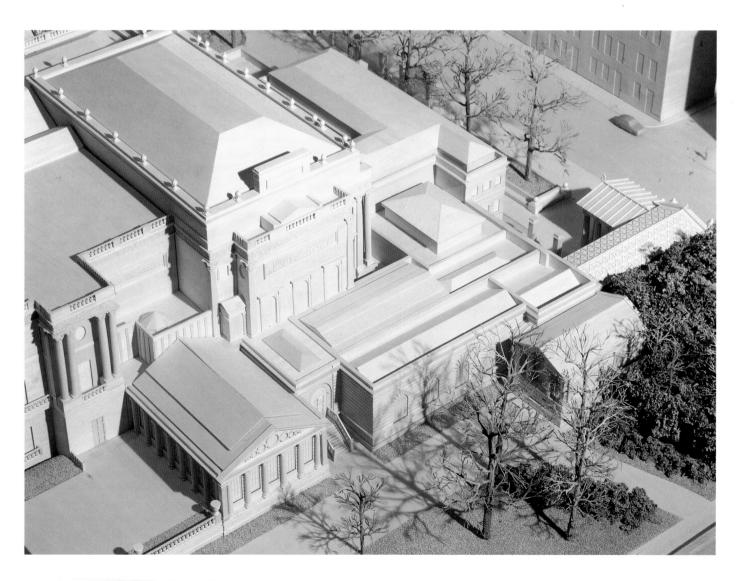

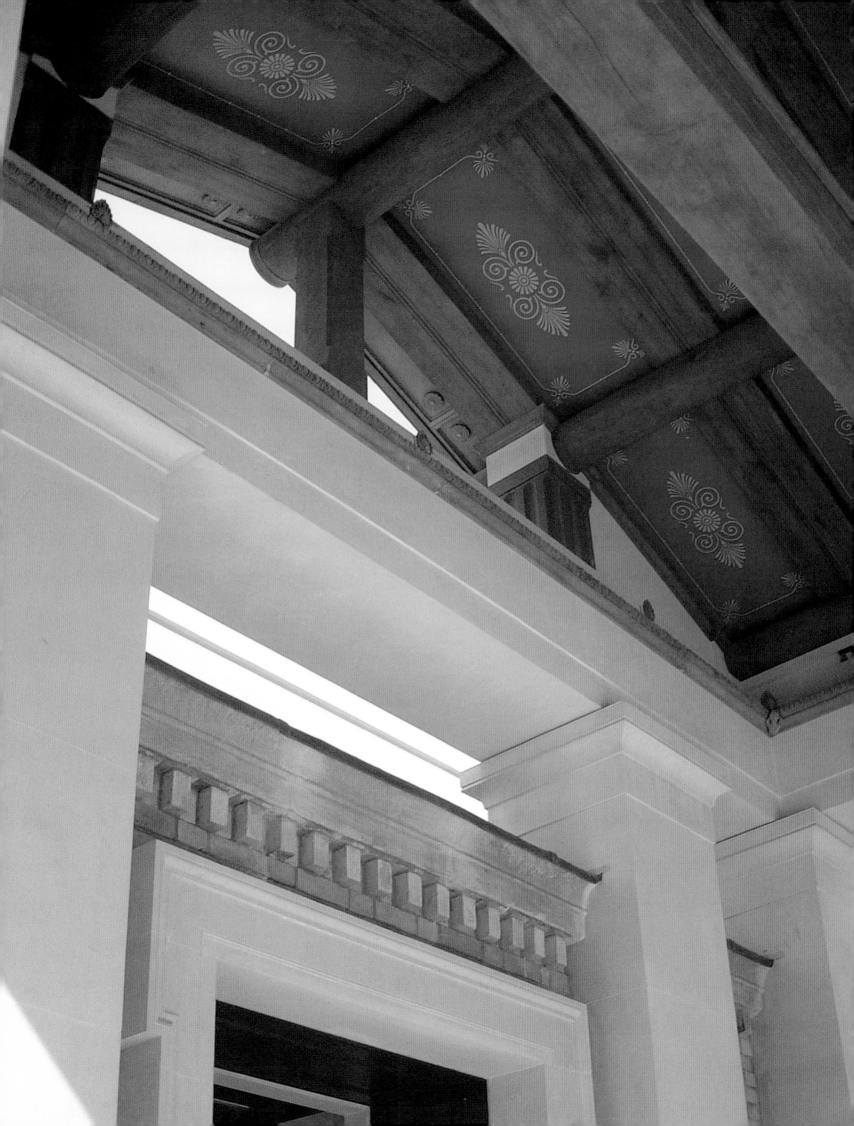

Plan of main gallery floor
Right: Corner stone of the entrance portico showing triglyph and copper embellishment on roof

1832-43, Sir James Pennethorne in 1853-55, Sir Aston Webb in 1913, and the Office of Works in 1962. On all occasions except the last, contemporary interpretations of the classical language of the original building were adopted. Simpson's new facades and interiors, inventive yet sympathetic to the traditions of the Palace, triumphantly demonstrate the wisdom of responding to the genius loci.

In the second half of the twentieth century, architects generally ignored the advice offered by Alberti, the greatest architectural theorist of the Renaissance. He urged that an architect called on to continue an existing building should not show pride by indulging in innovation, but should accept that "the original intentions of the author, the product of mature reflection, must be upheld." The new Queen's Gallery shows that an architect who follows the spirit of these recommendations is in no way prevented from producing designs of startling freshness and beauty. This new work owes much to a sensitive response to the work of two early-nineteenth-century architects, John Nash and John Soane, from whom Simpson feels that we have much to learn: both were pioneers in the display of works of art in public and private galleries; and both were employed by the Government in the reign of King George IV, frequently being obliged to work within existing buildings. Simpson's new galleries and lecture theatre are, indeed, partly situated in space carved out above the Royal Kitchen, and partly behind the replication of an existing Victorian screen wall.

ENTRANCE PORTICO

Much thought was given to the important question of this new entrance, for an unsatisfactory feature of the former Gallery was that the approach was through a mean side door off Buckingham Gate. Visible from a distance, the striking new entrance portico and higher pedimented entrance hall behind it beckon visitors towards the Queen's Gallery, the existence of which had previously been scarcely indicated. The open entrance portico is oriented so that it seems to face in two different directions at once, its side façade on to Buckingham Gate, and its front, on to the new public piazza, which has been created on a space formerly used as a car park by moving back the railings from Buckingham Gate.

The relation between the portico and the higher wing containing the entrance hall behind recalls the disposition of the Erechtheion on the Acropolis in Athens, built in 421-405 BC. The startling asymmetry of this temple led Vitruvius to observe of it that, "everything that is usually on the front has been transferred to the sides." Taking the Erechtheion as a guide to the handling of a shift in axis, Simpson was happy to emphasise the way in which the two parts, the portico and the entrance hall, over-shoot and oversail each other. The portico is of Portland stone, like the entrance front of the Palace which was added in 1913, while Simpson's sensitivity to local traditions is further evident in its columns which are Greek Doric like those of the screen walls with which Blore flanked the entrance front of the Palace in 1833. The most solemn of the ancient Greek orders, these proclaim the significance of the world to which the portico gives access. Strong historical precedent also exists for their use since the Greek orders were thought the most appropriate for the first major public museums created in the opening two decades of the nineteenth century, such as the Altes Museum in Berlin, by Schinkel, the Glyptothek in Munich, by Leo von Klenze, and the British

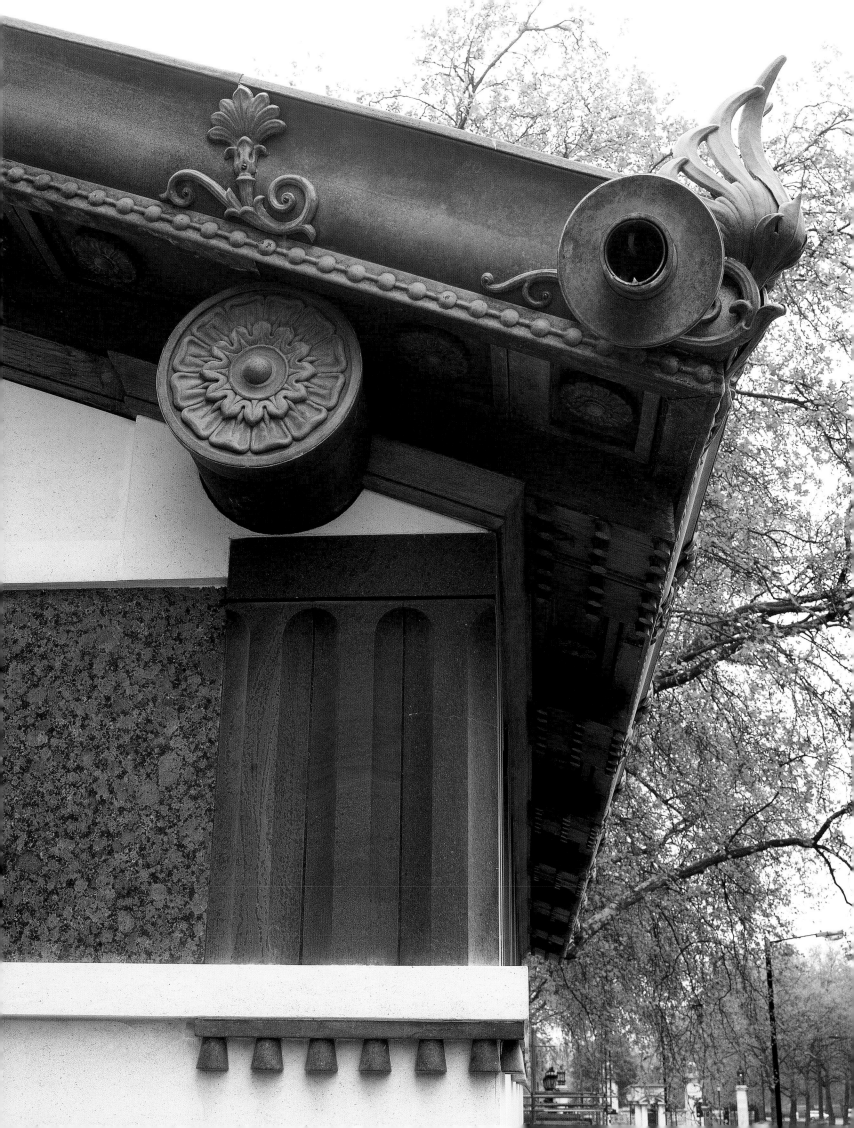

Museum, by Smirke. Indeed, the earliest picture gallery known to us was in the Propylaia, the Greek Doric entrance gateway to the Acropolis in Athens, built in 437-432 BC by the architect, Mnesikles.

For his own propylon, leading to the royal picture galleries, Simpson used a rare form of Greek Doric not used by Mnesikles, Schinkel, Klenze, or Smirke. He returned to the very roots of architecture, the early Greek Doric of the sixth century BC of the temples at Paestum, near Naples, which has not been widely used since its discovery in the mid-eighteenth century. It was then seen as primitive yet sublime, as is clear from the response of John Soane on his visit to the temples in 1779, and from the more rapturous account of Goethe who exclaimed eight years later, "At first sight they excited nothing but stupefaction. I found myself in a world that was completely strange to me ... Our eyes and, through them, our whole sensibility have become so conditioned to a more slender style of architecture that these crowded masses of stumpy conical columns appear offensive and even terrifying ... It is only by walking through and around them that one can attune one's life to theirs and experience the emotional effect the architect intended."

The entrance propylon thus marks a new and original stage in Simpson's career for he draws on the fresh, but forgotten springs of architecture in the first Temple of Hera, long known as the "Basilica," at Paestum. Dating from the mid-sixth-century BC, it is one of the earliest Doric temples, its columns boasting unique capitals, carved with rosette and lotus ornaments which Simpson echoed here. They support a bold entablature in which the frieze in red granite includes the customary triglyphs of the Doric order, here in green Westmorland stone. Two triglyphs are unusually raised up above the frieze three-dimensionally to act as brackets supporting the open pediment with its raking cornices in richly ornamented copper and its anthemion-patterned antefixes in bronze, all the kind of ornament which has now disappeared from ancient Greek temples. The open roof with its oak beams recalls the traditional origin of the Greek Doric order in timber construction, as recorded by Vitruvius. Above the beams, the ceiling is ornamented with painted decoration of the kind originally applied to Greek temples. To the right of the portico we can see the long east wall of the entrance hall, built of Bath stone, its glazed roof divided by ornamented ribs of copper.

A dramatic new entrance to the Palace, the portico is a tour de force in which the principles of Greek construction and ornament come more dramatically alive for us than in any other modern work of its kind. Moreover, the relevance of the early Doric becomes even more evident when we finally arrive in the entrance hall, for this is adorned with a sculptural programme of Homeric iconography.

ENTRANCE HALL

The imposing entrance hall, two storeys high, rises to a largely glass roof with timber glazing bars of great depth, painted dark red,

Right: View of entrance portico from the new square

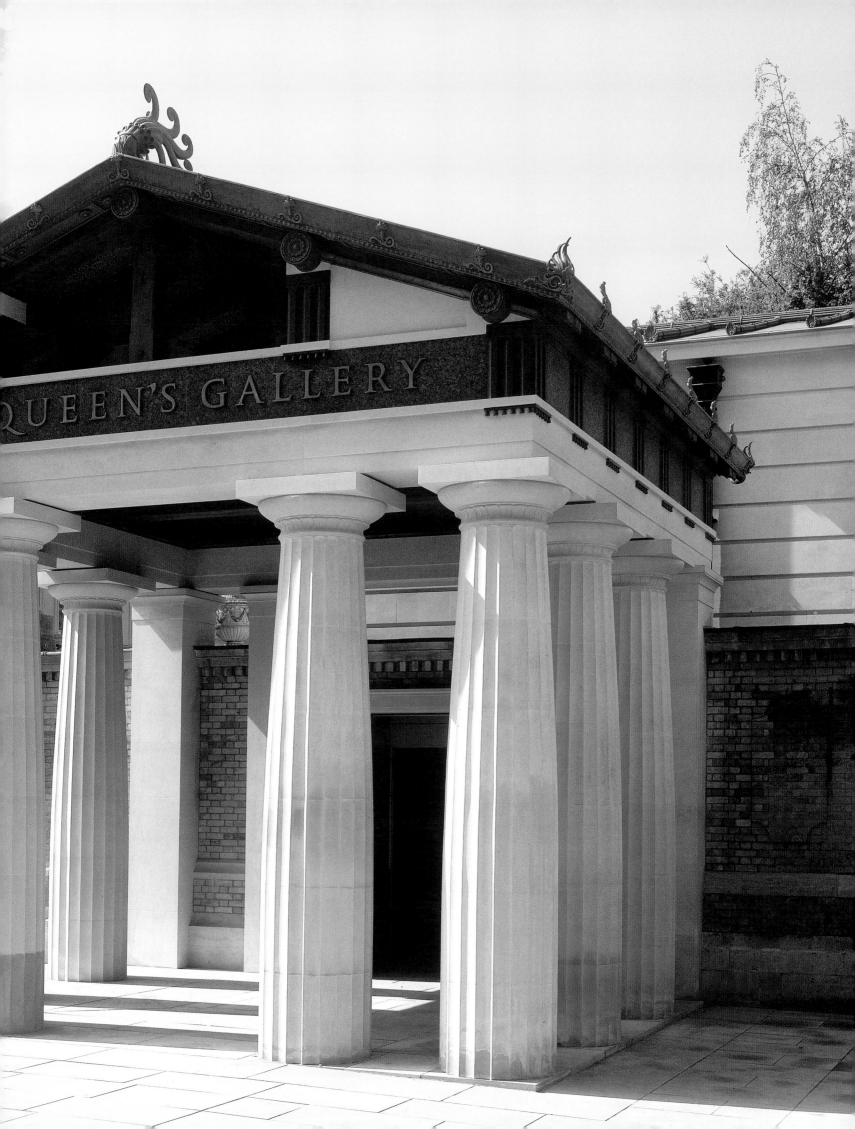

which follow the lattice pattern of the ancient Roman transenna or marble screen. Conceived as the interior of a temple of the arts, this room is defined spatially by a pair of Greek Doric columns at each end and by a single column in the centre of each long side. Of the fluted, baseless, type with the emphatically swelling profiles used at Paestum, these columns sport capitals carved with anthemion ornament in an alternating lotus and palmette pattern, again suggested by some of the highly inventive details which are unique to Paestum. High above the columns, the two long side walls feature two great figured friezes by the Scottish sculptor, Alexander Stoddart. Precedent for placing a frieze in this position in the interior of a Greek temple is provided by the remarkably inventive cella of the sanctuary of Apollo Epicurius at Bassae, in the Peloponnese, designed by Iktinos in the late fifth century BC.

SCULPTURE BY ALEXANDER STODDART

Together nearly seventy feet long and three and a half feet high, Stoddart's friezes were modelled in clay and cast in plaster. Their beauty and dynamism, like that of Simpson's architecture, complement the sculptural programme of Nash's existing building which also includes narrative figured friezes in the Throne Room, Grand Staircase, and Blue Drawing Room, designed by Thomas Stothard, and on the garden front by Richard Westmacott. Simpson and Stoddart have here brilliantly revived the tradition, needlessly lost in the twentieth century, of uniting architecture and sculpture in a way which, following John Wotton in *The Elements of Architecture* (1624), the first theoretical work on its subject in English, celebrates architecture as the mistress art with painting and sculpture as her handmaidens. It was this vision which, as we have seen, fired Soane when he found it in the writings of Le Camus de Mézières.

Well versed in classical literature and philosophy, Stoddart drew on the *Odyssey* and the *Iliad* as the inspiration for his friezes. These nostalgic celebrations of an heroic Greek past in epic poems dating from the 8th century BC, became at an early date the foundation of Hellenic culture and education. Stoddart explains that the friezes are an allegorical representation of aspects of the world in the reign of Her Majesty The Queen which dramatise the themes of war and peace, or discord and concord, the *Iliad* being the first recorded conflict between east and west. He writes how, "The former is evoked along the western wall in scenes of *The Rage of Achilles*, depicting the first words of western art which show how strife can rip through a community with disastrous consequences for the innocents of the world. The reference here is to events of the Cold War, while concord is evoked in the frieze along the east wall which depicts *Ulysses at the Court of Alcinous*. This represents the court of a felicitous state, ruled by King Alcinous and Queen Arete who welcome the stranger Odysseus, the first alienated man, who is shown kneeling in homage before the throne of Queen Arete."

The friezes are flanked by four panels in which Stoddart represents the four Patron Saints of England, Wales, Scotland, and Ireland, arranged so as to extend the opposing themes of the two sides of the Entrance Hall. Stoddart explains that on the western wall, "St George and St David signify Science and Industry, with the Honours of St George, the Order of the Garter, being conferred on the scientist-philosopher, who appears with a sun-dial, telling of the precipitate adventure of science in cosmological discovery during the reign of Her Majesty the Queen. St David is shown blessing the bees, with Cymra, a bee-keeper and a coal-miner depicted to the side." On the opposing wall, "St Andrew and St Patrick signify the quest for art and the quest for peace respectively, with the Honours of St Andrew, the Order of the Thistle being conferred upon the poet who plays a harp; St Patrick is shown casting out the serpents from Ireland."

The approach from the Entrance Hall to the dramatic Staircase Hall is guarded by two exquisitely graceful, life-size figures of winged Genii by Stoddart, which have complex steel armatures embedded into their plaster. Looking forwards at each other, these connote the Hall of Alcinous in the Odyssey, already represented by Stoddart in the frieze, where, according to the poet, gilded statues of youths bore torches aloft. Stoddart explains that they also "effect a radical transition from the world of Greek imagery towards that of the British Coronation liturgy with its appeal to ancient Hebraic imagery, as in Handel's Coronation Anthem, *Zadok the Priest*, sung at all Coronations since 1727. The transition is effected because the Genii also refer to the two winged cherubim guarding the Ark of the Covenant in the Temple of Solomon in Jerusalem. It was between the meeting gaze of these figures that the deity is said to have appeared." It is thus exactly between these two Genii that Stoddart's bust of The Queen is placed at the far end of the whole axis, on the landing above the staircase. Cast in bronze by the Morris Singer Foundry near Basingstoke, this massive portrait bust of Her Majesty in full Coronation regalia and the Crown of St Edward, is intended as a timeless, almost abstract, celebration of her role as monarch. Alexander Stoddart explains his unique creation of what he describes as "a totemic work, devoid of accidental personality, glance or character, indeed with aspects of the physiognomy deriving from the face of her father, King George VI."

Providing a transitional zone between exterior and interior, entrance halls are traditionally given rusticated, stone-coloured walls so as to throw into relief the greater colour and richness of subsequent interiors. This hierarchy is notably in evidence as we pass from the Entrance Hall to the Stair Hall.

Right: View across roofs showing copper and bronze embellishment
Overleaf left: View looking up towards Alexander Stoddart's Genii
either side of the entrance into the galleries
Overleaf right: Detail showing embellishment on capital of column in entrance hall
Page 30: Detail of ironwork railings
Page 31: View looking into entrance hall from shop
Page 32: View looking into the stair hall

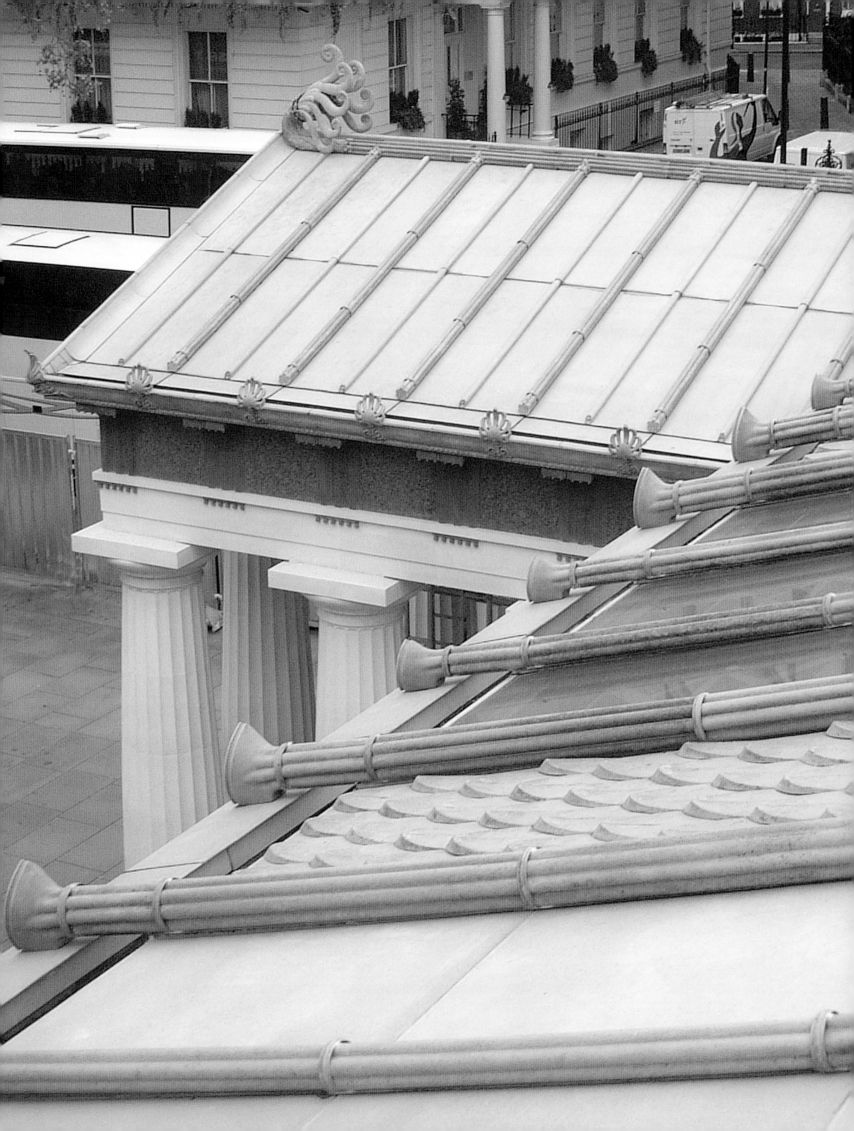

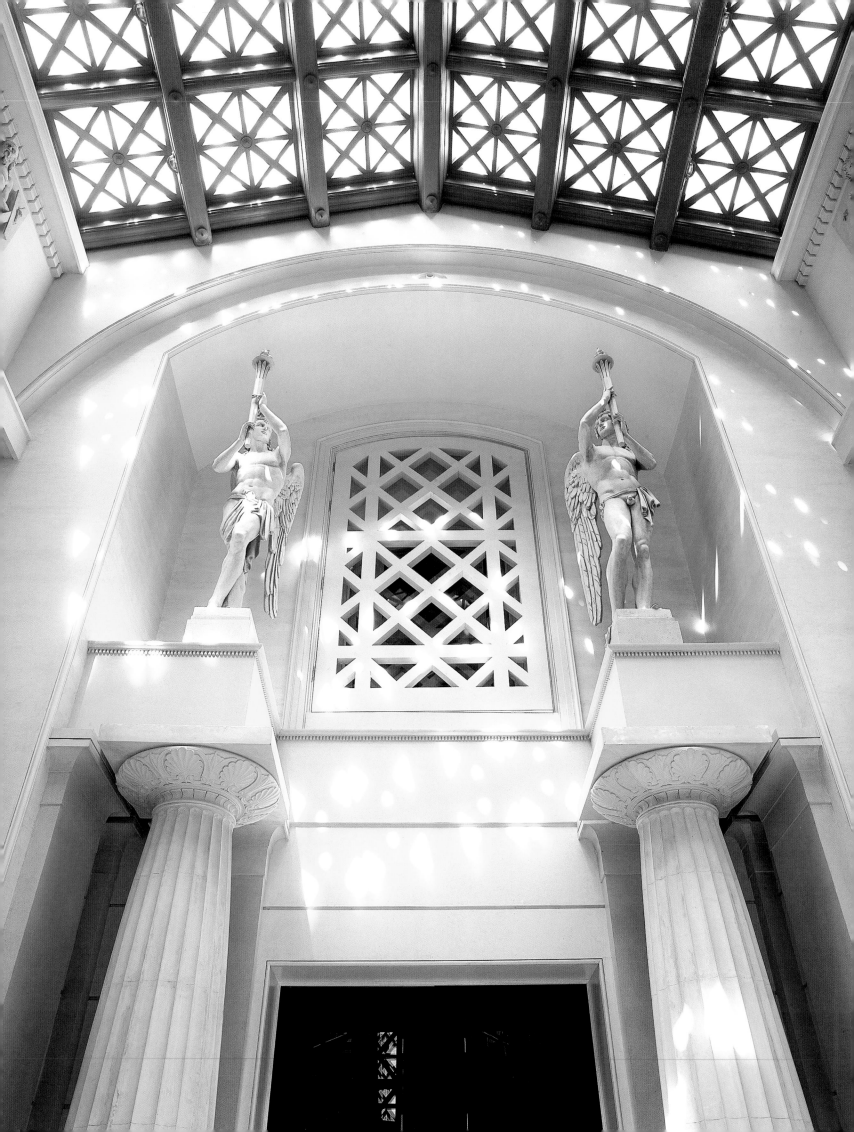

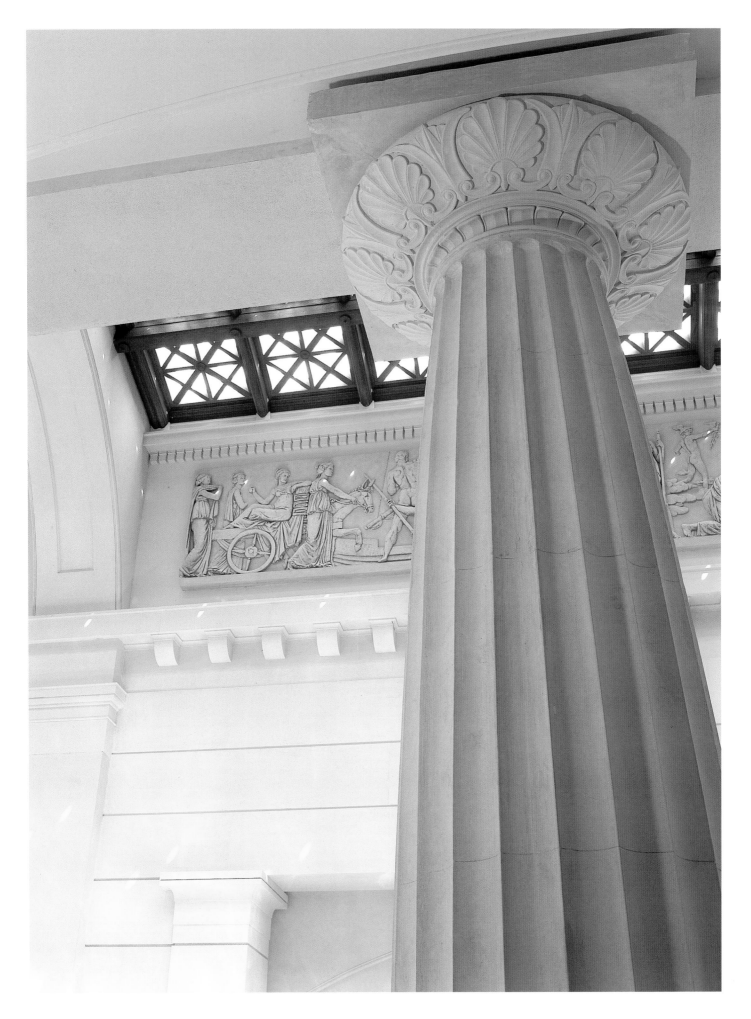

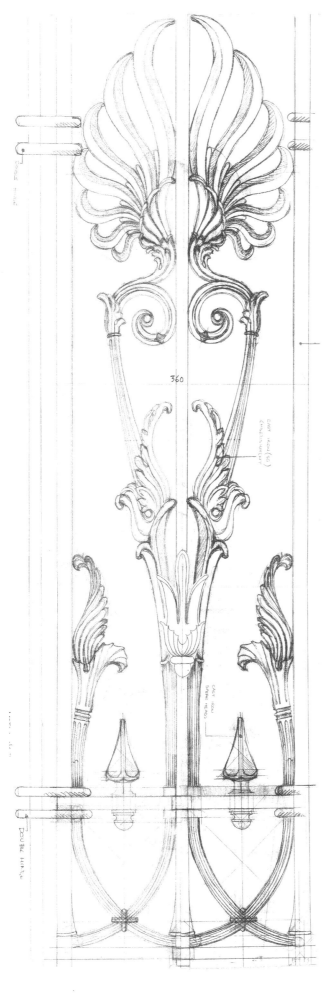

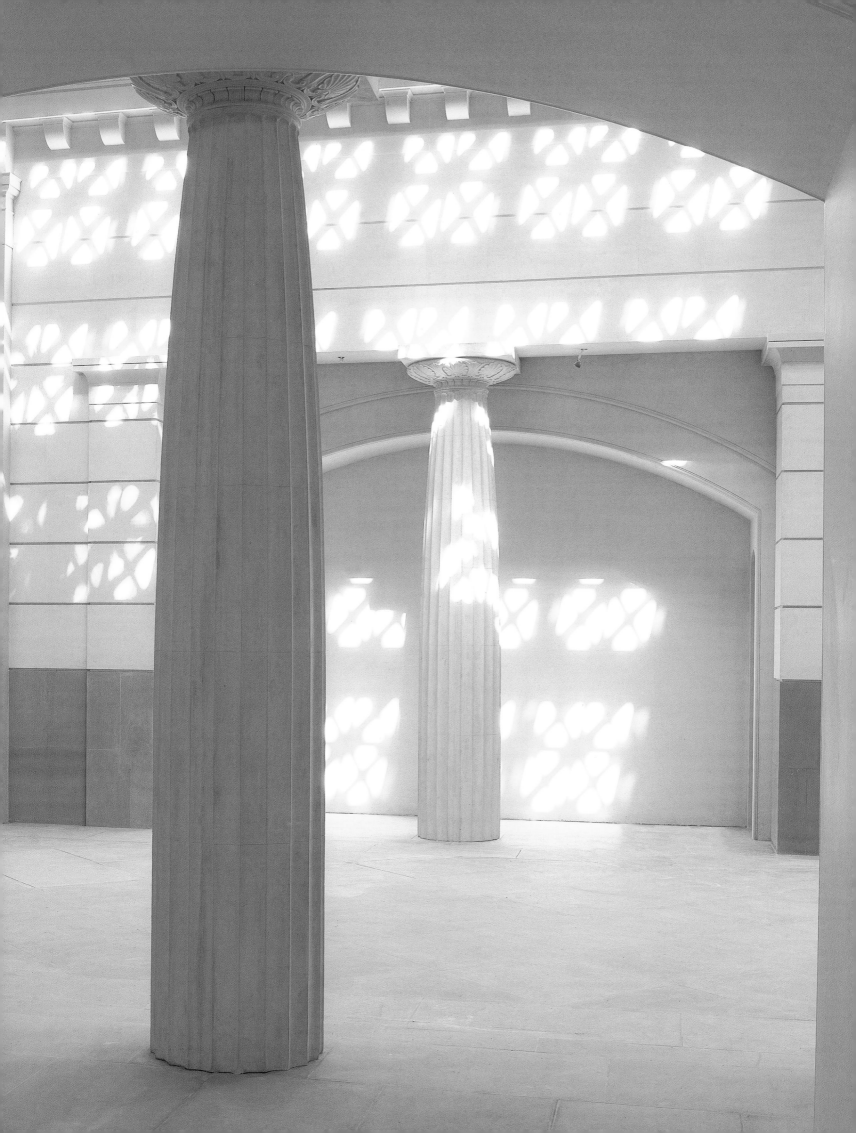

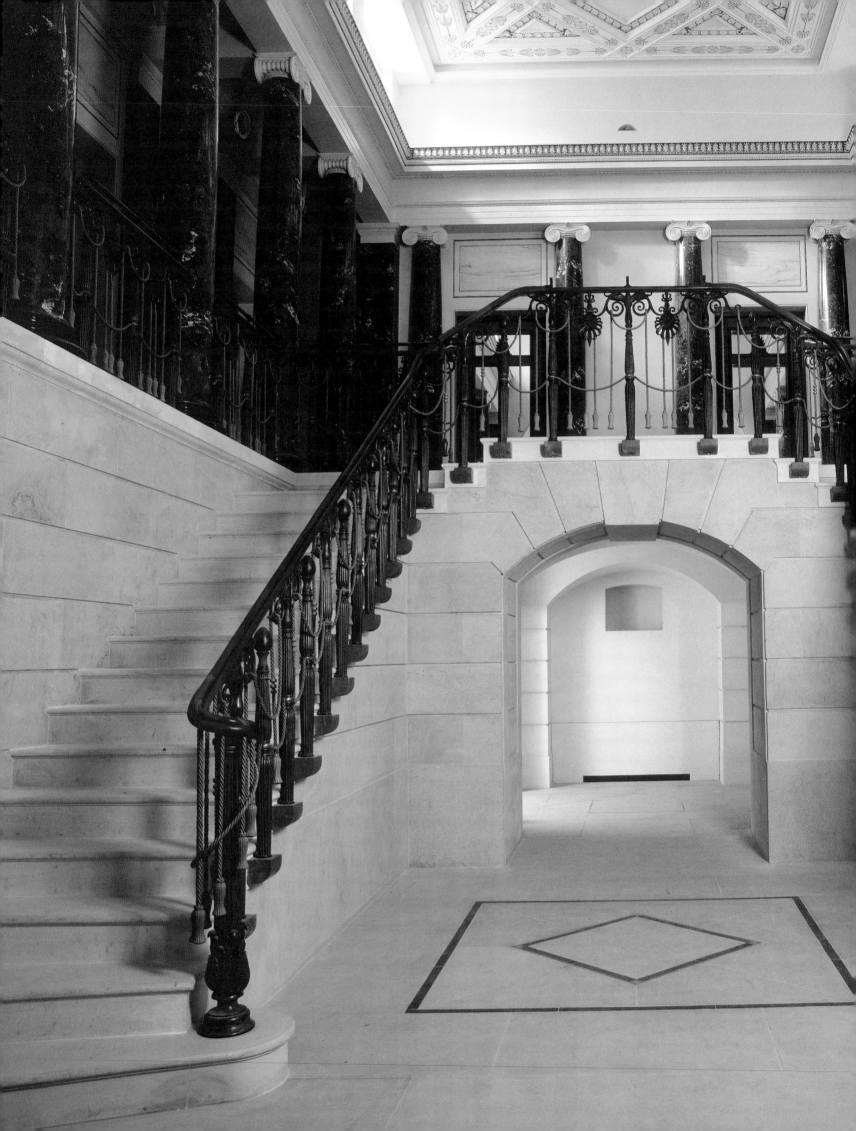

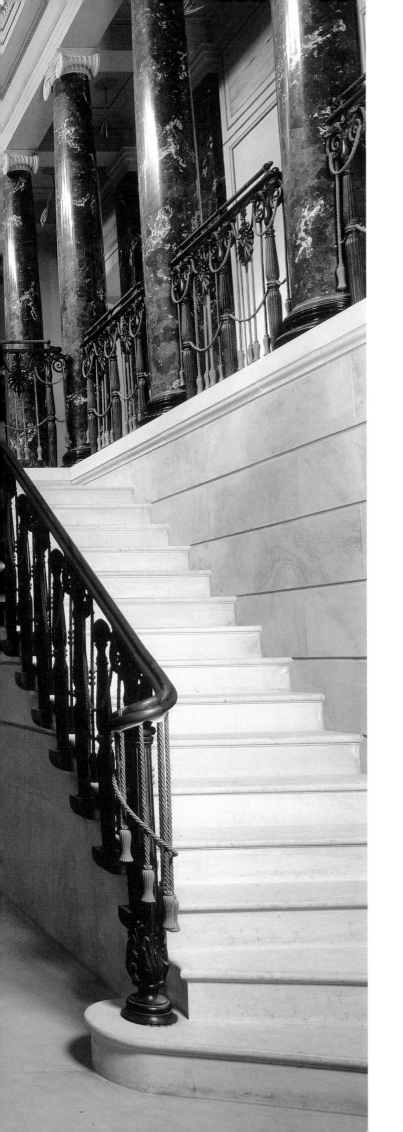

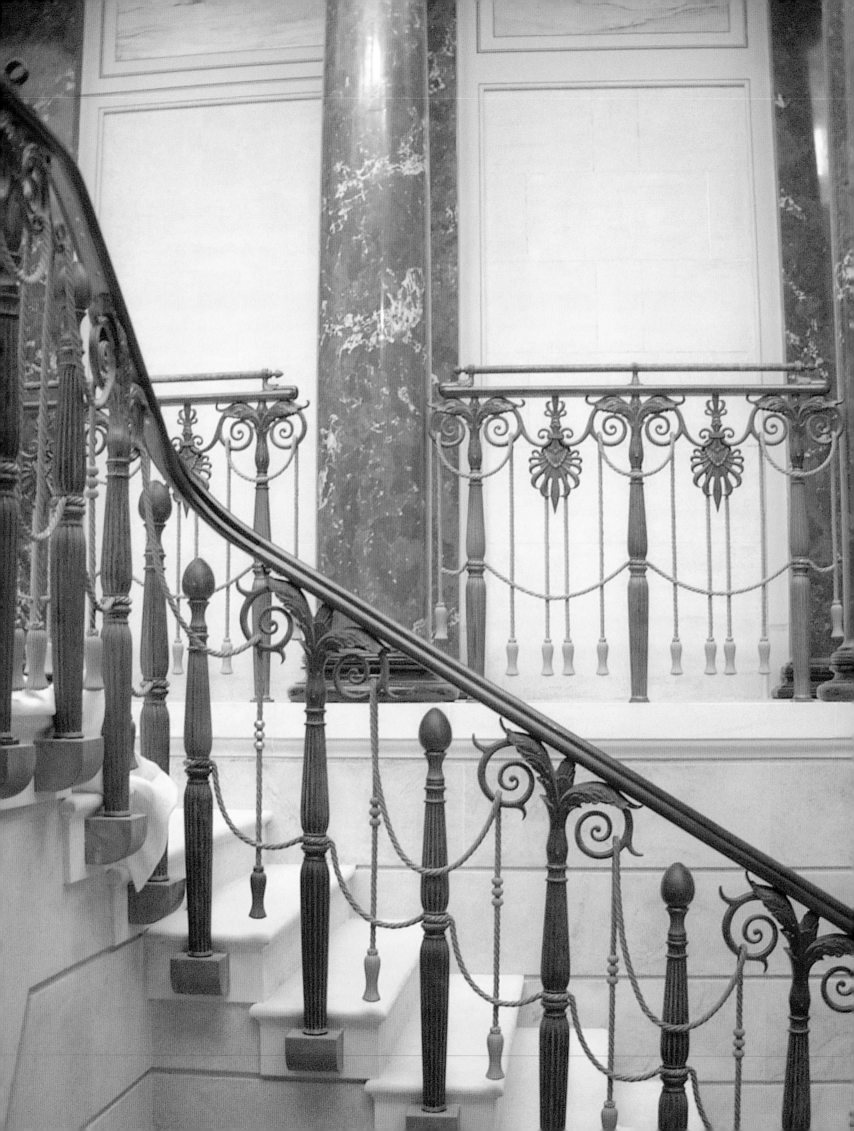

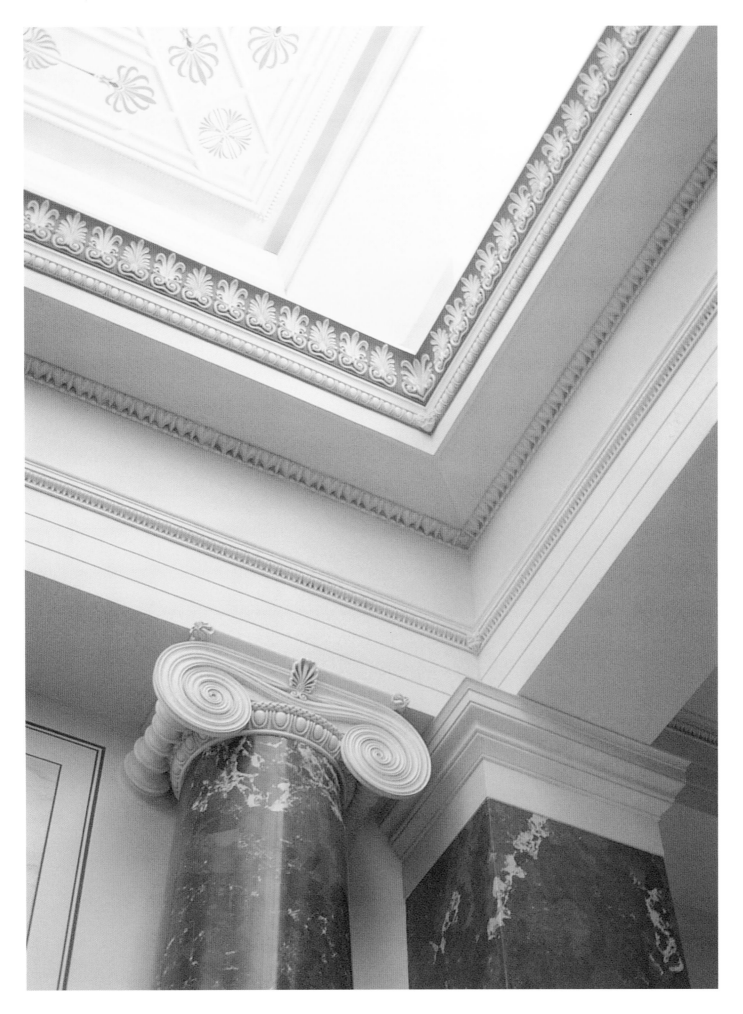

STAIR HALL

This highly ornamental interior features free-standing Ionic columns which, with their answering pilasters against the walls, are in green scagliola. They carry an elaborate frieze crowned by an anthemion cornice, also in green. The richly coloured ceiling, with much stencilled ornament in red, has vigorous diagonal coffering which echoes that by Schinkel in the Concert Hall of his State Theatre in Berlin of 1818-21. The trabeated clerestory of continuous rectangular windows also recalls that at the State Theatre. The graceful bronze banisters sporting anthemion ornament similarly recall the staircase at the Altes Museum, Berlin, designed in 1823 by Schinkel to house the Royal Collection in a new building open to the public.

In this room Simpson incorporates polychromy in both ornament and materials, for the staircase rises from a substructure of a golden-coloured Ham Hill stone, enriched with horizontally-channelled rustication, which contrasts in colour with the steps of the staircase in white Portland stone. The visitor can pass through an archway between the two flights of the staircase and descend to the lavatories, or ascend the staircase to the landing with its central bust of The Queen. The doors around the landing are of a warm, red, polished mahogany, their architraves surmounted by free-standing anthemia carved by Dick Reid. On the left, these glazed doors give access to the Education Room, a small exhibition space designed both for educational use and for small, specialised displays. When privacy is required in this room, shutters can be drawn over the glazing, the sides of the shutters facing the landing being faced with mirror. This attractive device recalls the unusual mirrored doors with gilded metal embellishments which Nash provided in the State Rooms in the 1820s. Simpson replaced the metal with dark walnut strips and provided a central pilaster and anthemion to conceal the joint in the mirrored shutters. When opened these fold into the reveals of the door and windows on either side. Like the entrance hall, the stair hall contains light-fittings in bronze and etched glass, specially designed by Simpson.

From here, there is a choice of direction, for visitors can turn left into the Education Room; right, up a short flight of stairs into the Lecture Hall, known as the Redgrave Room; or bear right to the three main new galleries. Two of the main galleries are top-lit in a way inspired by both Nash and by Soane, the master of top-lighting, as demonstrated in his own house and museum at 13, Lincoln's Inn Fields.

GALLERY VESTIBULE AND THE REDGRAVE ROOM

Simpson created an area designated the Gallery Vestibule between the Stair Hall, the galleries, and the Redgrave Room. This beautiful, flowing space cleverly reconciles conflicting circulation routes as well as accommodating the changing floor level between the galleries and the Redgrave Room. In planning terms, the Gallery Vestibule is close to the kind of device deployed in similarly complex situations by Soane, so it is appropriately defined by two linked spaces with Soanean domes and pendentives. It also contains a lift with a Soanean pendentive dome which, like that he provided at Gonville and Caius College, Cambridge, shows Simpson's invention in applying traditional forms to the products of modern technology.

The Gallery Vestibule is adorned with busts of monarchs who, from King Charles I, have been especially associated with the Royal Collection. A staircase ascends from it to the Redgrave Room, a large cruciform room defined by four pairs of columns bearing capitals adorned with lotus leaves inspired by those at the Hellenistic city of Pergamon in Asia Minor. These also echo the iron columns with palm-leaf capitals in Nash's Great Kitchen of 1820 for the Prince Regent at the Royal Pavilion, Brighton. The Prince was so proud of this room with its advanced steam-heating that he showed it to his guests. There is another unexpected link between Simpson's Redgrave Room and the Brighton Kitchen, for the former occupies space created by lowering the ceiling of the Great Kitchen at Buckingham Palace. The great saucer dome of the Redgrave Room, its horizontally ribbed pendentives recalling Soane's halls in the Bank of England, rises to an oculus of glass engraved with lotus leaves, against which the central plaster lotus flower is dramatically silhouetted. This recreates something of the lush and exotic splendour of Nash's interiors at Brighton Pavilion. Yet as always with Simpson, poetry and practicality are combined, for the rosettes in the pendentives conceal the vents for the air-conditioning system. As we leave the Redgrave Room we find that the landing outside it acts as a balcony which provides an intriguing vista across the Gallery Vestibule back to the Stair Hall. If we descend again to the vestibule, we find the entrance to the Pennethorne Gallery, so named because of its proximity to that part of the Palace remodelled by Pennethorne in the 1850s.

PENNETHORNE GALLERY

This top-lit interior has an elaborate tripartite roof, developed and enriched from ideas by Soane and Nash, in which a central section with a segmental barrel vault is flanked by lower aisles with horizontal roof lights. Like the two other principal new galleries, the Chambers Gallery and the Nash Gallery, its walls are hung with an Isle of Bute woollen fabric, here in a vivid green colour, and its deep skirting is of polished black marble. This room

Right: Detail of balustrade showing cast bronze uprights and anthemia with wrought iron ropework and tassels
Previous page left: Bronze and iron balustrade to staircase
Previous page right: Detail of ionic entablature in stair hall
Overleaf: View looking across upper landing of stair hall showing scagliola columns and mahogany doors

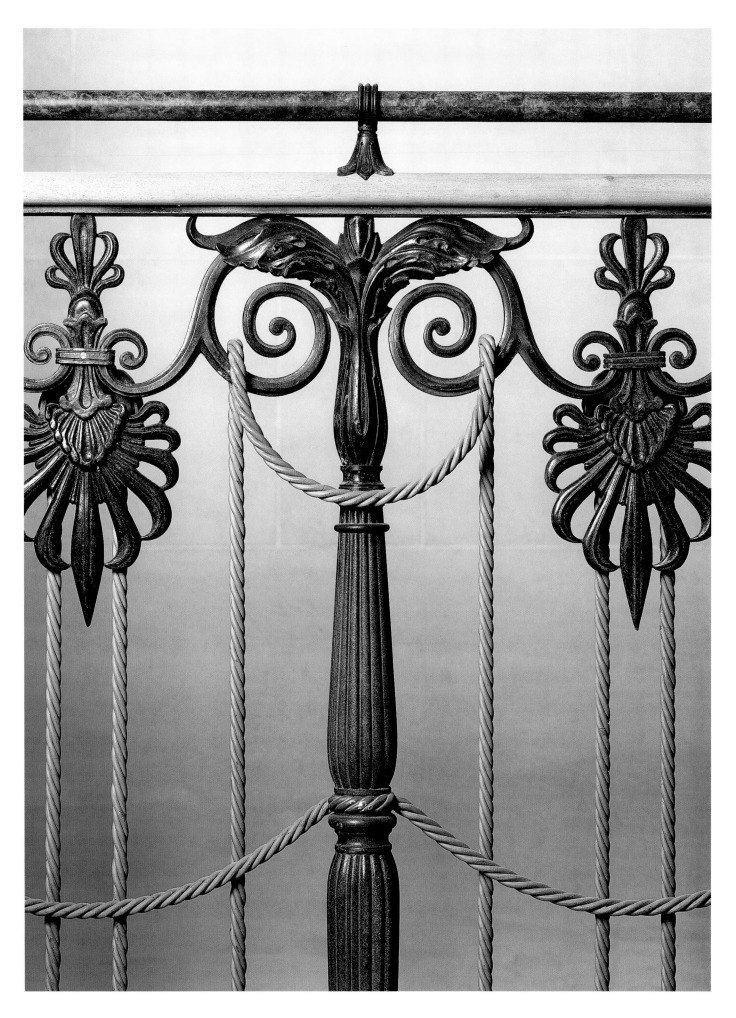

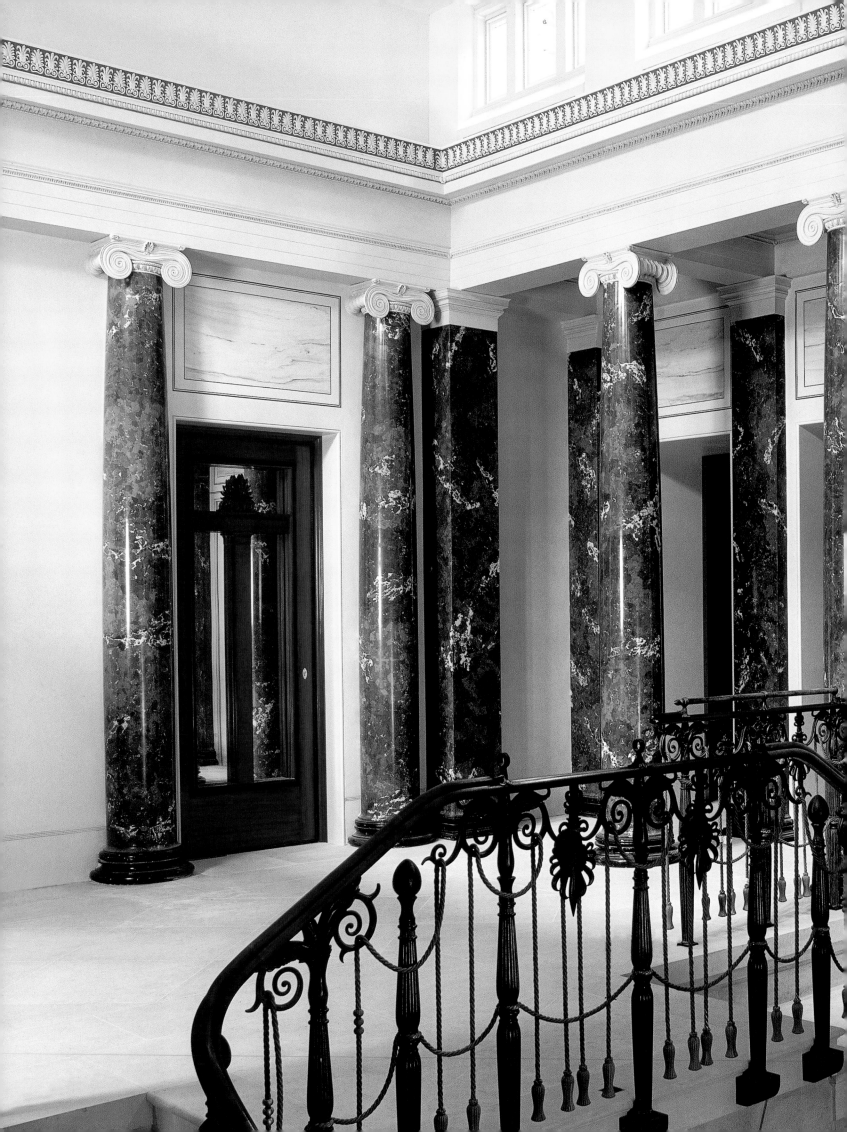

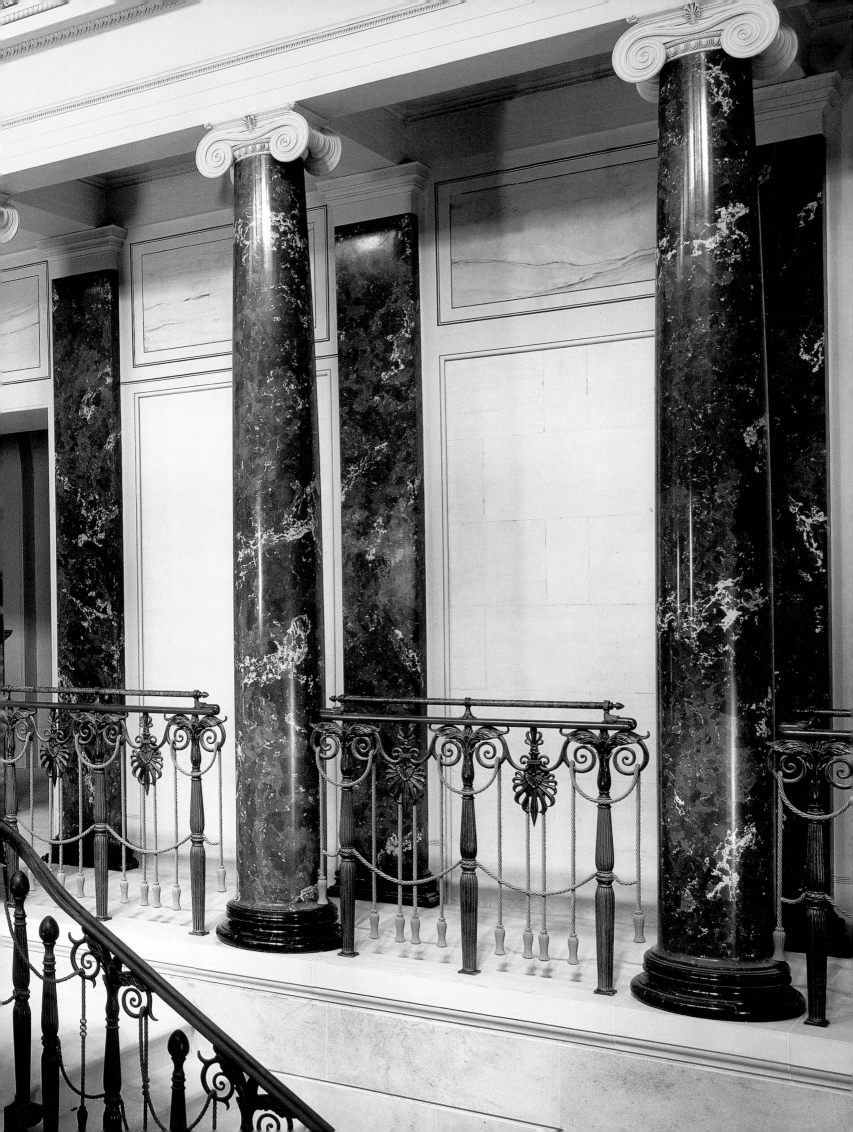

provides a handsome space for a changing display of works of art from the Royal Collection and will be open all the year round. Leading off it are two intimate Cabinet Rooms with Soanean domed ceilings and glazed display cupboards like Georgian shop fronts. These are intended for the exhibition of small objects such as miniatures, porcelain, silver, and jewellery, or for the mounting of small "object in focus" exhibitions.

CHAMBERS GALLERY

Parallel to the Pennethorne Gallery and approached from it or from a small vestibule off the Stair Hall, is the Chambers Gallery. The galleries are differently designed so as to accommodate the display of contrasting types of objects. The Chambers Gallery is essentially a graphic art gallery, designed for the exhibition of works on paper from the incomparable collection of the Royal Library at Windsor, though it may also be used to display a mixture of objects including porcelain and bronzes. To preserve works of art on paper, it is totally artificially lit, though the light sources are concealed, as in many of the new rooms, within elegant plaster rosettes in the coffered ceiling. As often in Simpson's work, what appears to be pure decoration also serves a modern technological role.

The walls are hung with Isle of Bute wool in a deep blue colour. A series of moveable screens at right angles to the walls provide additional space for hanging in a technique which owes something to Soane's moveable panels in his own Picture Room of 1824 at 13, Lincoln's Inn Fields. Covered in the same fabric as that on the walls, these screens terminate in timber obelisks on square bases with four turned legs in satinwood. They are designed to match the display cabinets and benches designed for this gallery in satinwood with bronze fittings. A series of sockets in the floor allow for a range of different positions for the display panels, while the light fittings in the ceiling coffers correspond with these so that light is cast on the exhibited work at the optimum angle of 30 degrees. Concealed doors in the end wall of the gallery open out to reveal a storage area for these panels where they can be kept when not in use. As everywhere, the beautiful cast-iron grilles in the floor are part of the heating and cooling system.

Four doors lead into the Chambers Gallery, thus permitting a choice of circulation routes between the adjacent rooms. When more hanging space is required, some of these doors can be locked and display panels can be unfolded from the wall to cover them. This provides a continuous hanging surface which even conceals the floor and architrave behind. The doorway from the principal landing, normally locked, has mirrored panels. Beyond

Right: View looking into the Redgrave lecture room built into the upper half of the great kitchen
Overleaf left: Detail of bracket over the door in the stair hall
Overleaf right: Detail of the central lotus flower in the oculus of the dome

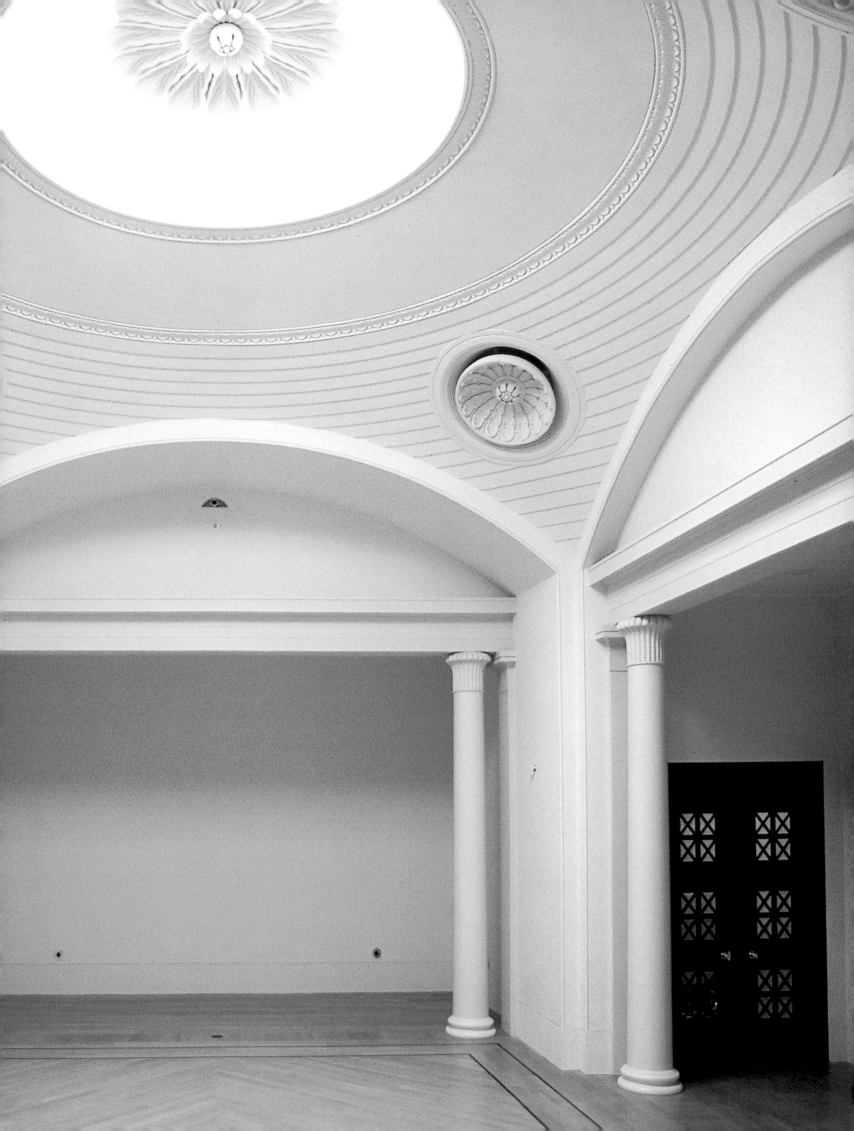

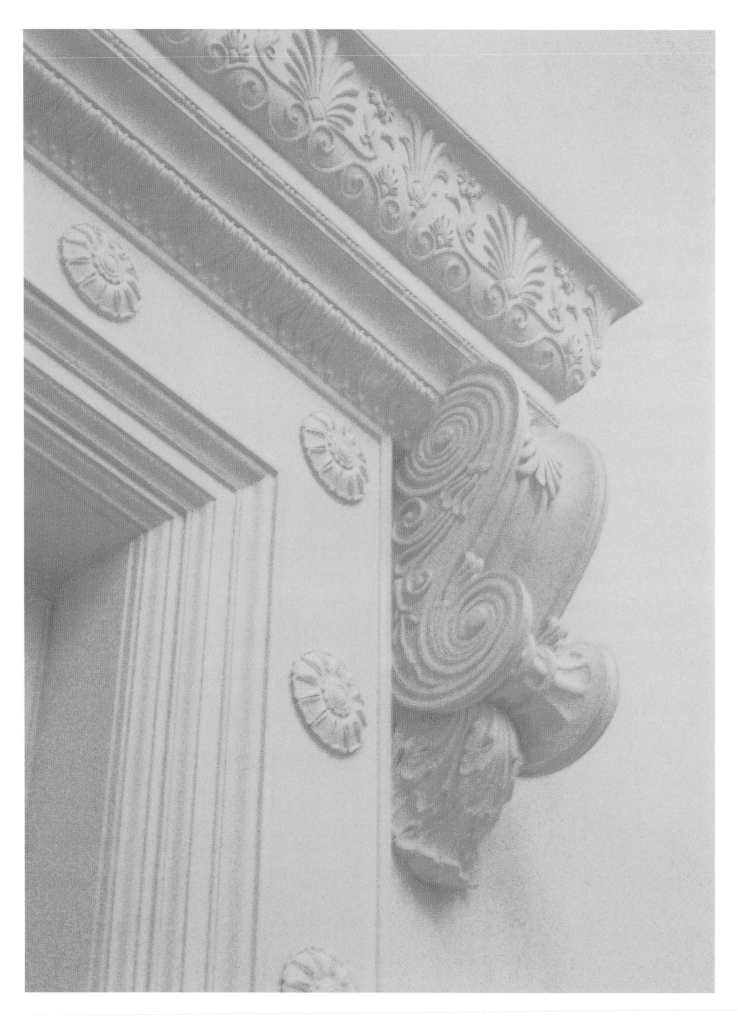

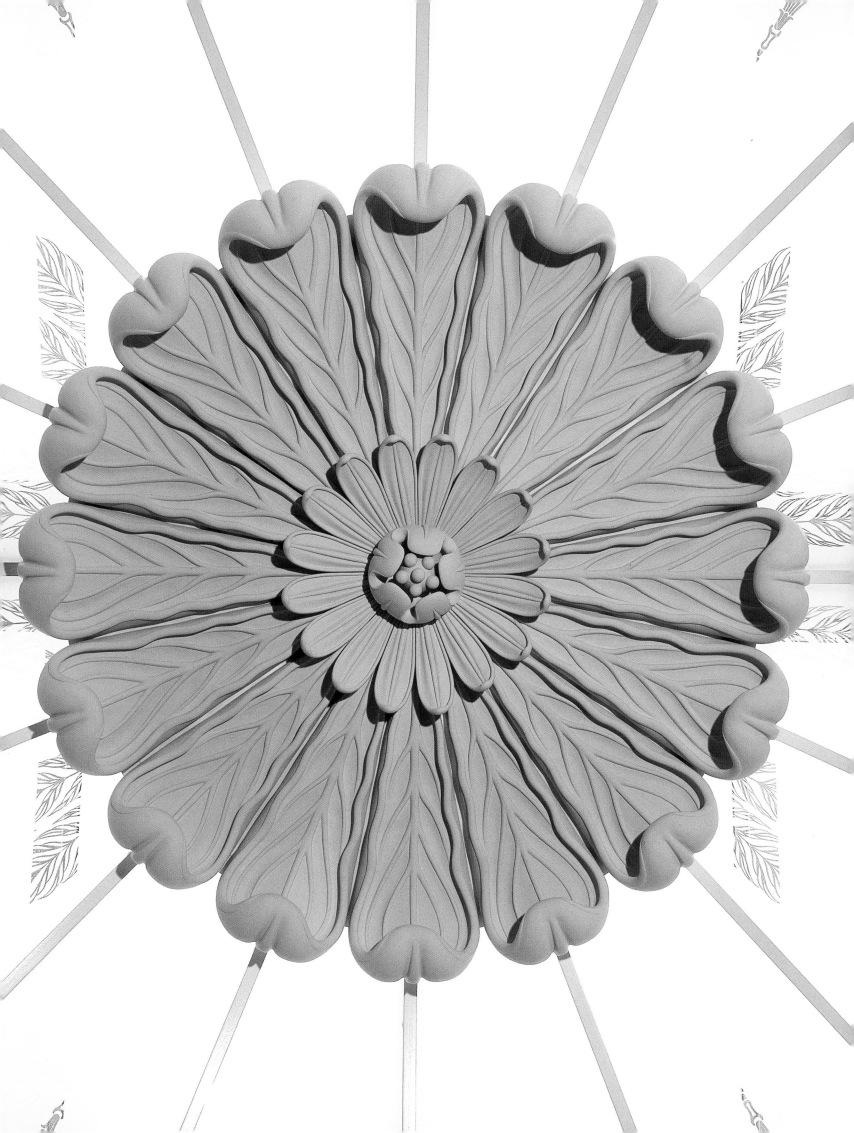

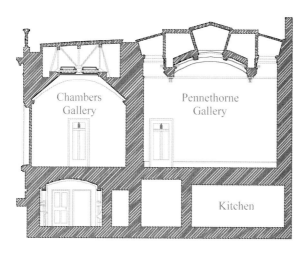

Section through the chambers and Pennethorne galleries
Right: Watercolour of the Pennethorne gallery by Ed Venn
Overleaf left: Detail of carved anthemion on mahogany doors
on upper landing of stair hall
Overleaf right: Detail of bracket and triglyph in the Pennethorne gallery

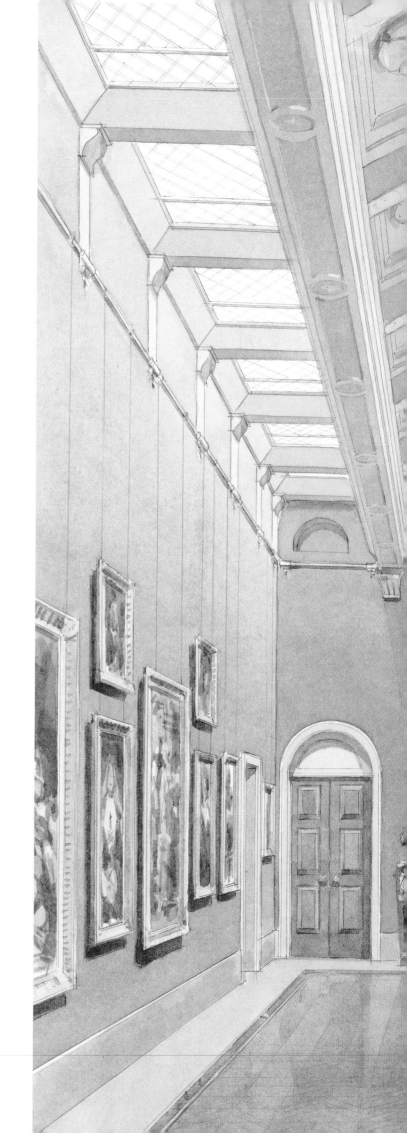

this gallery is a substantial lobby or gallery with an elaborate ceiling and walls lined with cabinets for the display of objects such as silver and porcelain. It has glazed doors allowing views into the gardens when The Queen is not in residence. This welcome new feature, with steps leading down it to the garden, will enable visitors to orient themselves in relation to the rest of the Palace and its gardens. From this lobby, we reach the climax: the main gallery, known as the Nash Gallery, which replaces the original Queen's Gallery of 1962.

NASH GALLERY

Simpson here took the opportunity of creating a breathtaking new interior which, unlike its 1960s' predecessor, is in harmony with the exterior of the Nash pavilion in which it is situated. The pavilion is one of three which Nash designed at the corners of the Palace. The original picture gallery designed by Nash for the Palace, which still survives, occupies the site of the first-floor rooms of the original Buckingham House, built in 1702-05 for John Sheffield, Duke of Buckingham, by William Winde. Designed for King George IV's outstanding collection of Dutch and Flemish paintings, many of which still hang there, Nash's gallery originally had an interesting ceiling somewhat in the manner of Soane with hanging arches and little glazed saucer domes or lanterns. Unfortunately, this was modified by Edward Blore in the 1840s and totally replaced for George V in 1914 by Sir Aston Webb with a rather dull, glazed, segmental ceiling which survives today. In fact, Nash had adopted this kind of ceiling in two other galleries, both now demolished: one for the sons of Benjamin West in Newman Street, and one in his own house in Lower Regent Street, a glamorous interior admired by Schinkel on his visit to London in 1826.

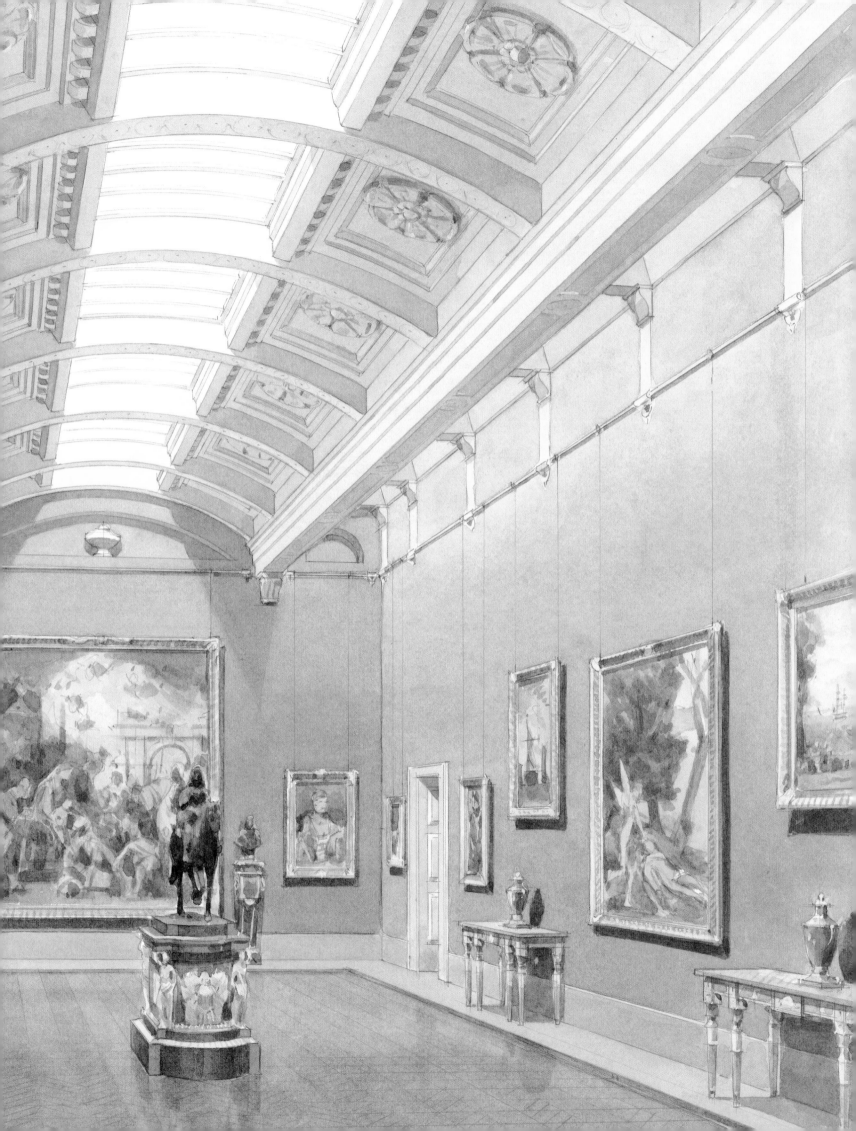

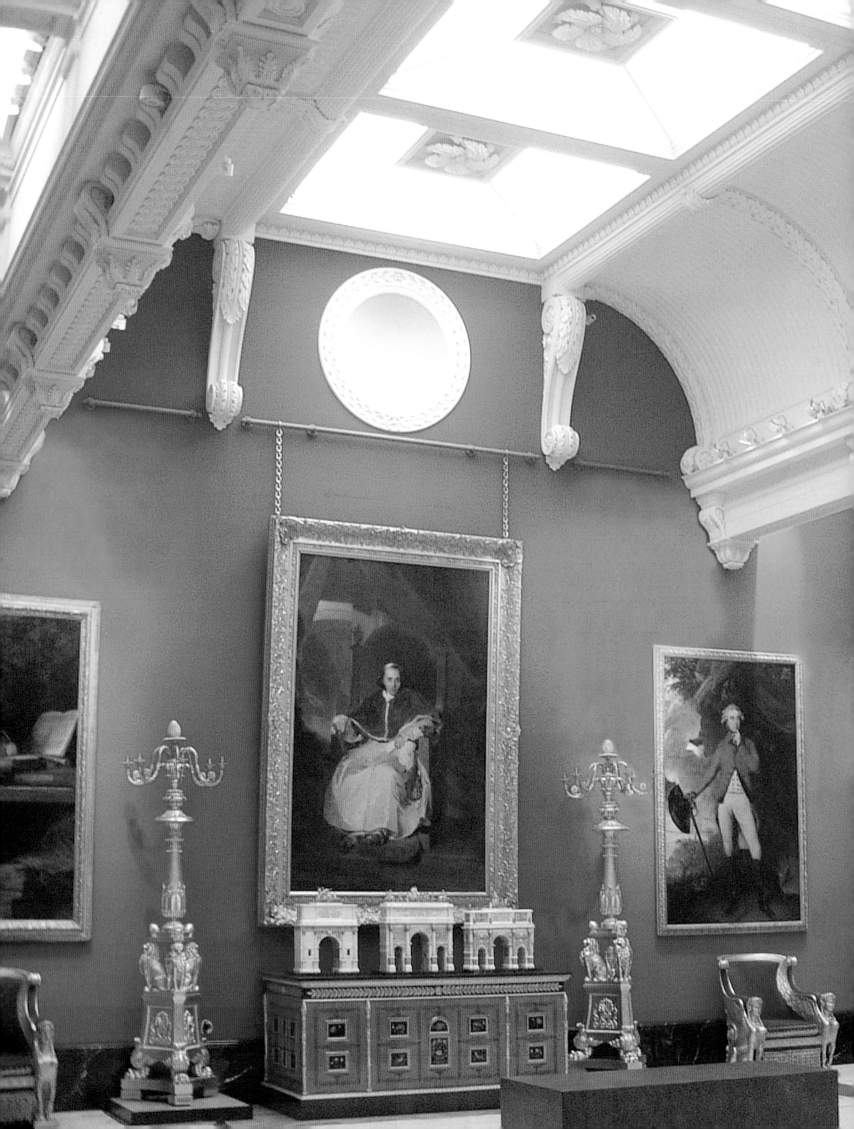

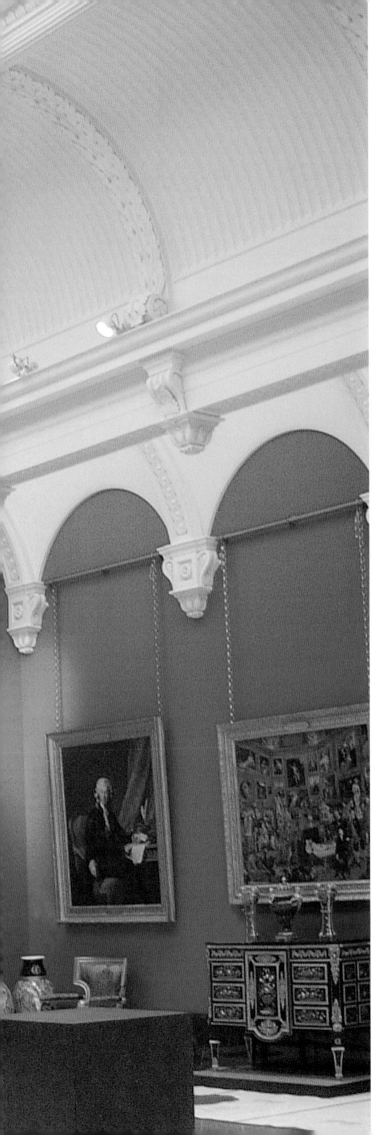

It was Simpson's idea to reinstate something of the poetry of these now lost ceilings by Nash in his own new principal gallery at Buckingham Palace. In Simpson's Nash Gallery, he has done this triumphantly, his massive ceiling beams being carried on brackets richly adorned with acanthus leaves, echoing those by Nash elsewhere in the Palace. The engraved glass in the ceiling, as in the Lecture Room, provides a stunning background against which the plaster rosettes are enthrallingly silhouetted above walls which are hung with a scarlet Isle of Bute fabric.

As well as being beautiful, the ceiling beams are functional for they double as walkways enabling technicians to reach the elaborate lighting system without recourse to scaffolding. The lighting for the naturally-lit gallery spaces is carefully controlled, using external louvre blinds which open and close depending on the brightness of the sky to ensure that the galleries are always lit to an optimum level without over-exposing the works of art to the unnecessary damage caused by the degrading effects of sunlight. The roof lights are also fitted with filters that cut out ultra-violet rays. Internal sensors control the artificial lighting, so that when daylight levels drop to below an acceptable threshold, artificial light is introduced to compensate. Humidity and temperature are monitored and controlled by a series of sensors designed within specially-designed wall-mounted flat pyramids. Smoke detectors have been concealed within small niches at each end of the gallery.

HOUSEHOLD ENTRANCE

Simpson has also created a new Household Entrance to the galleries which is, effectively, a private entrance for the Sovereign. This passage-way linking the principal floor of the Palace to the vestibule of the new Nash Gallery was made possible by inserting a new flight of stairs connecting Edward Blore's old entrance to the chapel with the gallery floor. The passage is flanked by a series of columns salvaged from the old chapel which survived in the Nash pavilion under the mezzanine level of the gallery of 1962.

THE SHOP

The new shop is another important feature, generating income for the care and maintenance of the Royal Collection. Though it was considered inappropriate for visitors to have to walk through it on arrival, it can be approached directly from the entrance hall. Containing a remarkable series of shallow Soanean domes, it is twice the size of the previous shop, having expanded into the enclosure created in the 1980s for the police who serve the Palace. Adjacent to the shop is a 'virtual gallery' with computer terminals which give access to information about items in the Royal Collection.

Left: View looking into the Nash Gallery towards the west wall.
The downstand ceiling beams double as service walkways for the lighting above

NEW GARDEN FRONT
OF EDUCATION ROOM

Resolving the awkward external junction between the Victorian buildings and the 1980s police base above the shop, Simpson has added a new building containing the Education Room on the first floor and the shop stock-room below. Built in Bath stone, this substantial addition to the west facade of the Palace resembles a garden pavilion and terminates the vista along the main terrace of the palace with its pedimented north front featuring an arch breaking into the entablature. Its overall form echoes a small freestanding building in the precinct of the Temple of Isis at Pompeii, while the unusual floral ornament of the capitals of the engaged Greek Doric columns was inspired by the peristyle at the same precinct. Simpson made measured drawing of these on site at Pompeii, thus returning to a fruitful custom established in the Renaissance of reinvigorating contemporary architecture by measuring the antique. He was, of course, aware that John Soane had been intrigued by the Temple of Isis, making his own drawings of it on his visit in 1779.

NEW ROYAL KITCHEN

The opportunity was also taken for a radical reorganisation of the vast service area which had become functionally outdated and inconvenient, the Royal Kitchen being added as long ago as 1852 by Pennethorne. Simpson was faced with a task of enormous complexity which he resolved by considerably reducing the height of the kitchen so as to insert the new lecture hall in its upper half. In addition to cooking for the Royal Family and for the State Banquets provided by The Queen who, as Head of State, entertains some forty thousand people here annually, the kitchen also provides meals for the four hundred Palace staff. Since the new kitchen had to conform to the latest recommended public health standards, Simpson equipped it with stainless steel equipment and air-conditioning, incorporating a ventilated ceiling covering the entire area of the kitchen. This extracts any steam and fumes at the point where they are generated, thus ensuring clean and comfortable working conditions. The ceiling is composed of a series of small panels that can be removed and cleaned on a rotational basis in a dishwasher, so that the ceiling is always kept clean. Simpson nonetheless contrived to retain much of the historic atmosphere of this great kitchen, so that it retains its traditional vaulted arches, original timber shelves, and cast-iron brackets. Two of the original ovens have been restored and the old mechanical spit re-erected. Four handsome new columns with bell-shaped capitals have been introduced symmetrically to emphasise the form of the old kitchen as well as to provide support for the floor of the Lecture Hall above.

Right: Detail of ceiling brackets and circular niche on end wall of the Nash gallery
Overleaf left: View showing the semicircular roof-lights
which provide daylight along the walls of the gallery
Overleaf right: Detail of pendant in the Nash Gallery

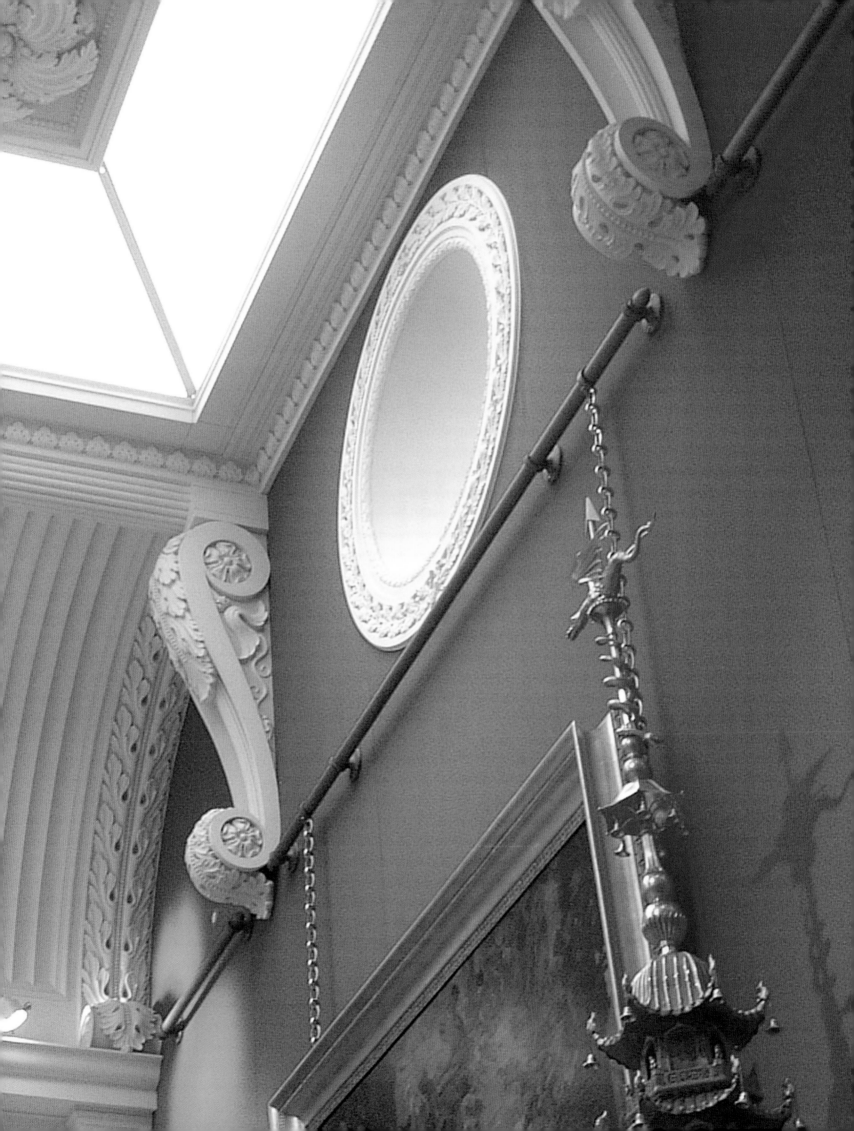

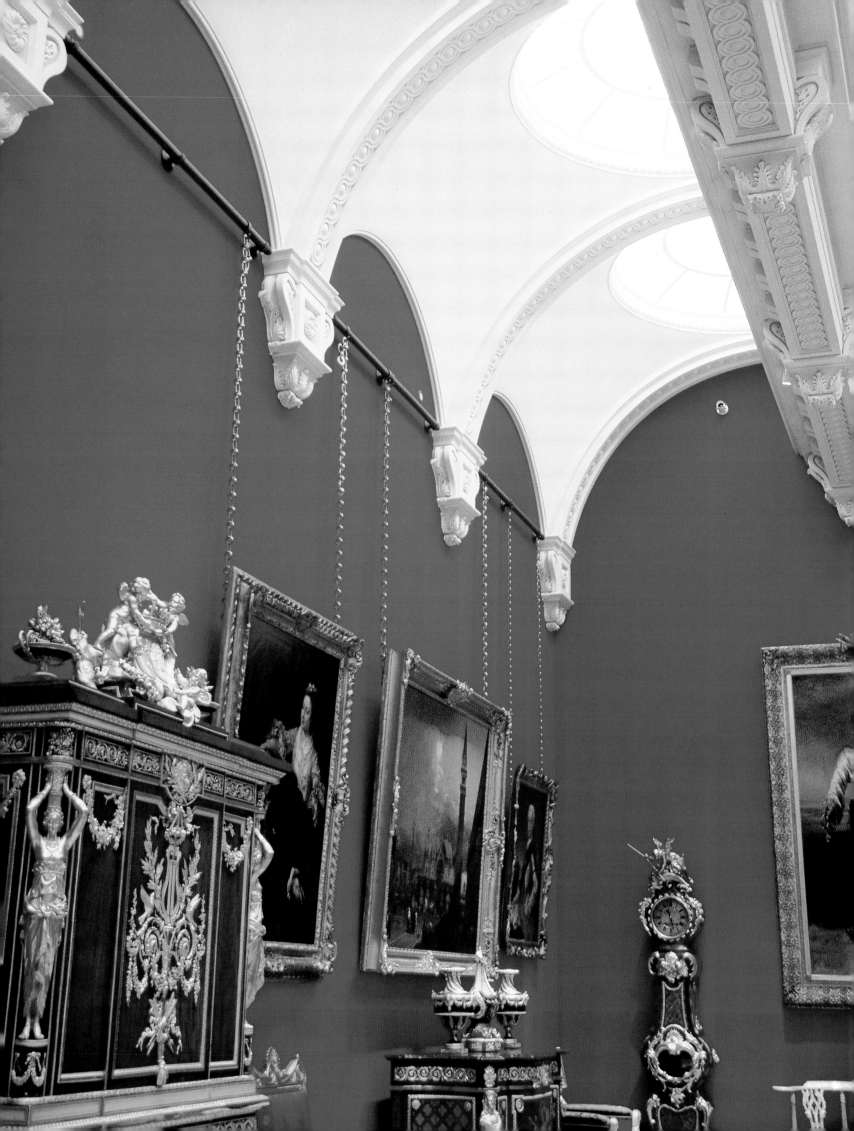

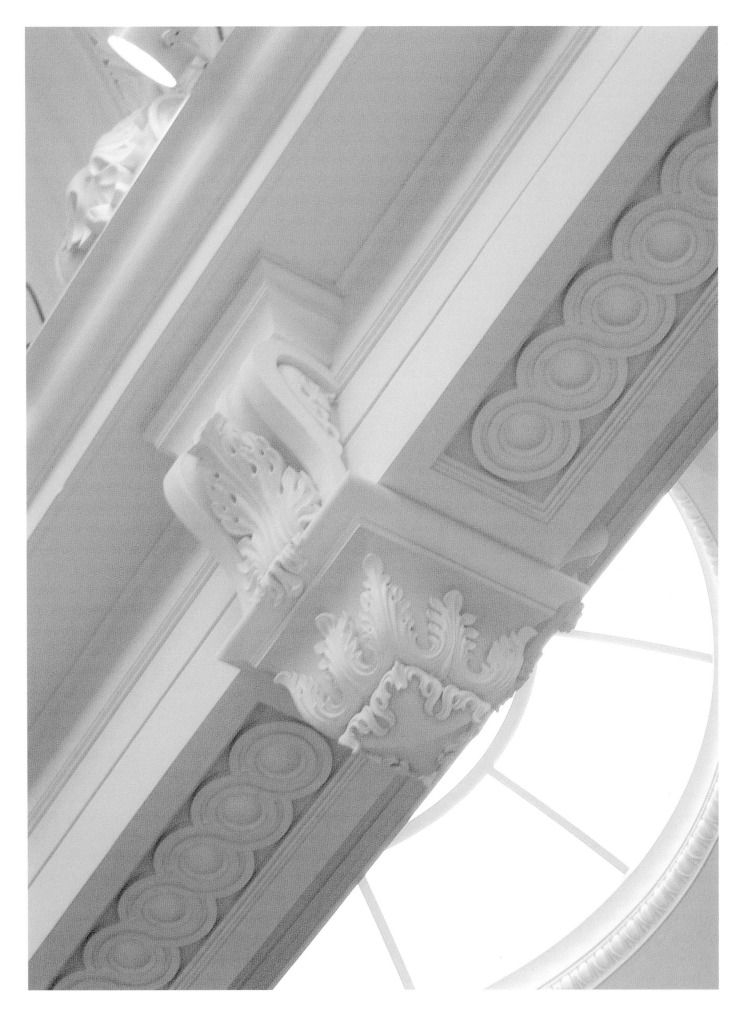

Elevation of the garden pavilion that terminates the vista along the main terrace of the Palace
Right: Detail of the cornerstone of the pediment

NEW TRADE YARD

Simpson transformed the circulation of this entire area by creating a separate entrance for the delivery of provisions so that they no longer have to be taken across the Trade Yard which is also the entrance for staff and for visitors to the Royal Household. Simpson also removed ugly and inappropriate additions which had been made to the Trade Yard over time. One that could not be removed, the annexe added in the 1880s to Pennethorne's ballroom, he is cleverly having improved. It had been built over half the Trade Yard, hovering bizarrely at a high level on exposed riveted iron beams. Simpson makes visual sense of it by providing a series of arches which are intended to give it visual support. He also reduced the yard in size, elegantly arching over it and building a new wall at the rear. His reorganisation makes a more dignified and efficient working area which also conforms to the latest public health guidance.

As part of the reordering of the service areas, modern staff rooms and offices were created, as well as new lifts to serve the Palace and to enable the movement of large paintings and works of art in and out of the galleries. In addition, a borehole, 125 meters deep, was dug in the Palace grounds from which water is drawn to serve as the cooling medium for running the extensive air-conditioning plant for both the galleries and the new Royal Kitchen. This ecologically-minded source of water also serves to supply non-drinking water for the Palace and to maintain the appropriate level of water in the lake.

CONCLUSION

In a striking departure from the minimalist treatment of many late twentieth-century museums, the interiors designed by John Simpson are rich with ornament, colour and relief, in harmony with those of the Palace itself, so that, like the great galleries of the past, they complement the outstanding works of art which they contain. The relation of a museum's architecture to its contents was pioneered in early-nineteenth-century England and Germany by architects whom Simpson has studied such as John Nash, Robert Smirke, Karl Friedrich Schinkel, and Leo von Klenze whose Glyptothek in Munich of 1816-30 was one of the earliest public

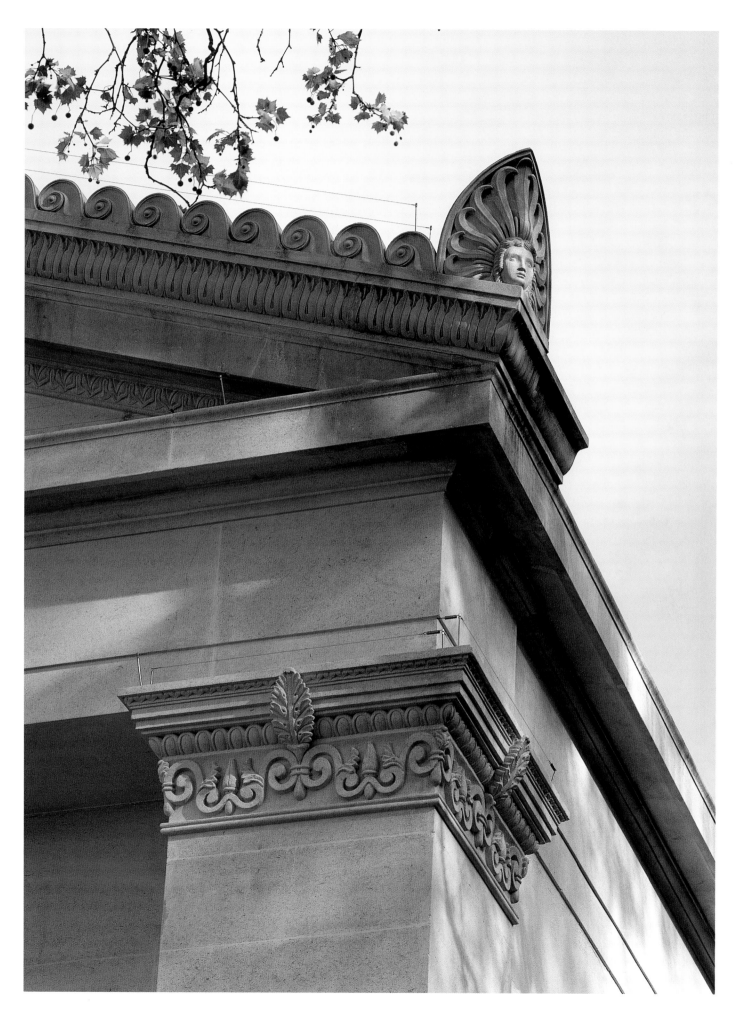

sculpture galleries. Klenze conceived his whole building, and particularly its sumptuously polychromatic interior decoration, as a commentary on its contents with which it entered into a kind of suggestive dialogue. Sadly, these rich interiors were not reinstated when the building was "restored" after being damaged in the Second World War.

Simpson's whole approach to building also differs from the throwaway mentality which characterises modernism with its energy-intensive materials and its high life-cycle costs. Simpson's walls of brick and stone, with roofs of lead, copper, and slate, are both durable and low in maintenance costs, so that as a triumph of modern design and contemporary craftsmanship, the new Queen's Gallery is enduring as well as beautiful. Visitors are struck by the beauty of the detail in areas such as cloakrooms, lavatories, passage-ways, lobbies, and lift, so often ignored in modern public buildings. Ornament, abandoned in the middle years of the last century, is now everywhere present again. Frequently based on plant forms such as flowers, buds, and leaves, it is gracefully and imaginatively stylised in a range of materials, including cast-iron, bronze, copper, stone, marble, fibrous plaster, stencil, terracotta, and etched glass.

Since Soane's work at the Bank of England from 1788-1833, there can hardly have been a sequence of classical interiors more skilfully fitted into a complex existing setting. Like Soane, Simpson has provided a brilliant example of how to smooth over subtly the fact that nothing can be in axis as it would ideally be in a conventional Beaux-Arts planned building. Yet at the same time he ingeniously exploits the picturesque possibilities which this complexity provides for the creation of those qualities of variety, intricacy, and surprise, which had been recommended by the eighteenth-century theorists, Richard Payne Knight and Sir Uvedale Price. Little is what it seems, for much of what appears to be solid and fixed, is moveable or hollow. Behind the beautiful vaults and walls of numerous lobbies and niches are convenient spaces used for storage or more often for the elaborate mechanical equipment which has become required in modern museums. In making sense out of what in other hands could have been confusion, Simpson has created order out of chaos: one of the marks of civilisation.

View of the garden pavilion showing the arch that breaks into the entablature
Overleaf: View of the Gallery facing Buckingham Palace Road

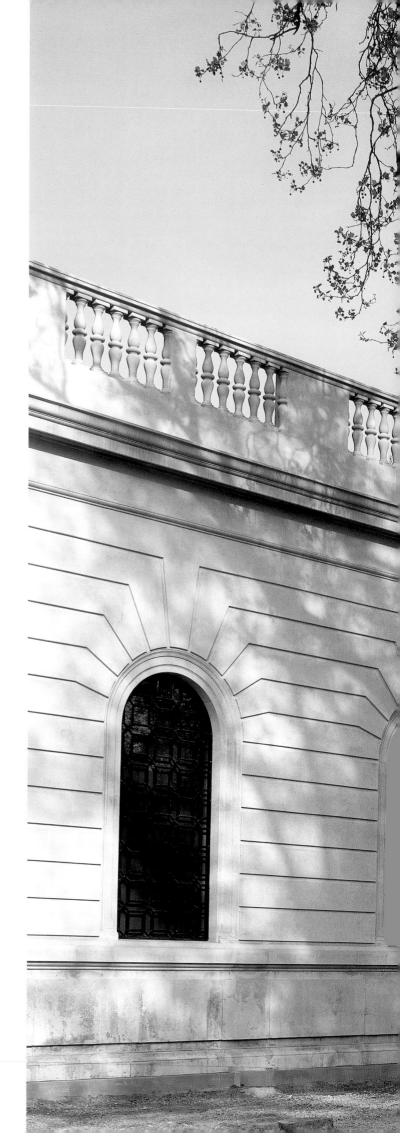

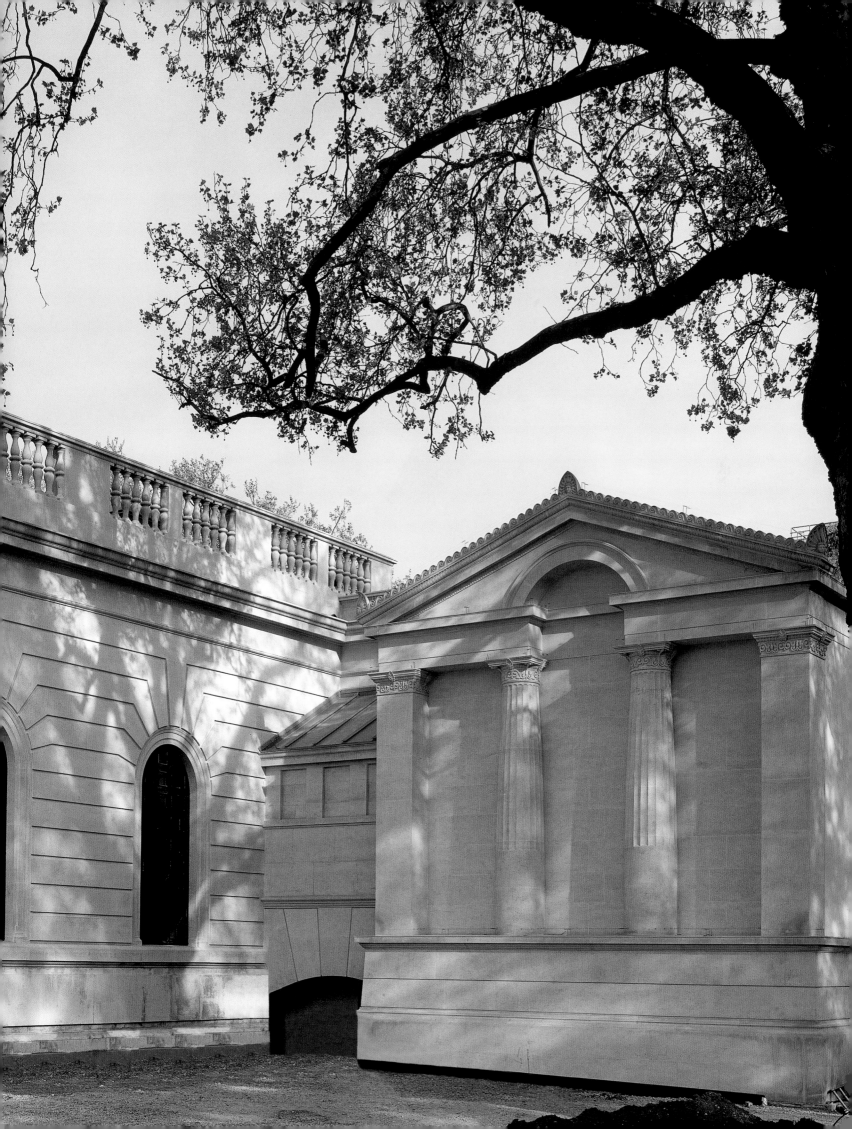

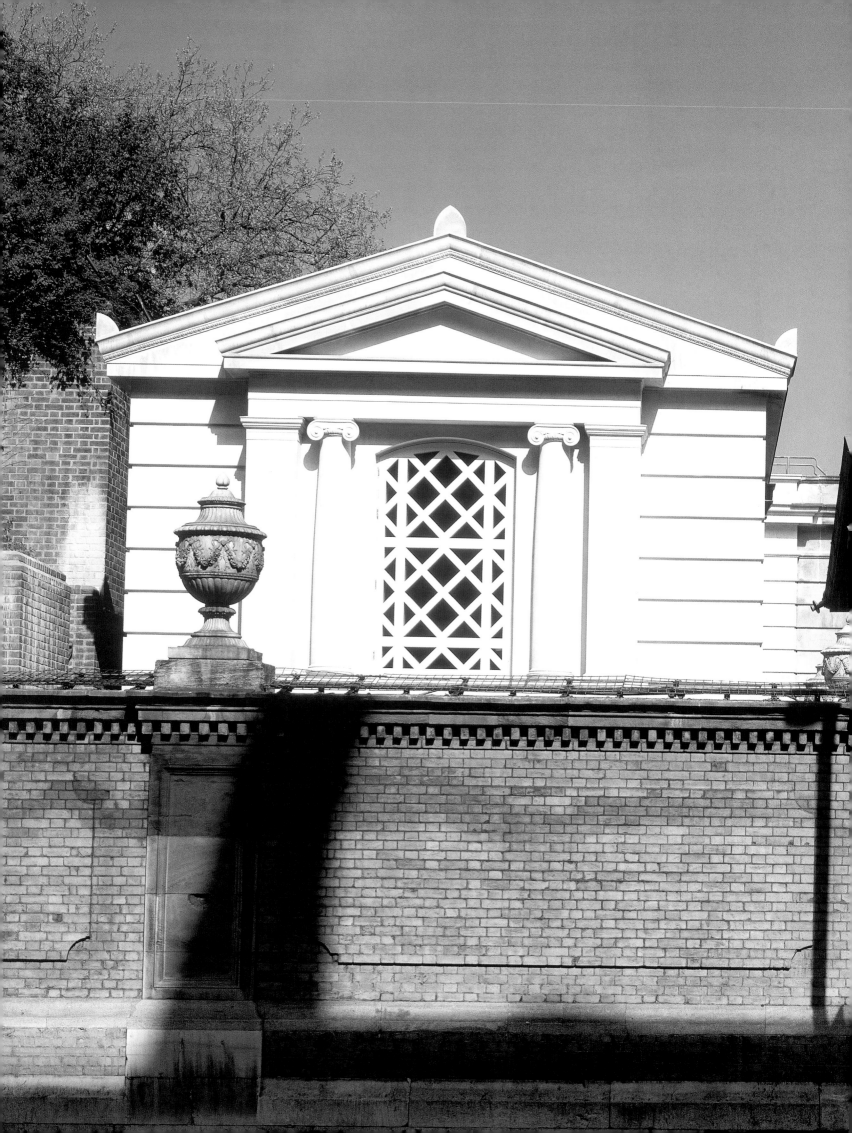

BUCKINGHAM
GATE SW1
CITY OF WESTMINSTER

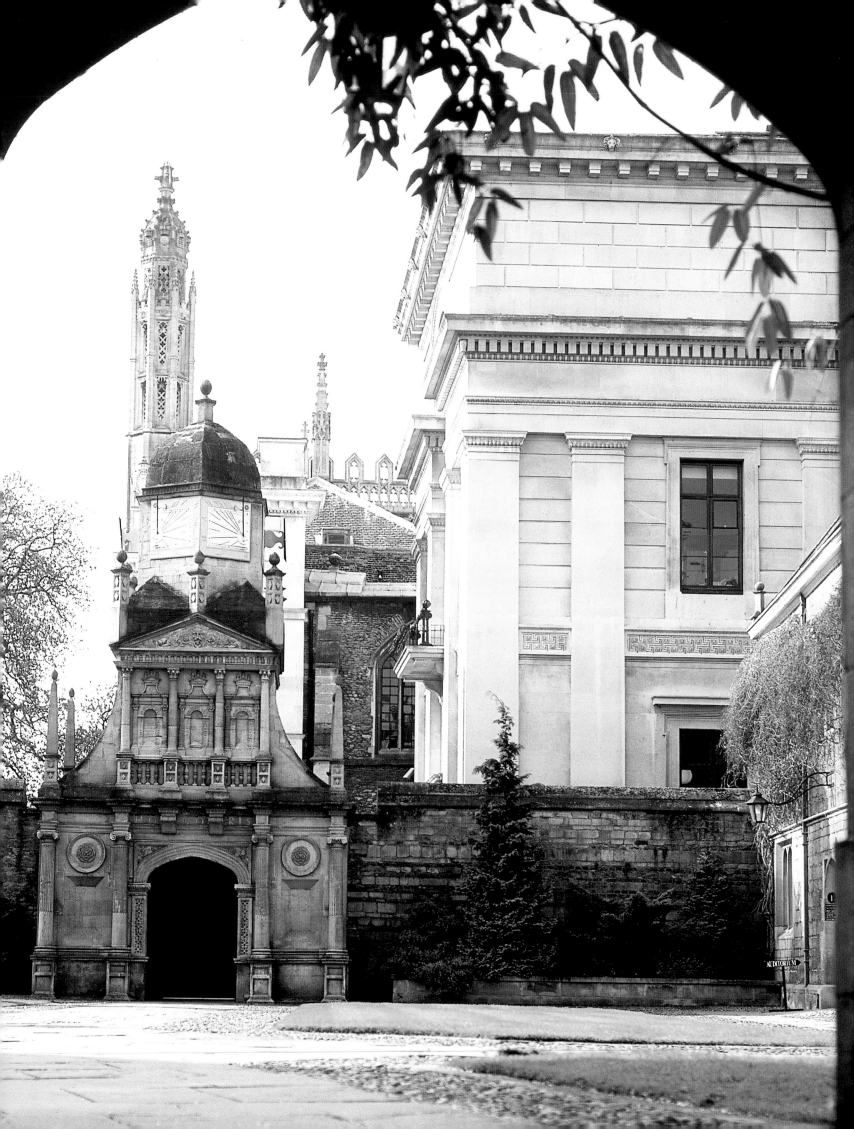

GONVILLE AND CAIUS COLLEGE CAMBRIDGE

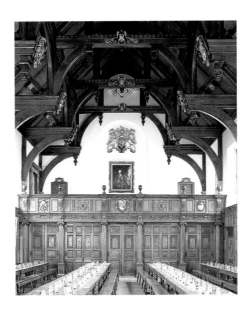

Refurbished Dining Hall
Left: View looking into Caius Court showing Cockerell's University Library building behind

Gonville and Caius College, Cambridge, is famous for containing one of the most intriguing achievements of the Renaissance imagination in English architecture. This is the allegorical "progress" represented by the celebrated gateways of Humility, Virtue, and Honour, erected in the 1560s by Dr Caius, Master of the College, and amateur architect. The Gate of Honour is both a product of medieval and classical learning as well as a theatrical, even fantastical, object, inspired by Renaissance festival decorations and triumphal arches by designers such as Serlio. Brooding over it is C.R. Cockerell's University Library of 1837-40, which the college acquired from the university to serve as the college library in 1988. Like the Gate of Honour, its entrance facade provides another variant on the triumphal arch theme. Roman in form yet Greek in detail, it combines scholarship with poetry as had the creations of Dr Caius.

The far-reaching consequences of the acquisition of the Cockerell Library by the college in 1988 involved finding new uses for the substantial rooms on the west side of Gonville Court which had until then been occupied by the college library.

Well before the books were removed from Gonville Court to the Cockerell Library in 1995, a limited competition for remodelling these rooms was held in 1993. This was won by John Simpson who recommended that imaginative respect should be paid to the very special historical and architectural circumstances of these spaces: in other words, that the college should "consult the genius of the place," as Alexander Pope put it.

The environmental sensitivity on which Simpson insisted brought architectural dividends at Caius for it meant paying respect to the work of two distinguished architects, Cockerell and Soane, who had both worked in or adjacent to the college. Cockerell, as we have noted, built a wing of the University Library adjacent to the college on the south, while in 1792 John Soane was commissioned to provide a new dining hall for the college within the shell of the existing fifteenth-century dining hall. Soane's work did not long survive, for the hall was considerably reduced in height and size by Anthony Salvin in 1853 and was further remodelled in 1909 by the Arts and Crafts architect, Edward Warren, at which time it became known as the Monro Reading Room.

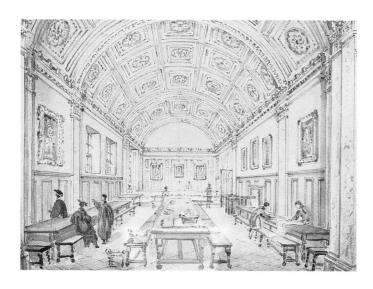

Watercolour of Soane's 1792 design
Right: The new Lord Colyton Room created,
based on Soane's design for the room

FROM SOANE'S HALL TO SIMPSON'S
COLYTON ROOM

Simpson's first scheme for the Monro Reading Room respected its largely Edwardian neo-mediaeval flavour, though introducing rich polychromatic decoration. Following research which Simpson and the college archivist now carried out, it was clear that far less of the mediaeval fabric of the hall survived than had been supposed, even by English Heritage. Thus, considering that the Edwardian work by Warren was undistinguished, it was agreed that it would be possible to produce an interior close to the one which Soane had inserted in 1792. Though Soane's work had, alas, been swept away by Salvin, two of his drawings for it survived, its appearance also being recorded in a sepia view of 1840. It was thus possible to create a version of this lost interior, though not to reproduce it exactly, for not all the details were known and, more importantly, the floor level had been raised since Soane's day and the room shortened to the south.

In other words, John Simpson was required to work in the language of Soane rather than to produce a copy. The coffers in his ceiling, for example, are slightly smaller than Soane's, to reflect the fact that the whole room is smaller. However, like Soane's hall, the room Simpson eventually created is ingeniously slotted into the shell of the existing walls so that it is, in a sense, demountable. Now serving as a Fellows' Reading Room, it is known as the Lord Colyton Room to commemorate the fact that the cost of creating it was generously borne by Lady Colyton in memory of her late husband.

Overleaf left: Detail of new chimneypiece, mirror and light fitting, designed for the
Lord Colyton Room
Overleaf right: Ceiling detail in the Lord Colyton Room

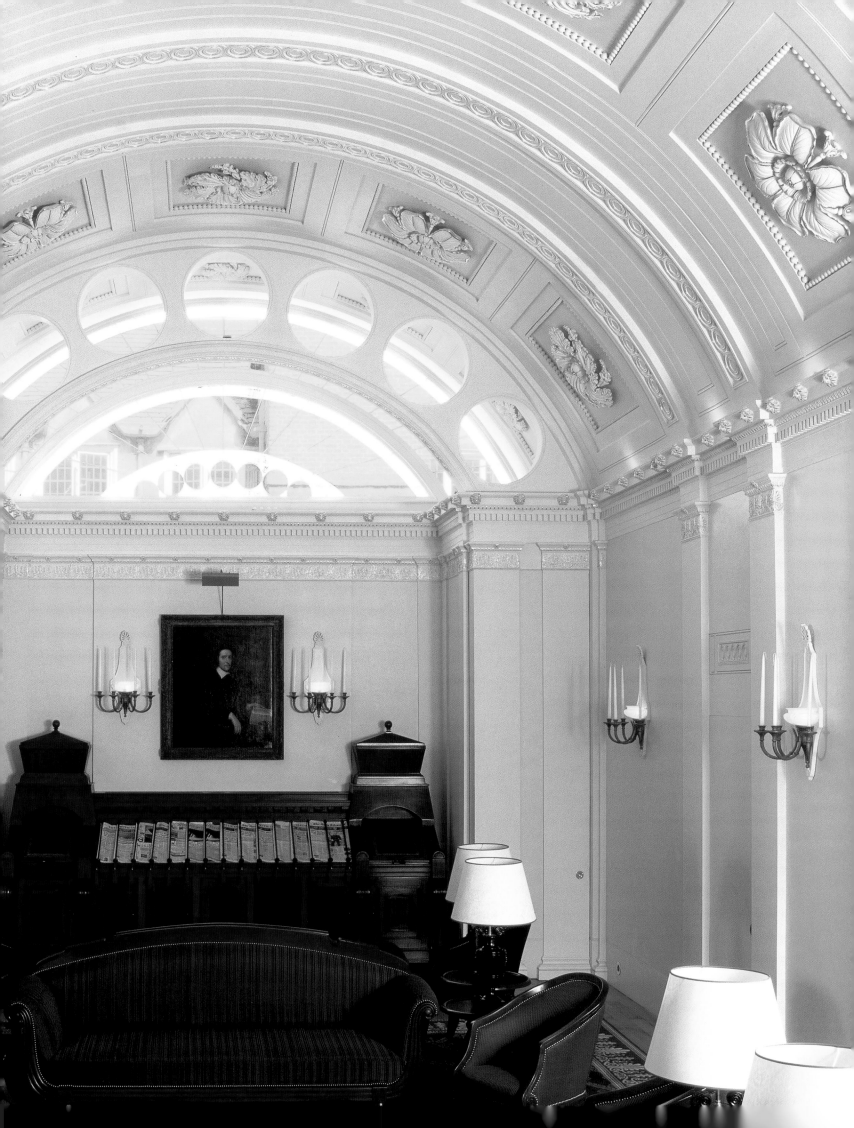

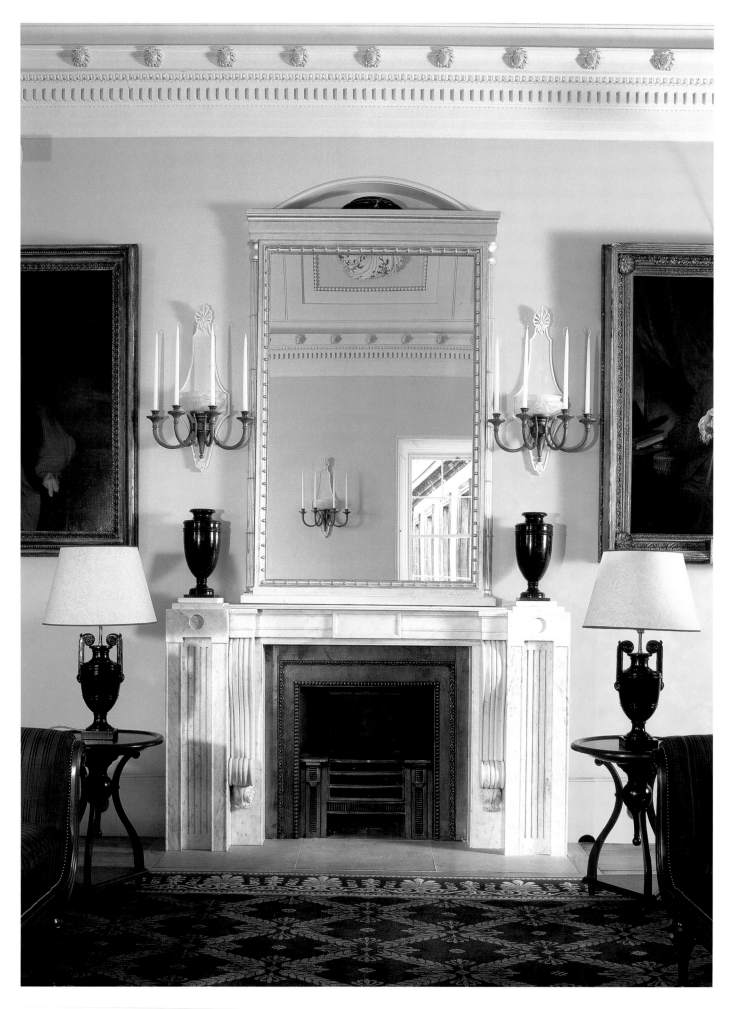

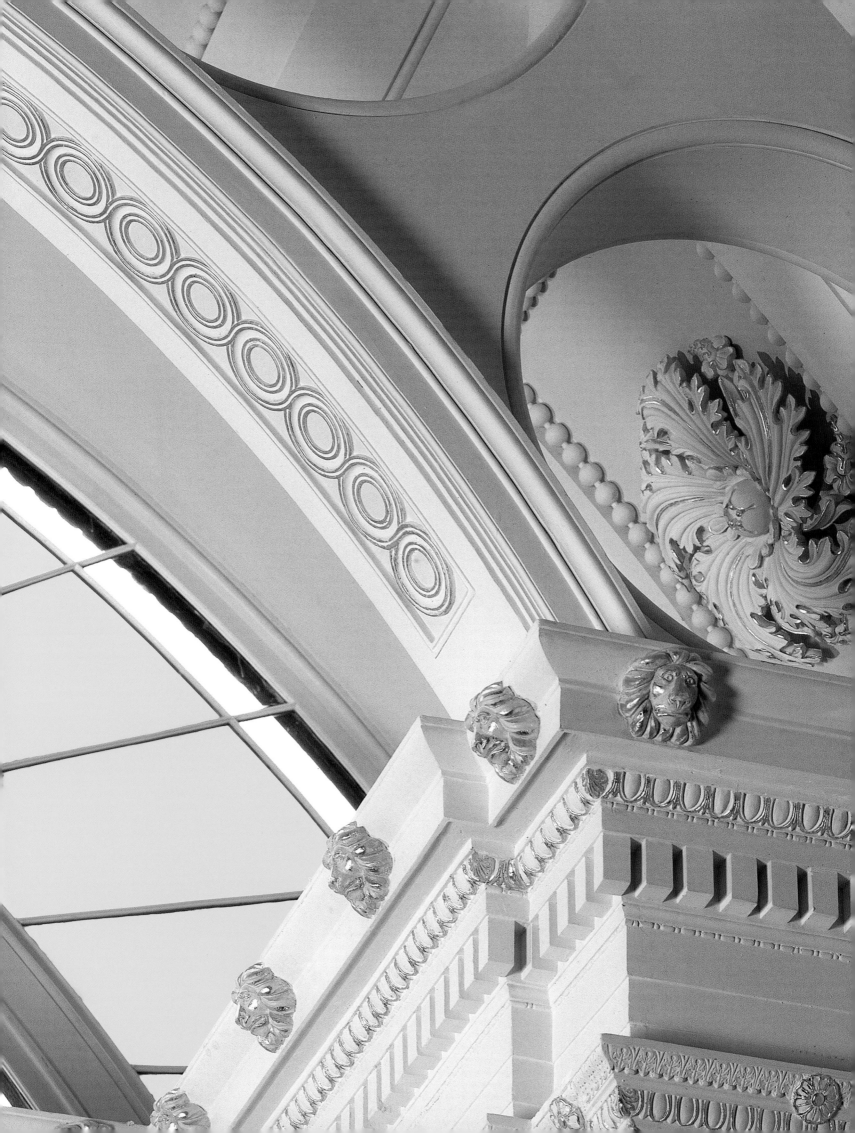

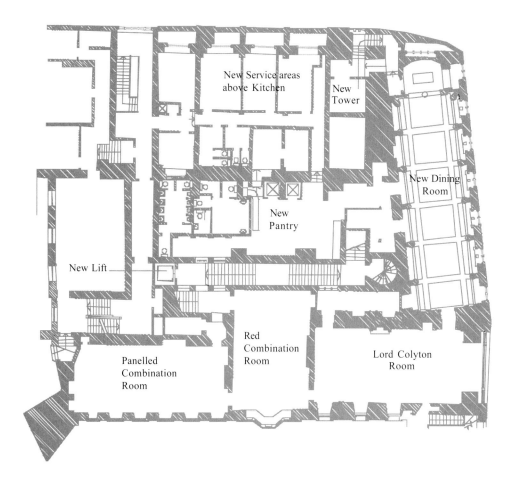

Plan of principal floor showing main rooms
Right: View looking up the staircase from undercroft showing the new rooflight over the Fellows' Landing

The ingenious spatial innovations for which Soane is best known were initiated in his career in one of his most remarkable interiors, designed at exactly the same moment as his hall at Caius: the Yellow Drawing Room at Wimpole Hall, near Cambridge. Indeed, we know from his Day Book that on 5 August 1792, for example, he visited both Wimpole and Caius, dining that evening with the Vice Chancellor of Caius. Certain architectural details and mouldings at both places were the same, notably the frieze of lion masks along the cornices.

Soane's hall at Caius, as recorded in a sepia perspective view of 1840, featured a segmental coffered ceiling perhaps influenced by that in the Queen's Chapel of 1625 at St James's Palace by Inigo Jones. This was itself inspired by antique types such as the masonry vault of the Temple of Venus and Rome in Rome as restored by Palladio, and indeed by ceilings by Palladio himself as in the Palazzo Chiericati in Vicenza. Soane produced a similar interior in his Accountants' Office of 1803 in the Bank of England. These resonances backwards and forwards in time from antiquity to Palladio, Jones, Soane, and now Simpson, are the very essence of

the endless suppleness and adaptability of the classical language in architecture, which each generation has to discover for itself and interpret anew. Thus, no one should use the word pastiche to describe the work of modern classical architects unless he is prepared to describe the work of Brunelleschi and Bramante as pastiche.

Towards the north end of the room, Soane introduced an unusual large arch or screen, pierced with seven oculi or circular openings. These allowed light to filter into the room from the new window which he added in the north wall behind it. An important step in the career of an architect who was to be known for his mastery of light, the arch not only introduced a picturesque visual drama, but served the practical function of concealing the two entrance lobbies which he introduced at its foot on either side of the hall at this point. The form of the arch and its openings were derived from Bramante's epoch-making east end at Sta Maria della Grazie, Milan, which dates from the 1490s. Bramante's pieced arches create an almost Byzantine luminosity at the end of the dark Gothic nave, an effect evidently admired by Soane on his visits to Milan in 1779 and 1780, twelve years before

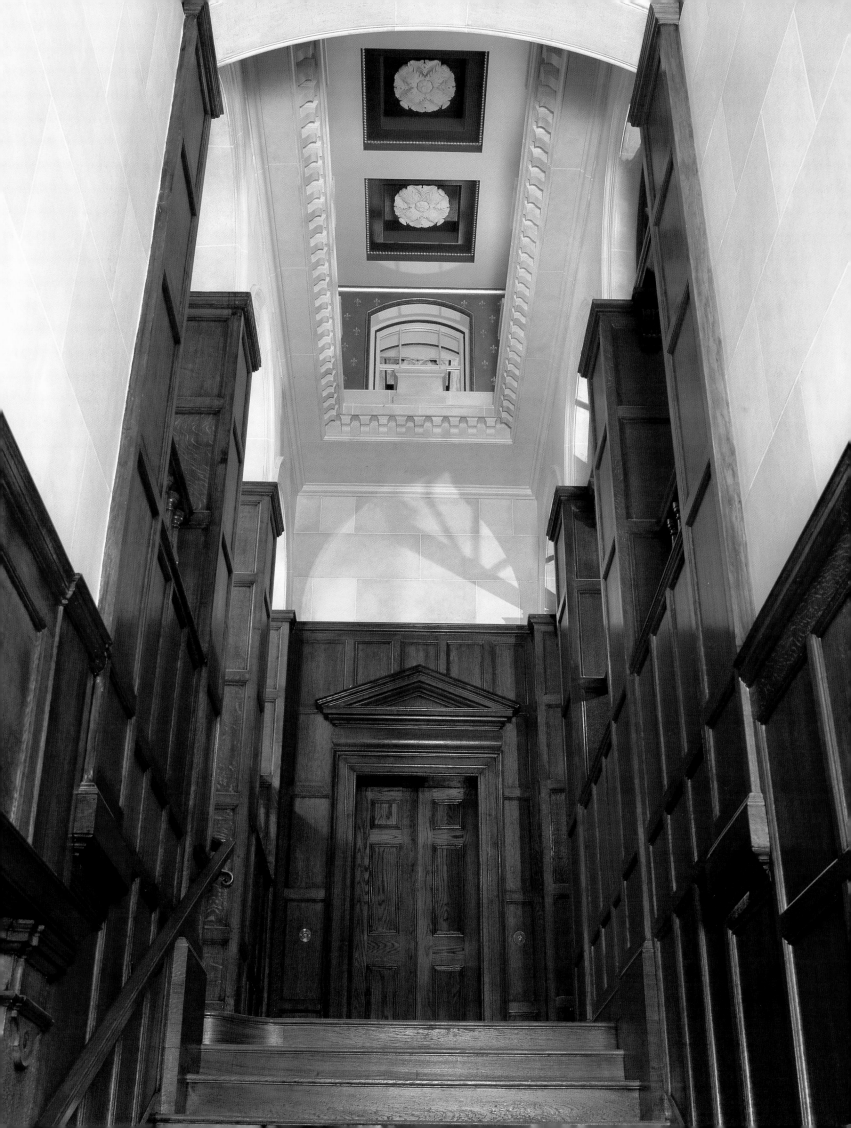

his work at Caius. This Bramantesque device, echoed by Palladio at the Basilica in Vicenza and at the Villa Poiana, does not appear elsewhere in British architecture, though Soane echoed it in the paterae above the segmental arches in his Book Room at Wimpole and in the oculi with which he pierced the pendentives of the dome in his Breakfast Parlour of 1812 in his house and museum in Lincoln's Inn Fields. Since Soane subsequently filled these oculi with mirrors in 1824, it occurred to Simpson to do the same at Caius, an idea eventually rejected because this would block out light from the north window looking into Trinity Lane.

Soane's segmental north window ran the full length of the north gable, but in the eighteenth century the room was dark, the windows on the west side having long been blocked by subsidiary service buildings, the only other windows being three modest small sash windows looking east into Gonville Court. Soane's metal window was replaced by a less interesting Perpendicular Gothic window when the hall was remodelled in 1909. Simpson's recreation of Soane's window repaid the complex engineering work involved, for it dramatically illuminates the otherwise rather dark interior. Though following the elegant patterns of Soane's glazing bars, Simpson did not incorporate Soane's small roundels of coloured glass, probably red and blue, for they had been criticised: according to a note in Soane's Day Book, "the Gentlemen of the College wished the stained glass and circles in the fanlight to be removed and ground glass put in its place."

Simpson painted the walls of the Colyton Room a strong yellow, the same colour that Soane used for his drawing room in 1812 at his house and museum in Lincoln's Inn Fields, today Sir John Soane's Museum. At Caius, it harmonises well with the yellow light coming from the amber glass with which Simpson glazed his great north window. Soane was obsessed by coloured light, like his close friend, the artist Turner. A child of the Enlightenment, with a belief in following reason and nature, Soane sought to echo the effect of sunlight through the use of amber glass. He used this at Caius, at the mausoleum at Dulwich Gallery, and in his Breakfast Parlour in Lincoln's Inn Fields where he treated the poetic interiors as though they were a garden, choosing not to show them to visitors on dark days. Simpson, incidentally, found that the manufacture of amber glass is problematic because it involves the use of arsenic which cannot be applied in situ by ordinary craftsmen but has to carried out in factory conditions.

A new and personal feature introduced by Simpson into the Colyton Room is the monumental chimney piece of Italian marble on the west wall. It contains a handsome Regency grate with reeded metalwork, discovered by Simpson in London. There was no chimney piece in Soane's hall, just a stove. Carved to Simpson's

designs by Spencer and Richman of Battersea, the new chimney-piece is a masterpiece of extraordinary sculptural power which combines the abstract geometrical qualities of Soane with the voluptuous volute brackets of Michelangelo who increasingly treated architecture as sculpture, as in his Laurentian library vestibule in Florence. Having claimed, in his only known statement about architectural theory, that "architectural members derive from human members," Michelangelo's sketches for the volutes in the vestibule of the library, recall biological drawings.

Like many leading architects from William Kent to Sir Edwin Lutyens, Simpson is a brilliant furniture designer who conceives his interiors as harmonious unities. For the Colyton Room he thus designed ambitious classical chairs, tables, sofas, desks, and wall sconces, as well as a massive architectural cupboard and reading desk below the segmental window. This is visually linked with the chimney for it exactly reproduces in timber its Michelangelesque consoles. The unity of line and colour in this remarkable room is further underpinned by the monumental carpet woven to Simpson's designs. In working on this project, he studied the designs for carpets of Robert Adam, greatest of the few British architects who have designed carpets. Adam's drawings, purchased by Soane and today one of the treasures of the Soane Museum, show the importance of relating the design of a carpet to that of the room as a whole. The claret-coloured outer border of Simpson's carpet bears an anthemion pattern in gold which echoes the frieze, inspired by the Erechtheion Ionic order, running round the room over the pilaster order. The body of the carpet is green with a diamond trellis pattern containing paterae framed by laurel borders. Its presence helps create ideal acoustics for the performance of music.

FROM COCKERELL TO THE FELLOWS' DINING ROOM

From the west wall of the Colyton Room a door leads into the new Fellows' Dining Room which Simpson created out of the long library built from designs by the architect Anthony Salvin in 1853-4. The removal of the handsome bookcases to the Cockerell Library in 1995 left an unprepossessing, featureless interior with plain and ugly ceiling beams and clumsily detailed mullioned windows facing north on to the nearby rubble wall of Great Court, Trinity College. Emerging from this sombre chrysalis like a gorgeous butterfly spreading its wings in the sunlight, Simpson's Dining Room is without question one of the most inventive and ornamental interiors created in England for many years.

Right: The new rooflit servery for the hall built within the old kitchen court
Overleaf left: View of the interior of the new bar
Overleaf right: The new staircase leading from the bar area
to the students' common room

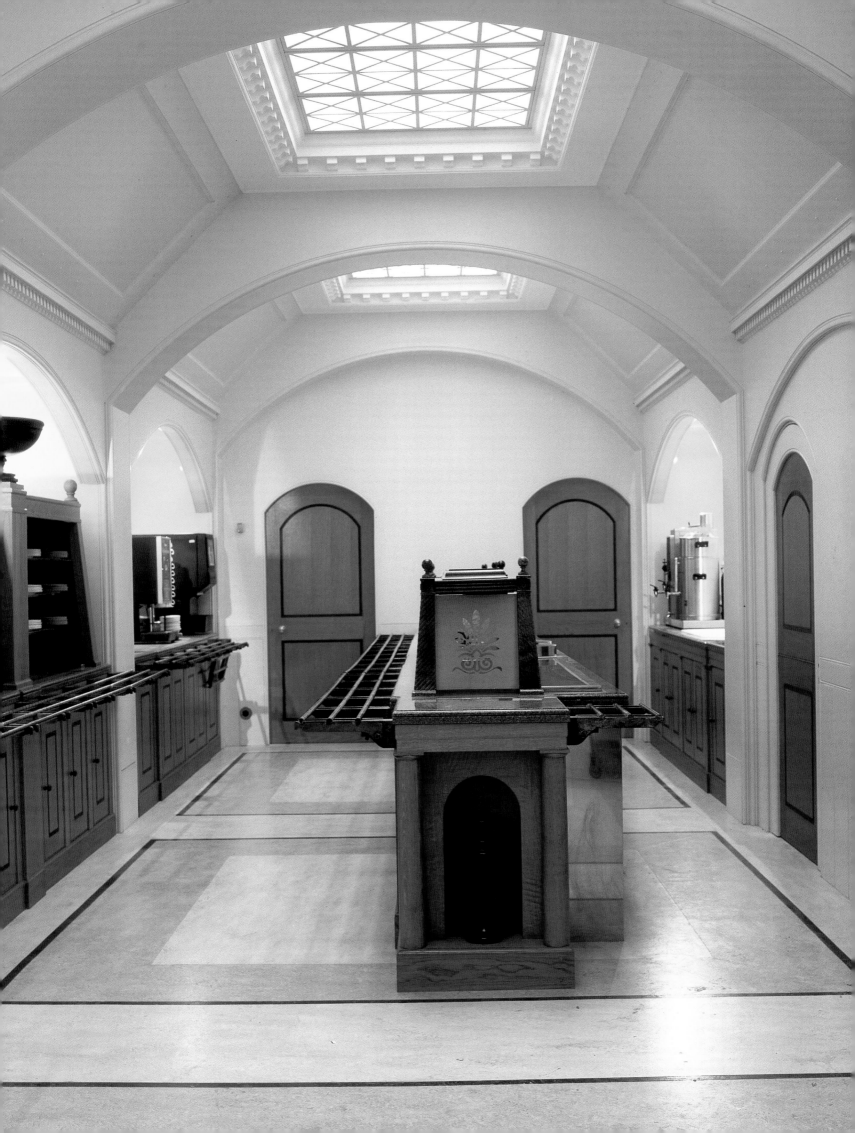

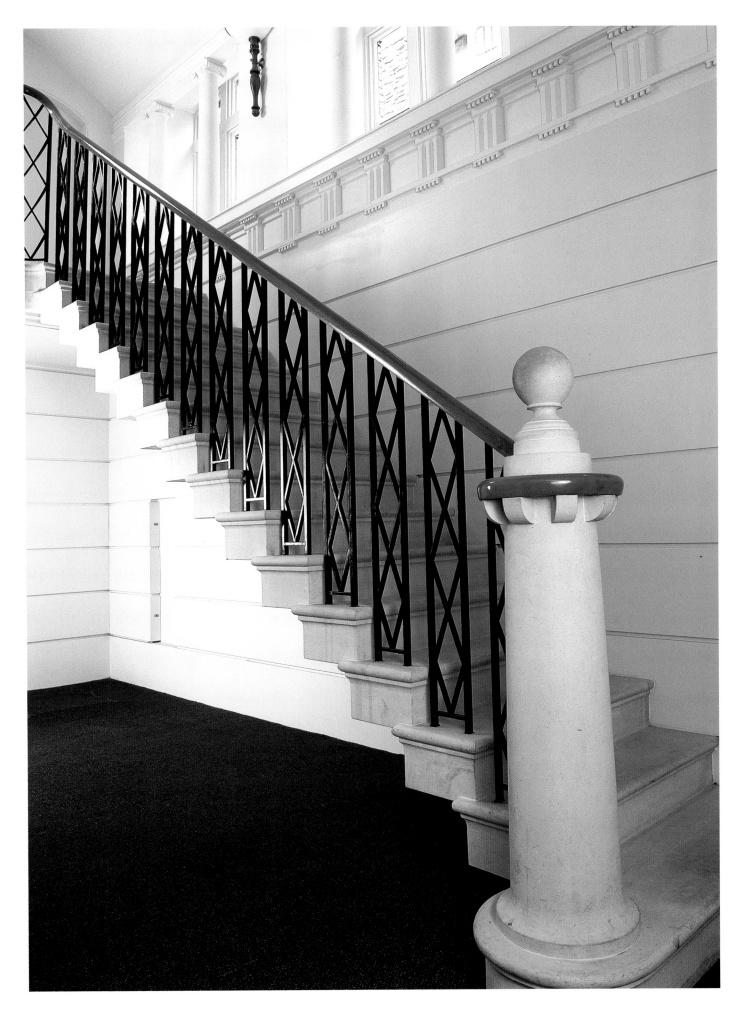

It is inspired by the interior of the Temple of Apollo Epicurius at Bassae which had been excavated and published by Cockerell who had used its unique Ionic order in his Cambridge Library. Apollo Epicurius, Apollo the Healer, is an appropriate dedication in a college where the study and teaching of medicine has played such an important role since the time of Dr Caius. An eloquent compliment to C.R. Cockerell, the Dining Room balances at the north end of the college Cockerell's masterpiece at the south end, the new paying tribute to the old, or, equally, the old to the new, for classical forms in the hands of architects like Cockerell or Simpson seem a timeless language. An inspired echo of the cella of the Temple at Bassae, Simpson's Dining Room incorporates some of the revolutionary archaeological discoveries made in 1810-11 by Cockerell who was notable as a distinguished Greek archaeologist as well as an architect. The discoveries he made at the temples of Apollo Epicurius at Bassae, of Jupiter Olympius in Sicily, and of Aphaia on the island of Aegina, included the fact that polychromy was integral to the design of Greek temples, that the basis of Greek design was essentially sculptural, and that the orders were used decoratively as well as structurally, which had not been widely understood. These discoveries, the fruits of which are all seen in Simpson's Dining Room at Caius, were revolutionary because they effectively demolished the Enlightenment view of Greek buildings promoted by Winckelmann, who had not seen any. Winckelmann's image of them as essentially timeless, colourless, and structurally "honest" is, curiously, still widely accepted today.

The orders of the temple at Bassae, built in c.430-400BC by Iktinos, architect of the Parthenon, seem to follow the anthropomorphic origin of the orders according to Vitruvius: thus, the Doric order of the exterior peristyle, modelled on the male body encloses the order of the interior, in the motherly Ionic, which in turn shelters the slender Corinthian, the girl-column, according to Vitruvius. This single free-standing column, bearing the earliest-known Corinthian capital, stood in the adytum, where the cult statue stood. At Bassae it is unusually open to the cella or principal internal space.

The Ionic columns in the cella are not free-standing but partly engaged, forming little more than the curved ends of short spur walls running inwards from the cella walls. The Ionic capitals and bases are flared so as to produce the kind of curvaceous lines with which we are more familiar in the work of Baroque architects like Borromini. A continuous figured frieze, now in the British Museum, ran round the walls inside the cella, a position for which there was no precedent. The interior location was doubtless chosen to enable the whole frieze to be seen at once, rather than in shorter stretches as at the Parthenon.

It has been necessary to describe this important interior because Simpson had to study and comprehend it fully before using it as the basis for his Dining Room at Caius. He was, of course, able to use the restoration of its interior which Cockerell published in 1860 in his book on the temples at Bassae and Aegina. Cockerell also made a modest echo of it in the dining room, demolished in 1972, which he built for Alexander Baring at Grange Park, Hampshire, in 1823. Here, he incorporated capitals with the flared Bassae volutes for the first time in any building since antiquity. As we have seen, he used them again in the Cambridge Library but in the meantime they recurred in 1823 in his Oakly Park, Shropshire, for the Hon. Robert Clive. Here, he combined them with casts of sections of the Bassae frieze which were given to him when he was negotiating the purchase of the frieze by the British Government in 1813. In 1821 Cockerell inserted further casts of the Bassae frieze in the Travellers' Club in Pall Mall of which he and Clive had been founder members in 1819. When Charles Barry came to build the present premises of the Travellers' Club in 1830-2 he incorporated these casts in the new library.

Cockerell included further sections of the casts in his possession in his staircase hall at the Ashmolean Museum and Taylorian Institution at Oxford, of 1840-5. Outside, on the facade of the Taylorian Institute there is a handsome array of Bassae Ionic columns. The authorities had wanted any figure sculpture to be male, but Cockerell insisted on female figures to represent the languages of Europe, for the Taylorian Institution was the University Department of Modern Languages. Moreover, female figures were appropriate terminations for Ionic columns, since, according to Vitruvius, the Ionic order represented the figure of a mature woman with the flutes on its columns inspired by the folds on her dress, and the volutes of its capitals by her hair.

In Cockerell's Royal Academy lectures, delivered from 1841-56, he invoked the authority of Vitruvius to argue that architectural design involves the representation of the human body defined as an ideal type of beauty. He demonstrated this in his wonderful chorus of swaying caryatids in his St George's Concert Hall in Liverpool, for he saw Greek architectural ornament and figure sculpture as encapsulating a vital human presence, believing that entasis, tapering, inclination, thickening, and the curvature of the stylobate, were part of Vitruvius's account of the relation of the body to architecture. He also pointed to Michelangelo's claim that, because architectural members derive from the human body, only a good master of the figure and of anatomy can understand architecture. Cockerell, too, wrote in organic terms of eyes, nose, and arms, treating architecture as sculpture, and upholding the Greek view that sculpture is the voice of architecture, the soul of her expression.

Cockerell's dining room at Oakly Park, with its Ionic capitals that were inspired by those in the temple at Bassae, could have

Bay of the new Fellows' dining room showing the ionic order from the Temple of Apollo at Bassae

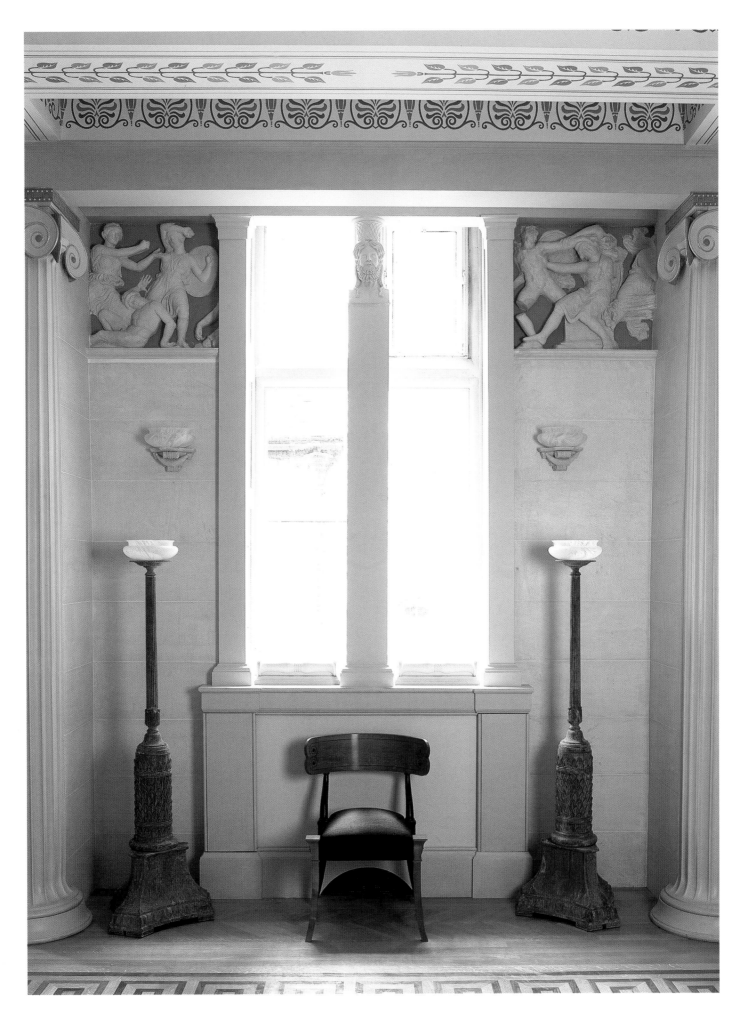

provided a useful starting point model for Simpson's Fellows' Dining Room at Caius. But Simpson's prime model was, of course, the temple itself, which has sometimes been hailed as the earliest Greek building with an aesthetically designed interior. As such, it offers itself as a natural source of inspiration for subsequent designers, though only Cockerell and Simpson have so used it. The length of the room by Salvin which Simpson found at Caius, seventy feet, is about fifteen feet longer than that of the cella at Bassae, while its width is about three feet narrower than that at Bassae, which is twenty-four feet. However, by reducing the length of the spur walls, Simpson was able to reproduce exactly the original distance between the Ionic columns across the room. He has also echoed the unusual disposition of the single free-standing Corinthian column, as well as incorporating casts of the frieze acquired from the British Museum.

Colour and pattern, so often neglected in modern architecture, form the keynote of the sumptuously painted Fellows' Dining Room at Caius, helping to produce that festive, even theatrical, flavour which we noted at the Gate of Honour. For example, following ancient Greek practice the background of the frieze is painted a soft red, while the details of the Ionic capitals are picked out in red, blue and gold. The room can thus be regarded as a conceit of which Dr Caius would have approved. Moreover, like the adjacent Colyton Room, it is by no means merely a copy as Simpson's ceiling is his own invention since the form of the ceiling of the cella at Bassae is unknown, while Cockerell's restoration drawing showed a ceiling of incongruously Regency character.

Simpson's ceiling, richly painted in rust red, light blue and brown, is dominated by beams with anthemion palmettes painted on their sides so as to create a continuous pattern as they recede into the distant perspective. This recalls the similar effect in one of Simpson's models, the Ionic Gallery in the Hermitage Museum in St Petersburg, designed in the 1840s by Leo von Klenze who, as a classical archaeologist and architect, was in some ways Cockerell's opposite number in Germany. The stone-coloured walls of the Dining Room are painted with horizontal rustication. As with the Colyton Room, Simpson conceived the Dining Room as a unity, designing the floor as well as appropriate furniture. The floor is of oak with a border in walnut featuring the Greek key pattern.

Further differences from the Bassae temple include the presence of Salvin's windows which Simpson has enhanced by adding central, free-standing terms surmounted by bearded male heads, and also by adding mirrored shutters which can be drawn across at night. This recreated the magical effect which Soane achieved by mirrored window shutters in his dining room and library at

Right: Detail of the single corinthian capital in the Fellows' dining rooms

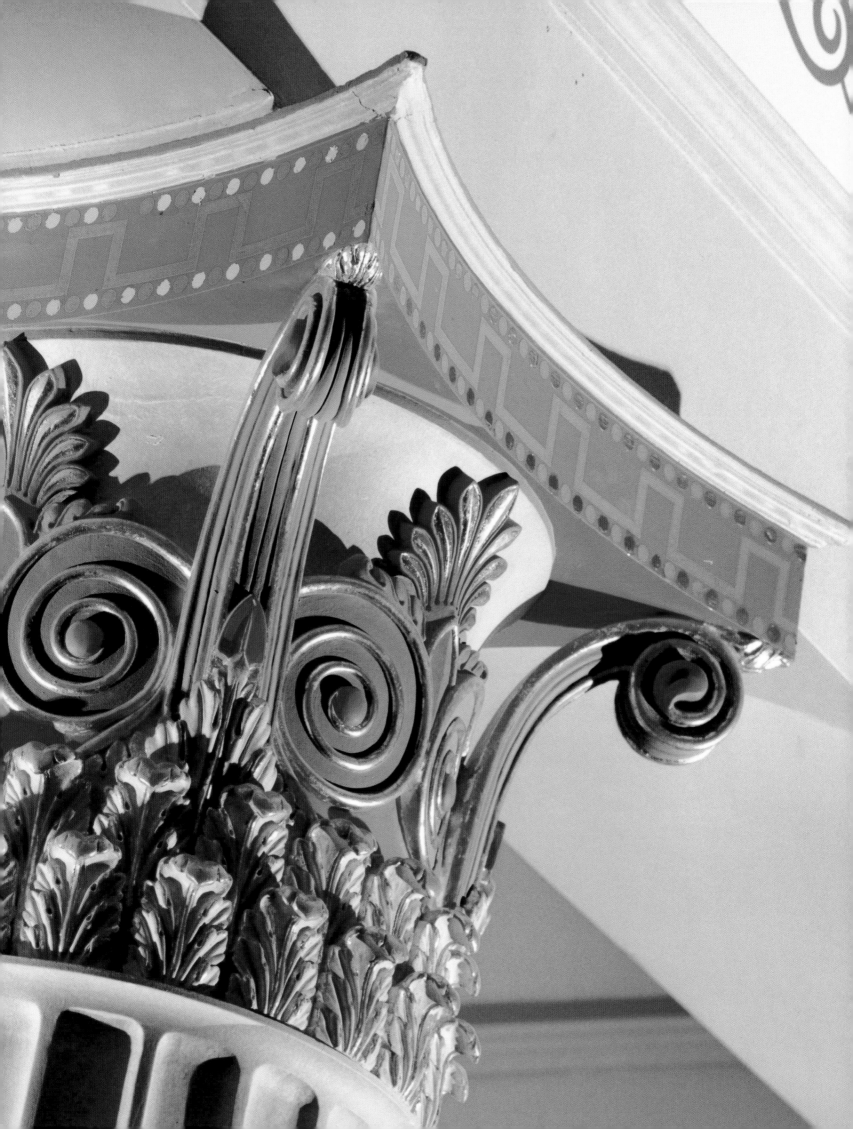

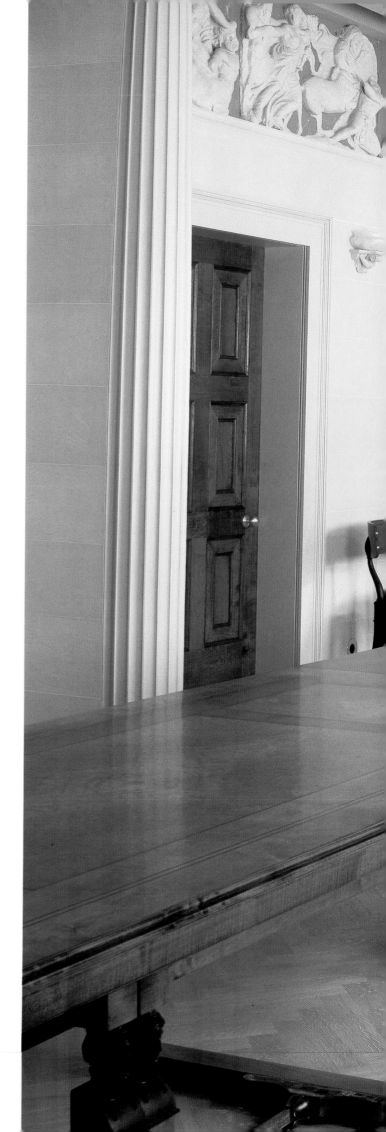

no. 13, Lincoln's Inn Fields. In front of the window at the west end of the room, filled with amber glass, is a Roman transenna or lattice work screen, for this area of the room, equivalent to the adytum, is the serving area.

Simpson's stunning dining table, forty-four feet long and capable of seating forty-six, is of walnut adorned with bronze mounts and inlaid with anthemion ornament in ebonised wood. It is punctuated by four monumental, richly decorated bronze torchères with pedestal bases and surmounted by uplighters. The table is designed so as to be capable of being broken up into smaller units on different occasions. Adjacent storage space has also been provided to house the table and chairs when the room needs to be cleared. The chairs are of sycamore wood and have the beautiful klismos form with scimitar legs derived from the chairs depicted on Greek vases. Simpson has made the rear legs of bronze for added strength. Ever practical, he has also designed these chairs so that they are stackable, even designing a trolley for their transportation.

This practical quality may come as a surprise in view of the rich visual drama of his work but in fact it is the essential counterpart to that poetry. He positively enjoys incorporating all the advantages of modern technology into his work, often using the mouldings which are essential to the civility of the classical language, as a convenient way of concealing ducts.

SERVERY, BAR, UNDERCROFT AND STAIRCASES

In appointing Simpson as architect, the college accepted his recommendation to take this opportunity of improving the entire circulation patterns and service areas in this part of the college,

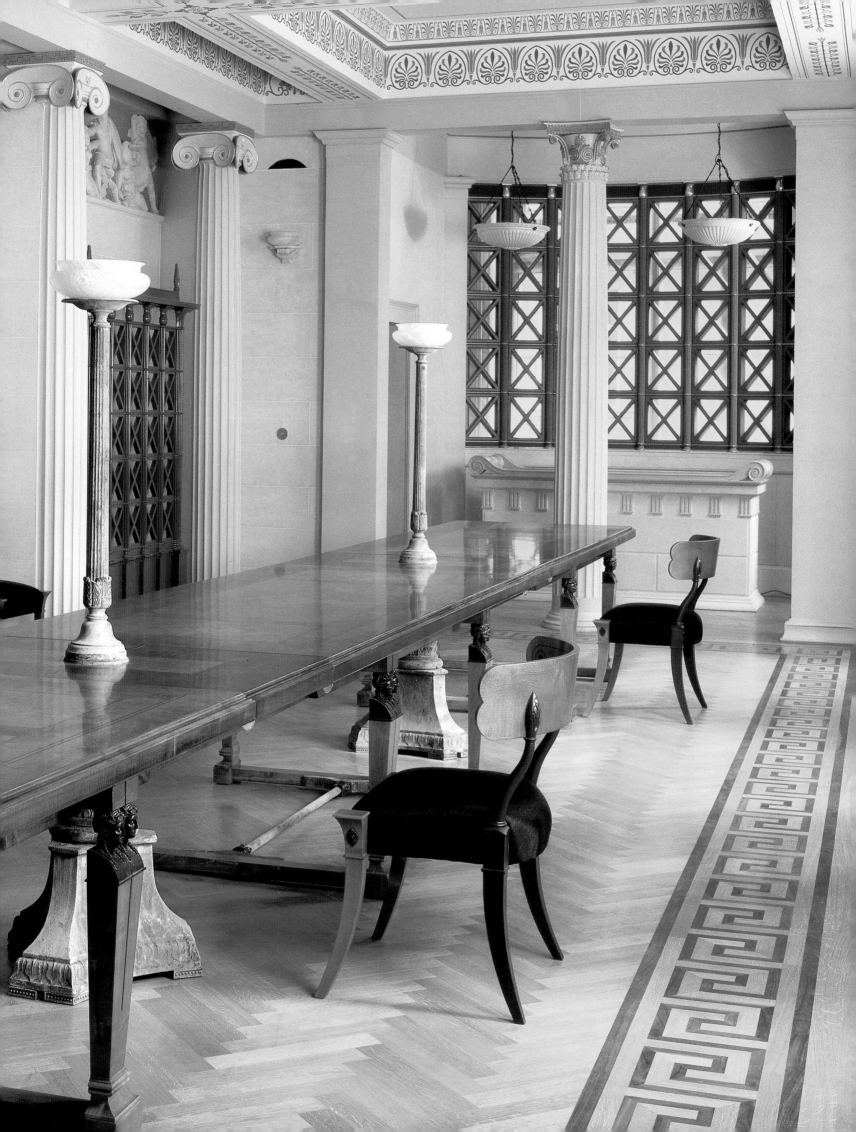

which had not been included in the original brief. What the college cannot have supposed is that he would bring the same attention to these functional areas as he did to the grander public spaces. Not for nothing is he known as "the master of the broom cupboard!" This refers to his ability to bring poetry to menial tasks, for he devotes the same care and invention to the design of a small ornament, a cupboard, or water closet, as he would to a whole colonnaded hall. Modern architects have made us suppose that such things will always be ugly or, at best, featureless. Simpson will have none of that, any more than would, say, Robert Adam in the eighteenth century, who would make a tiny powder closet a thing of joy. For Simpson everything must be beautiful, his lift at Caius being a perfect example. Modern lifts are generally hideous steel boxes, but Simpson's lift has panelled wooden doors and a miniature Soanean dome with a central oculus, so that it raises one's spirits as well as one's body every time one enters it. Not only is the thing beautiful, but until Simpson discovered, and more or less invented, the space which it occupies, no one had supposed that there was anything like enough room for a passenger lift in that part of the college.

Modern architects have persuaded us to assume that a servery designed to contain self-service food-counters will inevitably be an unalluring space which one will wish to leave as soon possible. By contrast, Simpson's Servery at Caius, with its arcaded walls, segmental ceiling arches, and oak counters with granite tops, tray slides with bronze poles, and bronze display stands with glass panels etched with anthemion ornament, recalls Pompeii or Herculaneum. It is not dissimilar to a smaller echo of one of Soane's banking halls at the Bank of England where, in rooms such as the Four Per Cent Office and Stock Office, he, too, was content to create interiors of high poetry for prosaic functions.

The creation of the Servery in a new building in the squalid kitchen-court shows how an imaginative architect can create order out of chaos. The Servery was also a key element in the total replanning of the service area which Simpson recommended at the outset. Once accepted, each improvement followed another like the pieces in a jigsaw puzzle. The new Servery made possible the removal of the ugly modern one then occupying space under the gallery at the north end of Salvin's great Dining Hall, so that it was possible to restore the original integrity of that end of the hall and reinstate panelling where the modern servery had been. In the gallery in the Hall, he also reinstated Salvin's tall blind arch in the centre which had been filled in, added handsome new doorcases, and not only removed the prominent Ventaxia fan which disfigured the north wall but replaced it with a lozenge-shaped plaster cartouche of Gonville's arms which cleverly conceals a new fan.

Improvements to the appearance and function of the circulation areas were also effected by the new lift and by the redecoration of the large ground-floor entrance hall known as the Undercroft below the Red Combination Room in Gonville Court. Simpson redecorated this low, dark, hall with polychromatic and heraldic ornament and a richly glowing nineteenth-century wallpaper from Watts and Co. He also added new coffers in the ceiling and stained the beams a dark oak colour. All this was to emphasise the character of the, largely Edwardian, room, rather than to modify it, as had been the case in recent redecorations. He made more ambitious changes to the Edwardian double-flight staircase that leads from the Undercroft, one flight ascending to the Combination Room, the other to the Hall. He removed the bulkhead that separates the flights, thus opening up an impressive cross vista, which he made more dramatic by hanging in it a huge lantern. This he modelled entertainingly on the octagonal domed cupola outside, which had been built over the Combination Room in 1728, probably to the design of James Burrough, a Fellow and subsequently Master of the College. Simpson further improved the lighting of the staircase by adding high coffered skylights of Soanean form containing rosettes and coloured glass.

At every turn in the long process of remodelling the college, great care was taken to consult not only the whole Fellowship but also the junior members and all the relevant college staff, heads of the buttery, kitchens, and maintenance department. The new work was the result of a continuous process of consultation. Every detail was taken through meetings open to the whole fellowship, explained by Simpson, and voted on. From the start, strong support for Simpson's scheme came from junior members who were particularly enthusiastic about the improvements to their quarters, which include comfortable new sets formed out of Salvin's two upper reading rooms. Handsome oak pigeon-holes for mail, ornamented with ball finials, line a corridor leading to a new bar, formed out of smaller rooms, the end of the axis being marked with a prominent urn in the bar. The furniture in the bar is robust but handsome with fixed seats sporting inverted Michelangelesque consoles, echoes of those placed the opposite way round in the Colyton Room above. Ceiling beams were added to disguise the haphazard pattern left when the existing wall divisions were removed.

Remodelling in this area made possible the recreation of a handsome parlour for junior members, lined with new bolection-moulded panelling. More remarkably, a new staircase nearby was made into an object of poetry, even though it merely leads down to a basement room for which it provides light. The stair has cantilevered stone steps sporting an iron balustrade with a mahogany handrail in the form of a snake, its tail at the top and its head wrapped round a circular stone newel at the foot. This

form of newel was used by Cockerell, while the snake, associated with Aesculapius, god of medicine, is an entertaining symbol of Dr Caius who included serpents in the coat of arms granted to him in 1561. The staircase has colonnades of miniature columns of the Greek Ionic order based on that of the Temple on the River Ilissus in Athens. Below these, the rusticated walls are capped with a Doric entablature, though anyone familiar with the Doric order will be intrigued by the use of guttae at both the top and the bottom of the triglyphs in the frieze. This apparent illogicality is sanctioned by an antique fragment surviving in the museum at Epidaurus. In a joke recalling the work of Lutyens, those parts of the entablature on either side of the landing can double as a bench.

CONCLUSION

Simpson is remarkable for the detailed attention he pays to the humblest aspects of a project, often considered by leading contemporary architects as unworthy of their consideration. Out of two mean cupboards and a tiny passage, he ingeniously contrived an elegant corridor leading to the dining room. With its barrel vault flanked by two shallow saucer domes, it is exactly the kind of imaginative lobby that Soane was so brilliant at creating in odd corners at the Bank of England. Similarly, in the Fellows' lavatory, divisions are marked by Doric columns capped with the miniature sarcophagus lids also loved by Soane. Many improvements were made in the Master's Lodge, notably the transformation of two featureless corridors into libraries, one of them lined with cases brought from the Munro Room, the other, on the right, with cases designed by Simpson who also inserted a new ceiling with a series of bracketed arches.

Simpson's designs for Caius provided numerous opportunities for contemporary British craftsmen to exercise their skills in marble, bronze, inlaid woods, stucco, woven fabric, and glass, engraved and coloured. It is also remarkable that the elaborate rooms which house these superb objects make no external architectural impact whatever. The task of fitting such spaces into an existing shell was unbelievably complex, but once again, Simpson had Soane as a model, for Soane faced precisely similar constraints in many of his most important works where he was adding to a complicated palimpsest of new buildings, for example at the Bank of England, the Law Courts, and the Royal Gallery and Scala Regia at the House of Lords.

Learned yet witty, functional yet poetic, Simpson's work has involved us in the contemplation of numerous previous architects: Iktinos, Bramante, Michelangelo, Palladio, Jones, Borromini, Burrough, Adam, Soane, Cockerell, Klenze, and Lutyens. This not only reminds us of the necessary recovery of reverence and the realisation that we have much to learn from the past, but shows

New corridor linking combination rooms and new Fellows' dining room

that such reverence is not incompatible with the incorporation of all the benefits of modern technology and services, and with an architecture of great verve and originality. The joy expressed in this work, both in general conception as well as in detail, is part of Simpson's ambition to achieve once more what Soane constantly described as "the poetry of architecture." The creative sensitivity to historic precedent shown in all this work is particularly appropriate in the context of the colleges at Oxford and Cambridge whose Fellows are bound to toast "In Piam Memoriam" the benefactors who have made possible the corporate life of scholarship and education in a continuous chain of tradition and rejuvenation.

As H.R.H. The Prince of Wales explained in the speech he made when he opened John Simpson's new work at Caius in March 1998, "These [additions] show how adaptable and flexible traditional approaches to architecture can be and how you can go on using the classical tradition in a fresh and really contemporary manner."

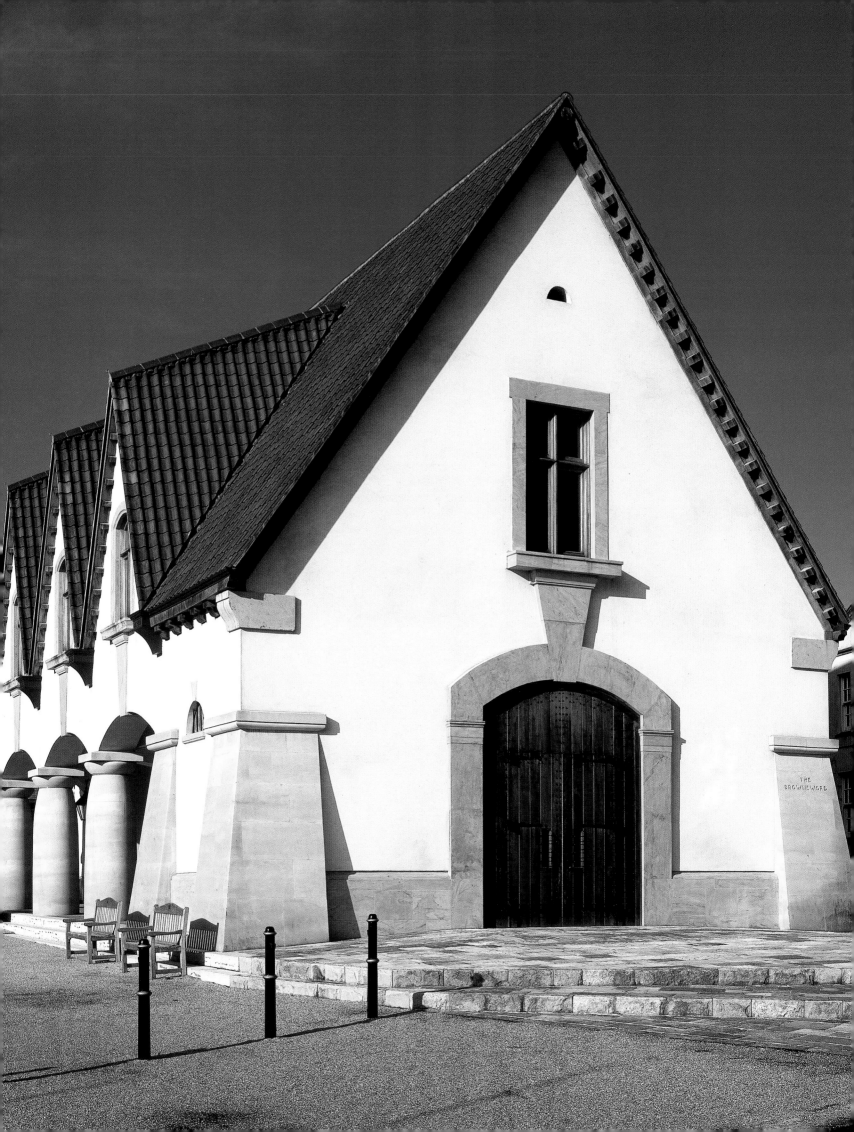

POUNDBURY MARKET HALL
DORCHESTER

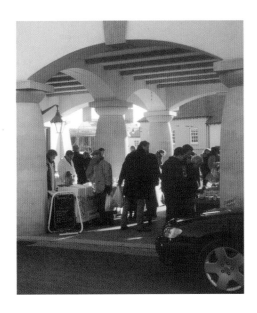

Market day at Poundbury
Left: View of the main door leading to the meeting hall at first floor level
Overleaf: View of market hall from Pummery Square

In 1993 the Duchy of Cornwall began building the first phase of a town extension to Dorchester called Poundbury. Designed by Léon Krier, this mixed use development was intended from the beginning to be in stark contrast to the suburban estates which conventionally sprawl out from towns in that it would be a complete and self-sufficient community with clear boundaries and a central focus. In addition to flats and houses, both free standing and attached, there are also factories, offices, shops and public buildings. At the centre of the first phase there is a square, called Pummery Square, with a market hall surrounded by shops, workplaces and even a pub, *The Poet Laureate*. A tower designed by Krier will be added to the square when funds become available. The market hall, the focus of this new community, was designed by John Simpson and built in 2000 thanks to a generous donation from Mr Brownsword, after whom the building has been named.

When the designs for Poundbury were initially unveiled, the market building was envisaged as a very simple trabeated structure with little in the way of enclosed space. It was represented in this way in an early rendering by Carl Laubin.

In essence it would have been a loggia composed of square piers, open on all sides but still providing shelter for stall holders to show their goods. There is, however, a long tradition of market buildings with more complex programmes than this which stretches from the stoas of ancient Greece to the ambitious market structures of nineteenth-century England such as Charles Fowler's Covent Garden. As the community grew, it became apparent that the brief for the building should be extended to include a large meeting hall, kitchen, lavatories and storage areas as well the space for stalls. Simpson's solution was to place the meeting hall with its civic functions on the upper storey, as a piano nobile, and leave the lower level as an undercroft for market activities, open on three sides to the square. This arrangement is of course very familiar from mediaeval Italian models, such as the mediaeval Basilica in Vicenza, which Palladio elegantly clothed in his cleverly tailored arcades, and from Renaissance English examples, as in the seventeenth-century market halls of Tetbury, Gloucestershire, and Faringdon, Oxfordshire. As Simpson developed the design it also became a very much more powerful building in visual terms than was originally imagined, with a vigorous muscularity that

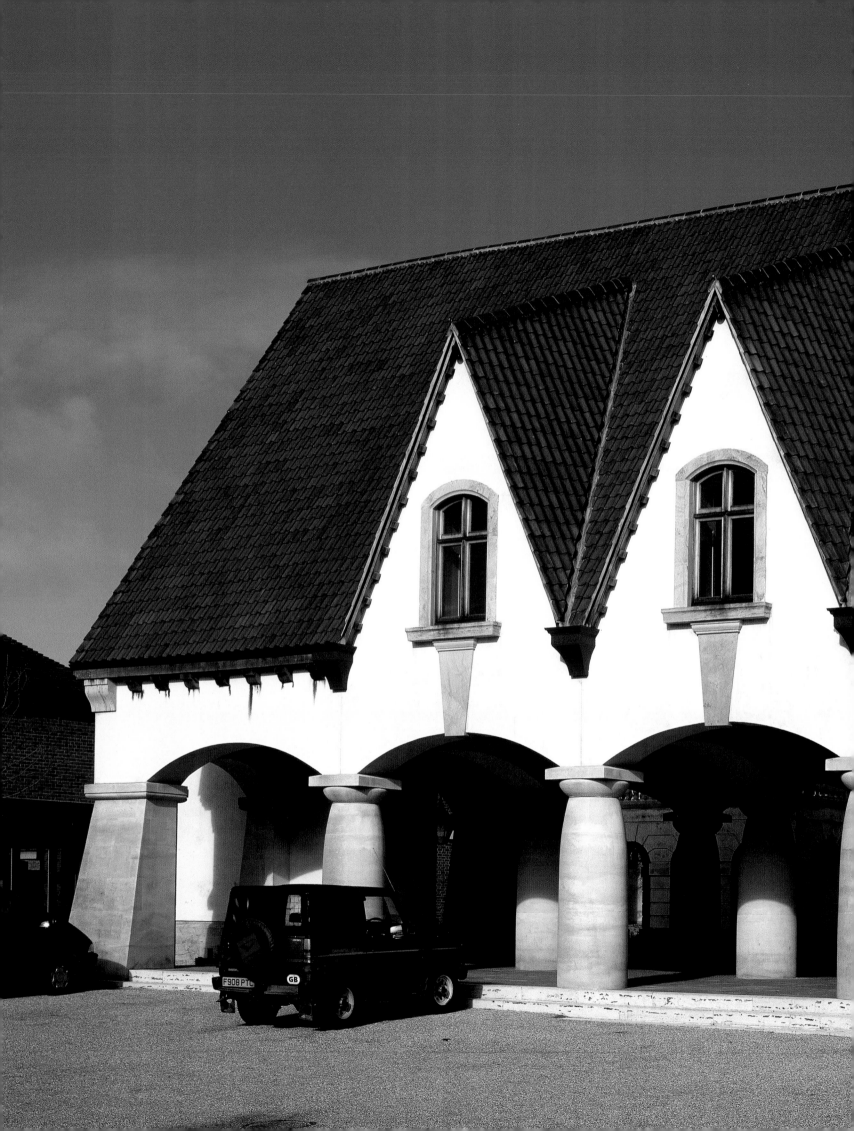

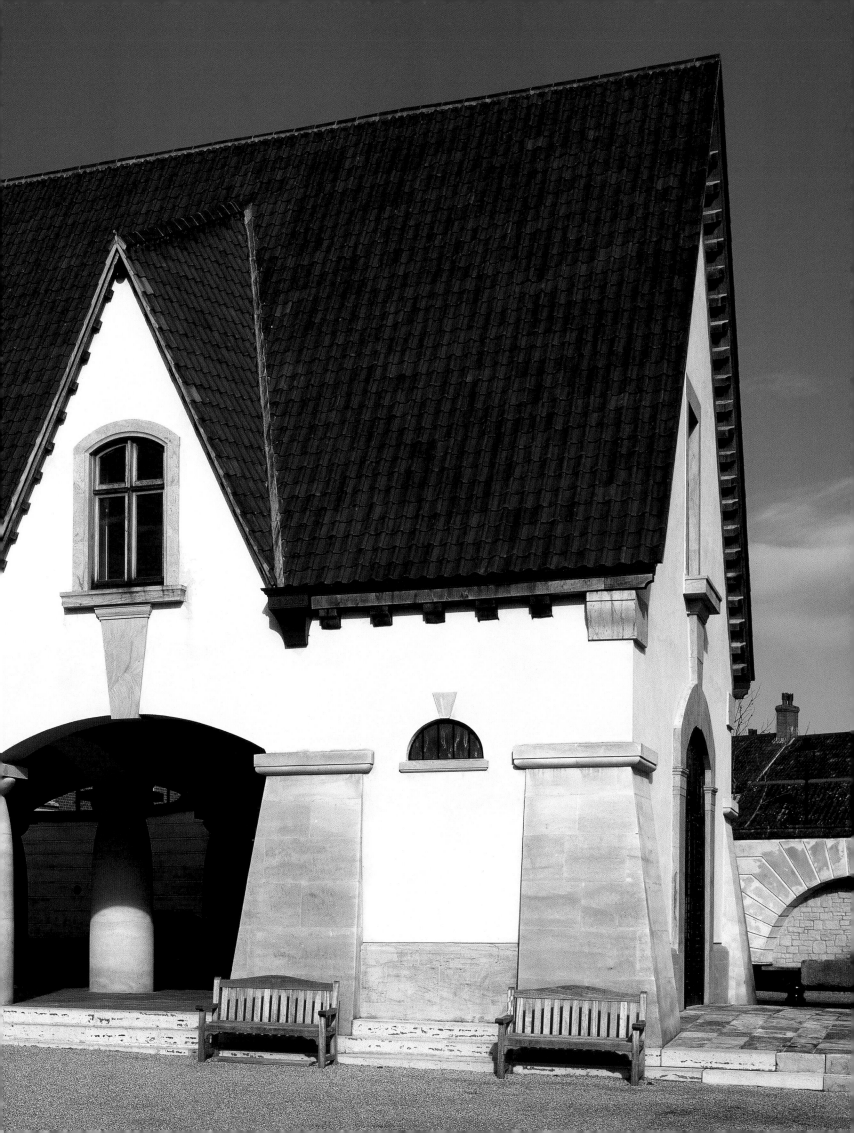

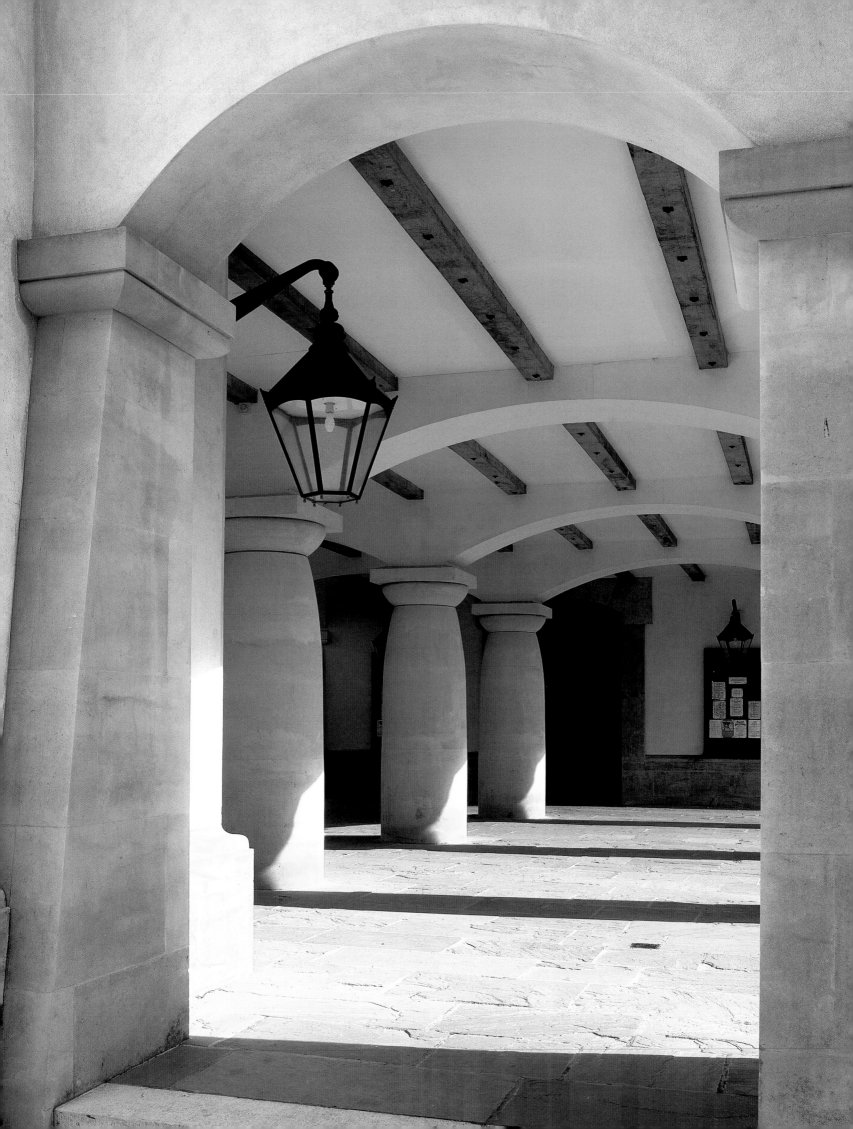

immediately declares the importance of its civic role as the surrogate town hall for this nascent community.

A strong distinction is drawn with the surrounding houses and commercial buildings through a variety of architectural and urban devices. The building has a high roof with a markedly steeper pitch than its neighbours, suggesting the lofty space of the public meeting room inside. The presence of this hall is also communicated by the giant dormers of an unusual raking form which suggest an exotic Central European precedent rather than any English domestic model. The difference is also apparent in the choice of roofing material: large heavily-ridged brown tiles, used at the express request of the Prince of Wales, which are quite unlike the more restrained terracotta tiles and slates of the nearby roofs. It asserts its presence urbanistically by stepping beyond the building line of the adjacent houses, and out over the pavement so that pedestrians are embraced by its arcade and must walk under its cover. The use of freestanding columns also suggests a public rather than private role and they are echoed, appropriately enough, on the other side of the square where a pair of tamer form flank the entrance to the public house.

The overall idiom of the market hall is strikingly primitive. The fat columns with their exaggerated entasis are reminiscent of the earliest Greek temples at Paestum. Their outline, which was slightly modified by the builder in execution so that they appear even more rustic than Simpson intended, vividly conveys a sense of the weight of the hall and great roof above. The undercroft is divided into two aisles by a central colonnade, a consciously archaic arrangement which again echoes Paestum, in this case the cella of the mid sixth-century Temple of Hera which is divided in half by a row of columns. During the nineteenth century this temple was mistakenly thought to be a civic rather than religious building partly on account of this unorthodox layout and so became known as the "Basilica." Henri Labrouste, who controversially reconstructed it when he was a pensionnaire at the French Academy in Rome, adopted a similar two-aisled arrangement for the primary space in his major public building, the Bibliothèque Ste Geneviève in Paris.

Simpson's building is anchored at its corners by massive square piers which take on an even more exaggerated shape than their analogous columns. Excessively battered, like pylons in an Egyptian temple, they become almost wedge-like in their form and their angled outer faces appear to continue the sweep of the steeply pitched roof down to the ground. Lengthwise the undercroft is divided into five bays, four of which are open and framed by doric columns carrying low arches. This is where stalls are set up by traders, such as the organic greengrocers who sell their produce at the weekly Farmers' Market. The fifth bay is closed as it houses the main staircase to the upper hall and and its associated

Left: Covered market area at ground level

services. This staircase can be approached from two large studded oak doors set on the longitudinal axis of the building, one opening from the undercroft and the other from the facade facing the square. The stair, guarded by a simple iron balustrade, rises easily to a landing with a large window framing views of the square and a ceiling divided into deep coffers by oak beams.

The main hall, the climax of this imposing ascent, dramatically fulfils the visitor's expectations. The space is grandly scaled, rising to the apex of the roof, and is framed by a massive structure of exposed cedar beams, recalling perhaps the noble interior of a Norwegian Stave Church. The deep red colour of the beams contrasts with the paler oak of the parquet flooring and doors. The space is rhythmically subdivided on both sides by the giant dormers, light from which floods the room during the day; at night, large iron chandeliers provide the illumination. At the end of the hall there is a conveniently placed kitchen. It is not surprising that during its short life the Brownsword Market Hall at Poundbury has become a much sought after venue for meetings of organisations as diverse as the regional R.I.B.A. chapter and the local group of amateur string players, the Casterbridge Camerata. The latter are particularly welcome to rehearse in the hall as they have willingly accepted as a condition of its rental a requirement that they give an annual Christmas concert there.

URBAN DESIGN

New archway at Painters Yard
Left: New building on Lime Street seen through the arch of Leadenhall Market (Painting by Carl Laubin)

During the opening decades of the twentieth century there were numerous successful attempts to build new towns from scratch. Inspired by Ebenezer Howard's *To-morrow: A Peaceful Path to Real Reform* (1898, republished in 1902 under the more familiar title *Garden Cities of Tomorrow*) an entire movement sprang up in Europe and America. This was perhaps best characterized by the work of Barry Parker and Raymond Unwin in Britain, as in Letchworth and Welwyn Garden City, and John Nolen in the United States, with towns such as Mariemont, Ohio, and Venice, Florida. The settlements planned under Howard's influence at this time were intended to be truly self-sufficient communities, not simply suburban dormitories as was to be more commonly the case in later twentieth-century greenfield development. Though Britain continued to have an active government-sponsored programme of New Town development until the 1970s, private initiatives of this nature became virtually unknown until about 1980 when Andrés Duany and Elizabeth Plater-Zyberk planned the small resort town of Seaside, Florida, for Robert Davis. Now celebrating its twentieth anniversary, this community has had a huge influence on urban design in America, and is for many people the most visible example of the national movement known as "New Urbanism."

The first attempt to create something similar in Britain was John Simpson's design for the new village of Upper Donnington, Berkshire. In 1986 Simpson was approached by the landowner James Gladstone who had become acutely conscious of the pressure for residential development around the town of Newbury in Berkshire where he farmed. He believed that a far better alternative to the anonymity and placelessness of conventional suburban sprawl was to build self-contained, compact settlements in the tradition of the English village. As he later wrote, "I imagined a village in the classical tradition, a place which would be as pleasant for its inhabitants as those which have developed naturally over hundreds of years. I imagined a place which would foster the growth of community spirit, which would have houses and flats, large and small so that someone could live there his whole life if he or she so wished, that would welcome children and pensioners equally – with a shop, inn, village hall, [and] places to work."

Simpson had become aware while he was still a student at the Bartlett of Léon Krier's polemical attacks on Modernist planning

and his exposure of its central flaw of functional zoning. Through his analytical work for DLGW on Covent Garden Simpson had come to appreciate in a practical way the role played by a mix of uses, an organic street structure, and a common architectural language in cultivating that feeling of special character which fosters a profound sense of community.

Taking advantage of an existing confluence of roads and rights of way close to the tourist attraction of Donnington Castle, Simpson proposed a development that would provide amenities for visitors as well as housing about a thousand inhabitants in a variety of residential types. These included sheltered accommodation for the elderly, flats, mews houses, terraced houses, and both detached and semi-detached family houses. At the centre of the village there would be a market square defined by three storey buildings including an inn and shops. This would be linked to a sequence of carefully designed streets and public spaces, each of which would relate to a significant public building such as the visitors centre, village hall, school and an open-air theatre.

The proposal submitted to the local planning authority for consent was very much more detailed than usual for Simpson had paid a great deal of attention to the issue of architectural quality, which he saw as central to the success of the project. He developed a modular approach to the design of the simple classical villas and terraced houses out of which the village was composed. This would enable the working drawings for a variety of house designs to be generated quickly with the use of the computer. The savings in costs that this would achieve was intended to ensure that it would still be economically viable in a speculative development to employ an unusual variety of house plans. This picturesque variety was crucial if Upper Donnington was to resemble a real village that had developed over time rather than a one-time development of off-the-peg houses. Sadly planning consent for the village was not granted and following the decision to approve the Newbury bypass which would pass through his farm, James Gladstone abandoned the project and moved to Scotland.

While Upper Donnington might be seen as harking back to the enlightened eighteenth-century tradition of planned estate villages, it was also in many important ways in the vanguard of planning theory. Even though it failed to gain approval in 1990, a decade later the principles of compact and sustainable development upon which it was based are firmly enshrined in government planning policy.

COLDHARBOUR FARM
AYLESBURY

Simpson's experience of planning a community for the pastoral setting of Upper Donnington placed him in good stead when he was approached by The Ernest Cook Trust with a commission for

a masterplan for a much larger project on a rural site as delicate as Gladstone's. The Trust was founded by a grandson and heir to the fortune of the travel agent Thomas Cook. Following the sale of the travel agency in 1928, Ernest Cook devoted his life to the preservation of country houses and their estates, a mission which has been continued by the Trust in an enlightened fashion. One such example is the Hartwell Estate which encompasses 1,800 acres on the outskirts of the thriving town of Aylesbury. While the historic Hartwell House has been preserved through careful conversion into a luxury hotel and most of the farms on the estate have been maintained as agricultural concerns, the Trust felt that there was the opportunity for a pioneering demonstration of how development might be sensitively handled so that it helps safeguard the countryside in an area where there is great pressure for urban expansion. Therefore at Coldharbour farm, a two hundred acre site adjacent to Aylesbury, the Trust developed a new town, Fairford Leys, according to a masterplan by John Simpson.

The brief called for two thousand houses, a community centre, a local primary health centre and shops, all in a development which would have a coherent identity, character and sense of community, rather than being just another collection of anonymous housing estates. Simpson set out to achieve this by arranging the houses to create streets, squares and lanes in the traditional urban manner. This deviation from orthodox estate planning was intended to cultivate a sense of place and create a hierarchy of public spaces similar to those one would expect to find within a traditional village. In addition, one of the major issues addressed in the plan was how to accommodate the car in such a way as to still make it convenient and desirable to walk about. The goal was specifically to avoid those kinds of dispersed suburban layouts which, through their emphasis on the individual private house result in a lifestyle which is inconvenient without the use of a car.

Simpson began his masterplan by separating the site into a number of recognisable neighbourhoods each with a major village green at its centre. Everything within the neighbourhood is arranged to be perceived by its inhabitants to be within easy walking distance, i.e. no more than five minutes' walk away. This encourages people to walk rather than drive but more importantly allows them to feel close to the centre of activity and therefore identify with the community. This sense of local identity is further enhanced through the decision to build houses in a range of local styles that reflect traditional vernacular design.

The project has now entered its second phase, with nearly a thousand houses built and another five hundred expected to be completed within two years. The speed of its construction is partly a consequence of its success in current economic conditions but is

Right: Artist's impression of the masterplan for Coldharbour Farm at Aylesbury, showing the central town area (Painting by Ed Venn)

also a result of its being built by national volume housebuilders, Bryant, Taywood and Wimpey Homes. Their involvement, combined with the fact that the Trust has insisted that the finances of the project fall within commercial parameters, means that Fairford Leys is a realistic paradigm for development elsewhere.

DICKENS HEATH
SOLIHULL

In 1991 Solihull Council approached John Simpson with a request to design a new village along traditional lines similar to that of the Ernest Cook Trust. In 1988 the council had predicted that it would need to accommodate over 8,000 new homes by the end of the century. As part of its Unitary Development Plan, the statutory document which designates land for future residential and commercial development, the council proposed siting a settlement of 850 new houses to be called Dickens Heath between two existing hamlets in a rural setting beside the Stratford-upon-Avon canal and only three miles from Solihull town centre. The proposal was considered by a public inquiry in 1991 and following a favourable review by the Government inspector the council approved the project at the end of 1992. Simpson's original concept was taken forward and refined in consultation with the consortium of developers who would be building the village, including Bryant Homes, Trencherwood Homes, Redrow Homes, and Laing Homes.

In his masterplan, Simpson set out his aims to ensure that Dickens Heath would closely resemble a traditional village: it would have a clear identity to foster a sense of place and belonging among its residents; it would mix opportunities for employment, recreation, social and welfare facilities with houses to create a cohesive whole; it would provide a range of housing, from starter homes through to family housing and retirement flats, thus creating an authentic community of all ages and income; and it would be pedestrian-oriented in a way which could still accommodate the car.

The village-like character of Dickens Heath is cultivated through specific design decisions. The density of development is greatest at the village centre and diminishes towards the edges, thus easing the transition to the surrounding countryside. At the centre and on the main streets there are a series of public squares and greens, each with its own distinct character and each possessing landmark buildings. The two-and-a-half acre village green at the heart of the development is triangular in shape and is intended to be a major focus for sports events and informal recreation. In typical English tradition it will have a cricket square and associated pavilion. To encourage good design and achieve consistency of character, Simpson devised a design guide for developers which lays down broad principles to observe including the layout of squares, the street pattern, building heights, the relationship of houses to the street, the pitch and colour of roofs, the position of parking and garaging.

Construction of the village began in August 1997 and by January 2002 some seven hundred houses had been completed. Work on the village centre, which was designed with the help of public participation, is expected to begin in 2002.

PATERNOSTER SQUARE
LONDON

One of Simpson's best-known and most influential projects, which he worked on between 1987 and 1992, was for the large triangular area known as Paternoster Square on the north side of Sir Christopher Wren's masterpiece, St Paul's Cathedral. This had been developed in the 1960s according to a plan by Sir William, later Lord Holford, with a series of wind-swept elevated plazas and grim concrete office blocks by the architects, Trehearne and Norman, Preston and Partners. Holford deliberately planned the site with no reference to the historic layout or setting. He believed that there was, in his own words, "more to be gained by contrast in design … than from attempts at harmony of scale or character or spacing." For achieving this he was greatly praised by Nikolaus Pevsner and the architectural establishment. It is surprising that Pevsner, who was an enormously sympathetic interpreter of historic buildings, was blind to so many of the failings of modernist architecture and planning which he did so much to promote. He was thus able to claim that the geometrical arrangement of Holford's lumpish blocks were a modern application of the principles of variety and surprise promoted by the English Picturesque tradition of the eighteenth century!

The area surrounding Paternoster Row, which was named after the makers of rosaries or "paternosters" to be found there, had developed alongside the mediaeval St Paul's Cathedral, following an organic street pattern that still exists in other parts of the city. Its busy market, streets, and lanes retained their dense urban character from the seventeenth century until the Blitz, when a fire ignited by an incendiary bomb swept through the neighbourhood's many bookshops on 29 December 1940 taking many lives and destroying, it is said, some five million books. The area had been razed by fire on three previous occasions, 961, 1087, and the Great Fire of 1666. Each time it was rebuilt following the existing network of streets and lanes to find a new vitality and prosperity. Only after the devastation of the Blitz was the traditional form discarded in the subsequent redevelopment.

William Holford, appointed as masterplanner by the City Corporation in 1956, proposed a plan that erased the traditional street

View of new Market Hall at Poundbury in Dorchester

pattern in favour of a giant abstract grid on which buildings were placed seemingly at random without any reference to the surrounding fabric or to Wren's monument. Though his scheme had been through both Houses of Parliament, it totally compromised the historic relationship between the Cathedral and the City by interrupting views of the dome with tall office buildings and by severing pedestrian connections through priority being given to vehicles and parking at ground level, with people being confined to draughty raised decks and precincts. Here, all traces of the City's mediaeval and Georgian past were deliberately eliminated. Holford permitted no reconstruction. Any surviving buildings were bulldozed. Moreover, his high-rise blocks, one of them sixteen storeys high, provided only three-quarters of the accommodation that existed in the traditional four- and five-storey buildings on the site before the Second World War. There was no reason or pressure to build high, for the required density could have been achieved with lower buildings laid out on a different plan. The widely spaced tower blocks were selected entirely for reasons of fashion and ideology. Moreover, with one exception they were made of Portland stone, an extremely costly material usually employed to allow a demonstration of the mason's art, but, by a hideous irony, here was crafted to appear virtually indistinguishable from concrete!

By the early 1980s, these buildings born of post-war Britain's misplaced faith in a modernist brave new world, were perceived as obsolete even though they were only twenty years old. In 1987 the property developers who had bought the site the previous year, Mountleigh Estates, invited seven architectural firms to take part in a limited competition to replace the existing buildings which no longer conformed to current office practice and were incapable of accommodating modern computer networks. The firms included Arup Associates, James Stirling, Arata Isozaki, MacCormac Jamieson, Norman Foster, and Richard Rogers; all produced High Tech or modernist proposals. The judges chose Richard Rogers and Arup Associates as joint winners, though the former soon resigned when he was offered only a minor role in the project rather than being appointed co-masterplanner with Sir Philip Dowson, the senior partner of Arup's. Mindful of the fact that the 1982 competition for an extension to the National Gallery had been derailed when the Prince of Wales savagely attacked the winning scheme by Ahrends, Burton and Koralek as a "monstrous carbuncle," the developers thought it wise to show the Prince the schemes under consideration. He was "deeply depressed" and "demoralized" when he saw that the proposed buildings would do little to undo the damage done by their predecessors to the setting of St Paul's Cathedral. Seeing this as one of the great icons of national identity, he believed that the oppor-

Right: View showing the buildings designed for John Simpson's Paternoster Square Masterplan in the City of London (Painting by Carl Laubin)

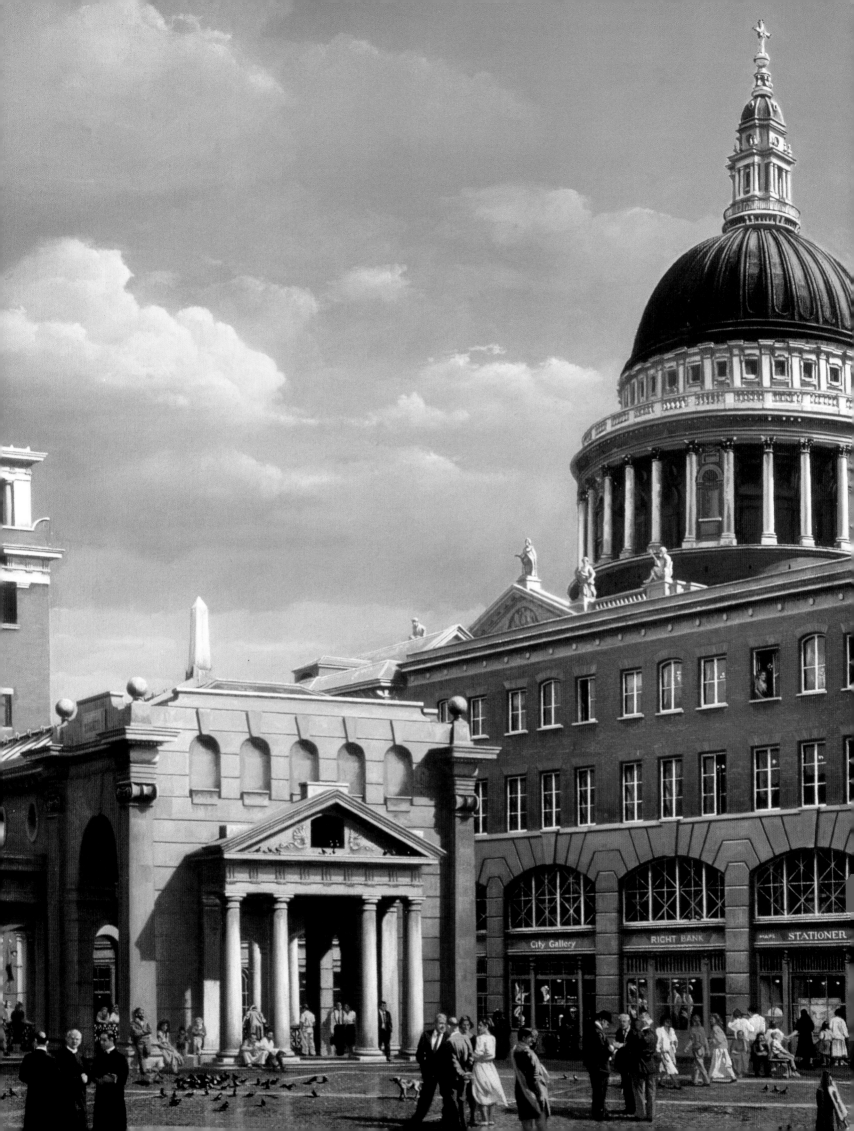

tunity should be taken to design new buildings which would respect and not reject it. He voiced these opinions very publicly at the invitation of the City of London at their annual dinner at the Mansion House in December 1987. In his speech he first attacked the idea of a holding a secret competition for a site of such historic importance and then urged that there should be a public debate and an informative exhibition which showed the area as it once was, the earlier plans of Wren, Hawksmoor and Lutyens, and the current proposals. Finally, he outlined a vision for the site: "I would like to see the mediaeval street plan of pre-war Paternoster reconstructed … I would like to see a roofscape that gives the impression that St Paul's is floating above it like a great ship on the sea. I would also like to see the kinds of materials Wren might have used – soft red brick and stone dressings perhaps, and the ornament and details of classical architecture." This vision, of course, was based on the ideas of John Simpson who had, with the encouragement of the Prince and the advice of Léon Krier, been working on a counterproposal which the Prince had already seen.

John Simpson now began the long task of elaborating a masterplan for a civilised and harmonious Paternoster Square which could be exhibited to the public as a viable alternative to the seven competition entries. With brilliant audacity, the Simpson masterplan achieved a density close to that which existed in 1940 and reinstated Paternoster Square as the focus for business, shopping, living and leisure, north of St Paul's. The square, and the network of streets and lanes at ground level that connect with it, were recreated according to a traditional street pattern. They were lined with complementary buildings designed within the classical tradition, ranging from small-scale vernacular buildings fronting the Church Yard as neighbours for Wren's surviving Chapter House to more sophisticated structures with freestanding columns in the square itself. Views of St Paul's from Paternoster Square at ground level were restored as was the image of its skyline from other quarters. The opportunity was also taken of restoring the traditional alignment of the Church Yard so that it would be bordered on the north, as it was before Holford, by a curved street. Here Holford's buildings formed a jerky row of right-angled blocks unrelated to the former street or the Cathedral. Perhaps most significantly of all Simpson addressed the issue from a much larger perspective than the competition entrants: instead of confining himself to the four and half acres owned by Mountleigh, he looked at the whole triangular site to the north of the Cathedral, seven acres in total, that had been so disastrously re-developed in the 1960s. He turned his attention to the south side of St Paul's proposing that the seventeenth-century gateway known as Temple Bar, which had been removed from the Strand when it was widened in 1878, could be re-erected at the head of St Paul's Steps thus framing the view down to the river from the Cathedral. Simpson also went

beyond the original brief in introducing a wide range of uses: instead of restricting the programme to the offices and shops requested by the developers, he included flats and an hotel as well as a museum, in the hope that the neighbourhood might have a life beyond business hours and appeal to more than office workers.

In place of a single monolithic superblock, Simpson's masterplan broke down the large triangular site running the whole length of the Cathedral, into seven smaller more humane units similar in scale to the surrounding city blocks. Both the construction and the materials, including stone, brick, slate, tile, lead and copper, were traditional, with walls of self-supporting masonry, the structural frame not carrying the masonry but only providing it with lateral restraint. The issue of construction was particularly important to Simpson who was critical of those recent apparently traditional or classical buildings which have thin veneer brick construction, so brittle that the movement happens at specially built fault-lines packed with rubberised mastic with a life of only ten to twenty years. Rain soaks through the brick and runs down the inside surface where it is collected in plastic trays and drains out through weepholes in the walls. By contrast, traditional brickwork is like an overcoat, thick enough to soak up the rain, and drying out without allowing water into the building. Such plastic trays and metal ties have a short life. Simpson believes that a classical architect should be interested in the long-term performance of his building: how it grows old, whether it can be reused and, therefore, in how it is built. Here, he is close to the poetical vision of John Ruskin who passionately believed that buildings, like people, need to age and mature so that they can serve as a commentary from the past on the present. Because of the practice of architects like Holford at Paternoster in the 1950s and 60s we now have a largely unskilled workforce, mostly trained only to assemble buildings on site out of prefabricated parts, not to construct them properly. Thus, unlike the first modernists who had the luxury of choice in their constructional techniques, most architects today have only the legacy of industrialised construction with which to work, with all its defects and shortcomings. However, for the numerous traditional buildings now being designed by architects such as John Simpson, Quinlan Terry, Demetri Porphyrios, Robert Adam, and Julian Bicknell, a whole new generation of young craftsmen in stone, timber, and plaster, is being trained. It is a moving experience to see once again evidence of Ruskin's belief that a craftsman can take pride in his work.

Simpson argued that the orthogonal planning, the repetition created out of the high-rise buildings and the simple grid elevations, were used by Holford and his associates as propaganda for methods of industrialised construction which were not then common. Their Paternoster Square proclaimed, "This is what future buildings must be like," for architecture was here used as the

driving force influencing if not forcing a change in the technology of construction, for techniques became cost effective when they became commonplace. The irony that the buildings were mostly of Portland stone not concrete seems to have escaped these believers in the moral crusade of Modernism which upheld "truth to materials and honesty of construction."

The exhibition that the Prince had requested in his Mansion House speech was duly organised in the crypt of St Paul's by the Paternoster Committee, a body set up to encourage public participation in the debate about the site under the chairmanship of Lord St John of Fawsley, Chairman of the Royal Fine Arts Commission. Opening in June 1988 it featured all the original competition entries, though curiously Arup's winning proposal had not been developed into a complete plan but rather had retreated into a series of ideas presented using diagrams and polystyrene blocks under the title "A Work in Progress." Simpson, on the other hand, had gained the backing of the influential London newspaper *The Evening Standard*, so that in addition to his extensive explanatory drawings he was able to show an ambitious model of the entire site and two seductive oil paintings by Carl Laubin including an evocative view depicting choristers crossing his recreated Paternoster Square on their way to the Cathedral. While baffled by Arup's conceptual offerings, the public, over seven thousand of whom flocked to the month-long show, were immediately enthralled by Simpson's lucid classical vision and made their enthusiastic opinions clearly known in their responses to questionnaires and in comments in the exhibition's visitors' book.

At the same time as the exhibition, *The Evening Standard*, in a dramatic public relations coup, announced that it would submit Simpson's scheme for outline planning consent, creating the spectre of an unprecedented situation in which planning permission for a site might be granted not to its developer's project but rather to an outside counterproposal. Unsurprisingly a few months later Mountleigh announced it had sold the now-controversial Paternoster site as part of a larger property deal to a Venezuelan company operated by two brothers, Gustavo and Ricardo Cisneros, media magnates who were personally acquainted with the Prince of Wales. Arup's, however, continued to work on their plan, unveiling a complete proposal in November 1988, which incorporated a number of Simpson's key ideas but retained the least appealing element of their original scheme: a giant "inhabited wall" facing the Cathedral behind which stretched a vast glass-roofed shopping mall in place of Paternoster Row. Simpson also continued to develop and refine the details of his plan which was again shown to the public this time at the Victoria and Albert Museum as the centrepiece of the Prince of Wales's *Vision of Britain* exhibition.

In April 1989 the Venezuelans announced that the property was again on the market and in October the site was sold, this time to a consortium of new owners who favoured Simpson's scheme. They were: Greycoat plc, a property investment and development company, based in London; Park Tower Group, a property developer with offices in New York, Washington DC, and London; and an affiliate of Mitsubishi Estate Company of Tokyo. Each owned one third of a company known as Paternoster Associates. In addition to Simpson, whose role in the masterplanning of the site was assured, they appointed two other firms sympathetic to traditional design to work on the detailed development of the plan with him: Terry Farrell, a British architect and urban designer with experience of shepherding a complex masterplan through construction at Embankment Place, and, at the request of Park Tower, an American, Thomas Beeby, who was at that time Dean of the School of Architecture at Yale University. This triumvirate then chose a number of like-minded architects to work with them to design individual buildings within the overall plan, including the British architects Quinlan Terry, Robert Adam, and Paul Gibson; the Anglo-Greek architect, Demetri Porphyrios; and the South African-born architect based in the United States, Allan Greenberg.

While Simpson's original plan had covered the entire seven-acre triangular area adjacent to the cathedral, the three corners of the triangle were in fact occupied by buildings which were then in other ownership: Sudbury House, Juxon House, and 5, Cheapside. The new Simpson, Farrell and Beeby plan therefore focussed on the four and a half acres actually owned by Paternoster Associates, while still giving indications of what might work best at the corners of the site. In May 1991 the results of this transatlantic collaboration were unveiled by the Prince of Wales at an exhibition held in a converted shop on the Paternoster site. The Prince on this occasion was careful not to express his opinion of the new scheme, though privately he was said to have reservations about the bulk of some of the buildings and the sunken courtyard in Paternoster Square. Under pressure to ensure the commercial viability of the development, which was now estimated to cost £800 million, the mix of uses originally envisaged by Simpson had been reduced to two, offices of which there would be about 625,000 square feet, and shops, of which there would be eighty-five, totalling some 125,000 square feet of retail space divided between ground level street-front units and a subterranean shopping arcade running from the lower courtyard to the tube station.

All visitors who saw this collaborative scheme, of whom there were as many as 18,000, were again encouraged to make their comments: nearly 75% were in favour, with 90% liking in particular the use of stone and brick and the adoption of traditional streets and alleys. A surprising percentage of the visitors were architects, about 10% of the total, and it soon became apparent that they held very different views from the general public. Indeed, of those architects who visited 68% disliked the scheme, with nearly

90% of them believing that the design was "inappropriate for the twenty-first century." This project was then submitted for planning approval in June 1991. The City of London Planning Committee, English Heritage, the Royal Fine Arts Commission, and bodies such as the relevant statutory amenity societies, that is to say the Georgian Group and the Twentieth Century Society, all made their comments, such is the complexity of modern planning procedures. They mostly recommended that the height of the buildings should be reduced and the lower courtyard eliminated. The architects did this and it was their modified scheme that was presented to the City Planning Committee who in October 1992 recommended that the Secretary of State approve it.

These final revisions brought the masterplan closer to Simpson's original proposal with his open Market Hall being restored to the central square. The site was divided up into six buildings each of which was the responsibility of a different architectural firm. Facing south on to St Paul's Church Yard, and running parallel to the cathedral choir, was an elaborate building by Allan Greenberg, architect of prestigious classical works in Washington DC such as the office of the Secretary of State. His contribution to Paternoster Square was designed in the language of Wren and Vanbrugh at Kensington Palace and the Orangery. Of red brick with giant pilasters, Ionic and Doric, rising through two storeys, it boasted windows based on the King's Gallery facade of Kensington Palace. Greenberg also drew inspiration from designs proposed for this site by Wren's pupil, Hawksmoor, with an arcade surmounted by a three-storey pilaster order and an attic storey. His building was to be bordered on two sides by two newly recreated historic streets: Paternoster Row on the north, and Canon Alley on the west.

On the other side of Canon Alley, facing south into St Paul's Church Yard, was a new building by John Simpson, U-shaped and surrounding Wren's surviving Chapter House. This complex building adopted a number of different styles and heights to accommodate itself to the adjacent buildings on this key site. The south front, next to the Chapter House, was of just four storeys, rising to a height which is just below that of the cornice line of the ground floor columns of the cathedral. In white brick with stone dressings, this part of Simpson's composition was in a plain Georgian style. The north front of the building formed one side of the new Paternoster Square which was an enchanting recreation of the market squares of European cities. With the open Doric loggia of the market hall at its focus, this whole traffic-free complex would have become a hugely popular addition to the public open spaces of London just like the redeveloped Covent Garden which Simpson had originally studied when working for DLGW. The loggia or market hall followed the tradition established on this site over three centuries ago when Newgate Market was moved from a modest site into a purpose-built hall in a new square.

The north side of Paternoster Square contained three large building groups by Farrell, Adam, Gibson, and Porphyrios, running back to Newgate Street, the northern boundary of the whole site. Furthest from St Paul's Cathedral, these are amongst the tallest of the new buildings. Though echoing large Renaissance palazzi, their scale and ebullience catches something of the flavour of Edwardian and inter-war commercial architecture in this part of London. The opportunity was to be taken of recreating the lost Ivy Lane which emerged as a charming Gothick shopping arcade with a glazed fan vault. Porphyrios's building, with the Grecian neo-classical flavour with which he is associated, terminated in an attractive tower capped with an open belvedere of Greek Doric columns. He has since incorporated a similar feature in a handsome office building at Brindley Place, Birmingham.

Finally, on the west side of Paternoster Square was a dramatic building by Thomas Beeby, fresh from designing his marvellous Harold Washington Library Center in Chicago. His vast pile has an imperial Roman splendour though it is also indebted to Sir Edwin Lutyens' work in the city of the 1920s. Greycoat plc had already carried out an exemplary restoration of Lutyens' Britannic House, Finsbury Circus, a huge office building in the City with stone facades of sixteenth-century Italianate richness hung on a steel frame.

In February 1993 the environment secretary, Michael Howard, decided not to exercise his right to judge on the planning application, thus allowing the Corporation of London to grant permission for the development to proceed. But despite this final granting of planning approval, nearly six years after the initial design competition, the story did not end here. By the close of 1992 the property market in London was deep in the doldrums compared to the boom years at the end of the 1980s. Between 1986 and 1988 high demand for office space in the City from banks and securities firms had led to rents doubling; this, in conjunction with the Corporation's relaxation of planning controls in 1986, had stimulated a building spree which resulted in about twenty million square feet of new office space. With the sharp rise in interest rates, an unexpected slump in demand for financial services and the descent into country-wide economic recession there was suddenly a vast surplus of office space. It was estimated that in central London alone at this time there was forty million square feet of empty offices, one fifth of the total. While an article by Kenneth Powell in *The Daily Telegraph* under the title "Classicism's Finest Hour" boasted of Simpson's triumph as having "pulled off a coup and defeated the modernists" the moment had passed. The economic climate was such that the project was shelved and it was not seriously reconsidered for another four

Right: Street view of new buildings at Painters Yard, Chelsea, London

years. But by 1997, the Prince of Wales's closest advisors were anxious that he should be disassociated from the architectural controversies of the past decade and in particular, given the growing resurgence of interest in modernism amongst the metropolitan public, that he should be distanced from any association with classicism. Thus when Mitsubishi Estates, by now the sole owner, resurrected the idea of redeveloping the site little was done to support the Simpson scheme; instead, in the hope of mending fences with the architectural establishment, the selection of the veteran conservation architect Sir William Whitfield as the new masterplanner was endorsed.

Work finally began on the site in 1999 with a view to completing the redevelopment in 2004. This time, the team of architects who had been assembled by Whitfield included Eric Parry, Allies and Morrison and, ironically, one of the losers of the 1987 competition, MacCormac Jamieson and Prichard. No one from the previously approved scheme was involved, and yet, though the buildings now under construction lack the sophistication and beauty of those of Simpson and his collaborators, Simpson's profound contribution to the urban design of the site should be acknowledged. Whitfield retained four of his fundamental ideas: respect for the hierarchical importance of St Paul's through the adoption of an appropriate scale and materials; the re-connection of the site to its surroundings using pedestrian streets and lanes; the reweaving of the urban fabric through the use of traditional city blocks; and the provision of a suitable civic dimension for this sensitively sited development through the recreation of a pubic square at its heart.

PAINTERS YARD
CHELSEA

In 1999-2002, Simpson was able to put some of his urban ideas into practice in Old Church Street, Chelsea, a new residential development in an historic area of London. The first phase, completed in 1999, consists of twenty apartments, two Georgian style town houses, and two substantial cottages behind a single classical facade. Incorporating part of the premises of a firm of plumbers at nos. 6-16, Old Church Street, it is grouped round a newly formed Italianate courtyard and incorporates car-parking. Working with the developer, Richard Collins, John Simpson was inspired by the urban grain of this part of old Chelsea and by the example of the distinguished architects who have contributed to it from the Baroque period to the Arts and Crafts movement. These include architects as varied and distinguished as Wren, Soane, Norman Shaw, Halsey Ricardo, and C.R. Ashbee.

Most modern developments in historic settings tend to destroy or dominate the streetscape, but the essence of Painters Yard is making the street part of the development. This new townscape is not just for the privileged inhabitants, for the courtyard forms a kind of semi-public space visible from the street through a tall arch. In this, it is like the cortile of a Roman palazzo, though, unlike them, not blocked with cars.

As project architect at Painters Yard, Simpson produced the broad outline plan and the facades, with much of the interior finishing left to other hands. The whole has something of the ad hoc picturesque atmosphere of much understated eighteenth-century domestic architecture. It is, indeed, a parallel to the way in which much in our old Georgian towns was produced, piecemeal, not the product of a single egotistical architect.

It is in scale with its neighbours, which are modest buildings from the age of the painter, Turner, who lived round the corner: a low tree, an old shop front, and 1920s warehouses. Simpson's first design incorporated on the street front a symmetrical red-brick house of five bays in a Queen Anne Style, a little like Norman Shaw's nearby Swan House of 1876 on Chelsea Embankment. As executed, this had a more under-stated flavour for, following the unwelcome intervention of the local planning officer, it became two houses each of three bays.

The Italianate courtyard garden has a backdrop at the north end like a piece of stage scenery designed in the form of two "cottages," resembling a single Palladian unit with a broad pediment and a statue in the central niche. The whole facade is faced in stucco with a surface that has been deliberately "distressed" or mellowed. On the west side of the court, one of the two new houses has a separate guest pavilion in the form of a miniature temple, placed high up rather in the manner of Schinkel's garden buildings at Schloss Charlottenhof, Sanssouci, of the 1820s. Indeed, the blending of buildings and gardens at Painters Yard is a reflection of Schinkel's practice, which was informed by his belief that "architecture is a continuation of nature in her constructive activity."

For the design of the courtyard garden, Richard Collins engaged the services of the horticulturist, Anthea Gibson. She introduced two hundred-year old olive trees and mature magnolias, all brought from the Matti nursery outside Florence, as well a new fig-tree and espaliered pears. The exceptionally large lead planters were brought from Gloucestershire, while the new lanterns were dropped in acid to soften their newness. Anthea Gibson divided the space into formal and informal areas, planting the sides with mature Italian hedges, and training old vines and wisteria plants against the walls. Down the centre runs a narrow canal or channel, like that at the famous Villa Lante at Bagnaia. From a higher level at the south end water pours through a nineteenth-century mask brought from Florence by Richard Collins. Elsewhere there is a Roman marble bath filled with water, and a seventeenth-century bronze spout feeding a small stone basin from which water overflows onto the pebbles.

On the east side of the courtyard, Simpson contrived to create a view of the river from a higher private terrace 44 feet by 26 feet. On the north is part of the original building for the plumber and builders' merchants with machinery for winching up horses, used in deliveries, and stabling, oddly on an upper floor. The car park at the rear is approached discreetly through Lawrence Street.

The interiors of the flats echo something of the Bohemian atmosphere of traditional Chelsea. The planting and ornamentation of the whole project owes much to the developer, Richard Collins, who enjoys finding 1930s Art Deco lights in Paris or good modern furniture in Milan. He commissioned Robert Kime, Anthony Collett, and William Nickerson to design the interiors and was involved in discussions with John Simpson about the planning. Seeing himself as a developer interested in good design, he has found that to create work of good quality makes good economic sense. Painters Yard is a perfect expression of that truth.

The second phase of John Simpson's development, completed in 2002, provides two further houses, both substantial compositions of four bays each, the southernmost consisting of a new vicarage. Its ground floor incorporates an arch leading down a ramp to a car park. Adjacent is a handsome new two-storeyed church hall at the back of the vicarage and above the car park. The facade of the church hall incorporates three arched bays inspired by Petyt House, an earlier building on the site. In the summer, these can be opened so as to suggest a cloister on one side of the new courtyard between the hall and the old parish church in Cheyne Walk.

NEWCASTLE GREAT PARK

In 1998, after seven years of debate and consultation, the city of Newcastle-upon-Tyne adopted a Unitary Development Plan, the fifteen-year land-use and transportation plan that must be produced by each local authority in accordance with the 1990 Town and Country Planning Act. It envisaged the development of a large site to the north of the city centre and to the east of the airport which would complete the edge of city by linking it to the adjacent communities of Brunton Park and Kingston Park. This site, initially called the Northern Development Area and now known more inspiringly as Newcastle Great Park, consists of 400 hectares of farmland, about half of which will be preserved as habitats for wildlife and open green space. Of the remaining land, 117 hectares is allocated for 2,500 homes, and 80 hectares for high technology businesses expected to provide 8000 jobs. The development will occur over a twelve-year period and is intended to address two interrelated shortages that seriously threaten Newcastle's future prosperity: the lack of high quality housing for highly-skilled graduates and affluent professionals, and the lack of venues for high technology industry.

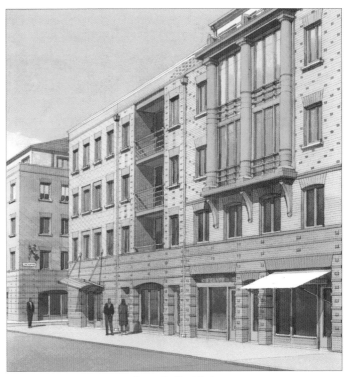

Newcastle Great Park.
Artist's impression of street within town area (Painting by Ed Venn)

In June 2000, the Deputy Prime Minister, John Prescott, decided not to exercise his right to intervene in the granting of outline planning permission for the project, thus speeding it on its way. In giving his approval for the project, he was won over primarily for two reasons. First that the developers had agreed to participate in a unique arrangement whereby for every house built on this greenfield site they would build two on brownfield sites. The second was that to ensure the project would be a high quality, sustainable mixed-use urban extension as recommended by the new Planning Policy Guidance Note No. 3 on Planning for Housing (PPG3) the developers engaged John Simpson as masterplanner.

Simpson's scheme for the site, outlined in a concept plan published in 2000, again drew together all his urban design concerns in a single coherent approach. He proposed that uses are mixed at the level of the block, street and building; that the site is divided into distinct neighbourhoods each with its own local centre no more than five minutes' walk from any residence; that walking, cycling and the use of public transport are actively promoted through the integration of routes and the adoption of appropriate densities; that speeding in particular and car use in general are discouraged through meandering vehicle routes; and that, above all, the development should have a strong sense of identity with its character drawn from the local vernacular of the city. By early 2002 ground had been broken on this ambitious and forward-looking development and the two major housebuilders involved in the projects, Persimmon Homes and Bryant Homes, had already started to sell houses in the first phase.

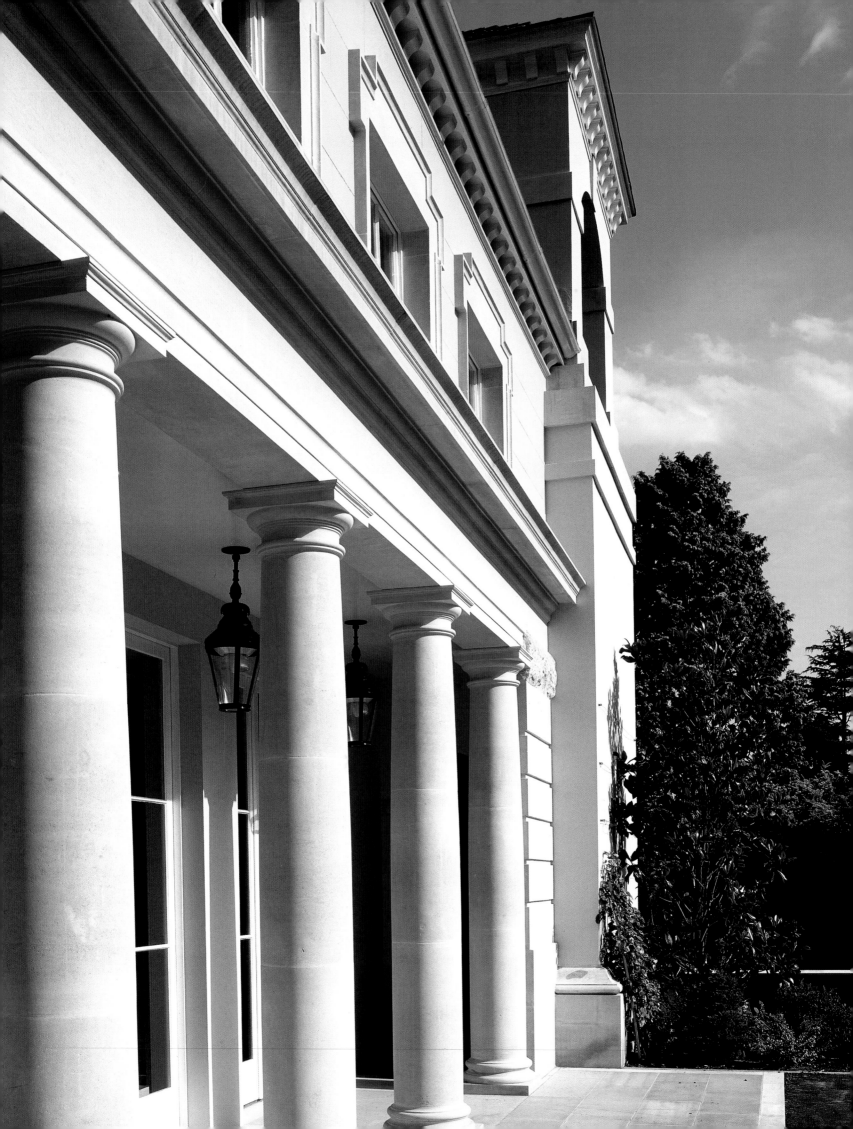

RESIDENTIAL COMMISSIONS

Portico for New House in Belgravia, London
Left: New colonnade at Buckhurst Park at Ascot in Berkshire

Most architectural practices specializing in classical work in the latter half of the twentieth century depended for their survival on residential commissions; one thinks, for instance, of Raymond Erith or Francis Johnson. Considering that John Simpson has been in practice for more than two decades it is unusual that he has undertaken relatively little residential work concentrating instead on public buildings, major commercial developments and urban design. His major undertaking in the domestic arena, Ashfold House, is discussed below, but it is also worth mentioning the other projects illustrated here. Simpson was commissioned by Her Majesty Queen Noor of Jordan to extend and remodel a substantial house near Ascot, Berkshire, Buckhurst Park. Queen Noor is, of course, unusual amongst royal architectural patrons in that she studied architecture and planning at university, receiving a bachelor's degree in the subject from Princeton in 1974.

Buckhurst Park is a stucco-fronted Italianate house that was much altered in a variety of styles during the later nineteenth century. Simpson added two large wings to the house: a two-storey extension at the front which comes forward to frame an entrance court with a colonnaded loggia on the ground floor. This wing is terminated by an ashlar tower that houses a staircase running down to service areas at garden level. The second wing extends the whole width of the house on the other side. Towards the forecourt it presents a powerfully-modelled façade in a language indebted to C.R. Cockerell, featuring an arch rising up into the pediment above. At the rear it ends in a great curving bay with three windows that overlook the garden. Behind these are new reception rooms, including a drawing room in which the plasterwork of the ceiling cleverly combines classical and Islamic details in a single coherent design.

Simpson's proven ability to work sensitively with existing historic structures led to a commission to extend and refurbish a major house in Oxfordshire, Thame Park. This Palladian country house, designated Grade I by English Heritage with a Grade II★ listed eighteenth-century park, is the culmination of a complex building history dating back to 1138 when a Cistercian monastery was founded on the site. After languishing for eighteen years in the hands of absentee owners, Thame Park was sold in 2000 to a purchaser who intends to restore and enlarge it as a private residence.

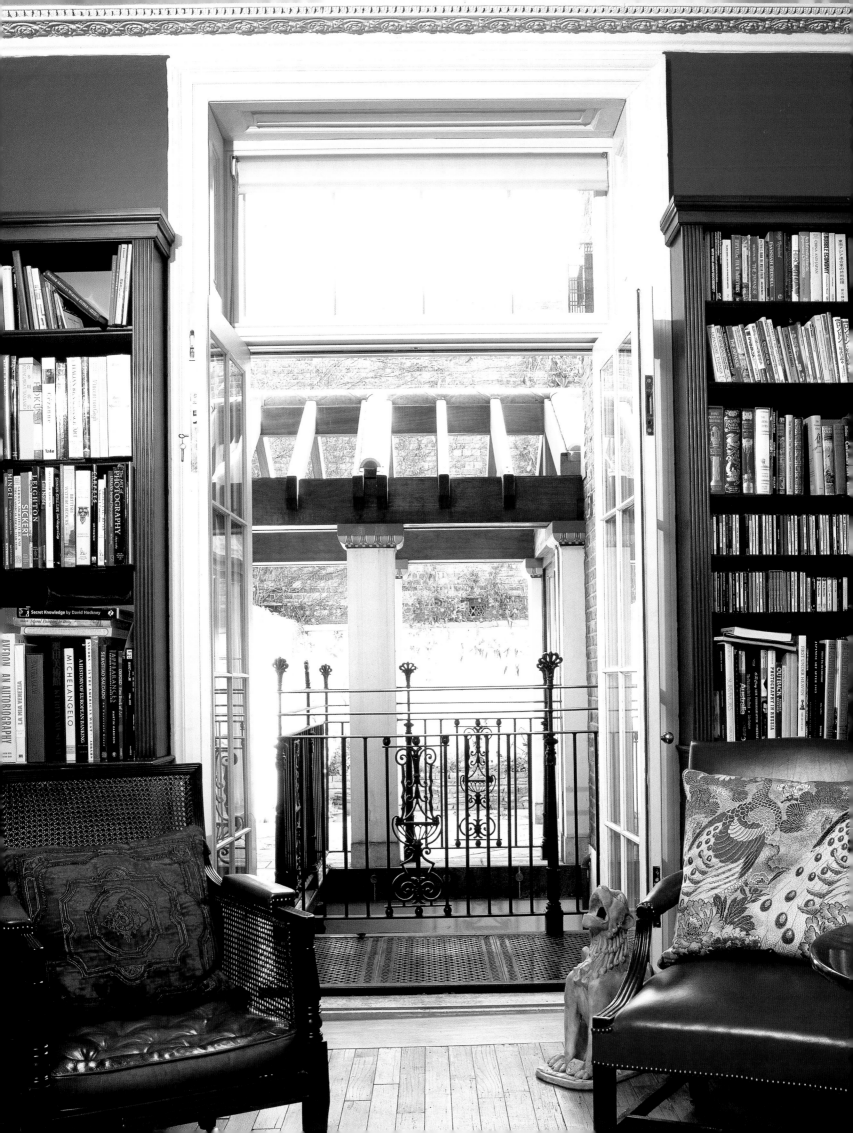

ASHFOLD HOUSE
SUSSEX

Ashfold House, though the work of a young architect, has a remarkable consistency of aim, displaying all the hallmarks of John Simpson's mature work: the combination of spatial poetry with minute attention to detail in which not even the design of a light-switch is overlooked. It demonstrates his recognition that the incorporation of modern technology need not have any visual effects, for architecture is not truth: it involves the creation of beauty in which concealment and surprise can be as valuable as "honesty." Ashfold was designed by John Simpson, for his parents, John and Lydia, John Simpson senior being himself an architect. "My parents wanted a house that would be easy to maintain," John explained, adding, "Not so daunting a commission. Nobly, they left the great intangibles of space and proportion to me. My main objective was to give an impression that it is larger than the basic two-and-a-half-thousand square feet. Space is the most elusive of all architectural illusions."

To anyone familiar with the history of English architecture, the springs of inspiration for this house will be recognised as lying in the work of John Soane: the north entrance front of Ashfold distantly echoes the entrance front of Soane's country house, Pitzhanger Manor, Ealing, of 1800-03, while the south front recalls the entrance front of Soane's house and museum of 1812 at 13, Lincoln's Inn Fields. As we noted in the Introduction, Simpson's kinship with Soane must go some way to explaining the essence of his approach to architecture. Soane, who stood at the cusp of classicism and the modern world, despised modern architecture for what he condemned as its visual poverty, its crude, commercially-driven materialism. Simpson shares this outlook so that his constant ambition, like Soane's, is to create "the poetry of architecture." For both, this is inseparable from the knowledge and practice of classical architecture. Soane saw architecture as a hierarchy which ran from the primitive hut and the simple vernacular architecture in which he excelled, to the most sumptuous public buildings in the classical style. "Art," Soane memorably declared in his Royal Academy lectures, "cannot go beyond the Corinthian order." But it was a hierarchy of which neither end could be appreciated without awareness of the existence of the other. Thus, the simple stripped classicism of Soane's most modest works only has meaning when set against the richness of the full deployment of the classical orders in his more ambitious commissions.

Soane was at the same time a child of his time in that he exploited new developments in technology as much as possible. In parts of his own house in Lincoln's Inn Fields, he used the most up-to-date forms of central heating then available so as to abolish solid walls and chimney-pieces with the aim of allowing space to flow freely. Ashfold exploits the surer heating methods of the modern world so as to place an open hall, rising the full height of the house, at the heart of the building. This is not sealed off by solid walls from the rest of the house; and nor is there any need to provide buffer zones against draughts in the form of subsidiary lobbies. A German system of underfloor heating, with a heat recovery boiler, makes unsightly radiators unnecessary.

The hall at the centre of Ashfold, lit by a glazed circular dome, recalls the top-lit tribunes that Soane placed in similar positions, such the one at Tyringham Hall, Buckinghamshire, of 1793-1800, now destroyed. The hall or tribune at Ashfold has a generous arch on each side of wood painted and detailed to resemble horizontally-channelled stone rustication, a device Simpson borrowed from Sir Robert Taylor whose work Soane remodelled at the Bank of England. One of these arches provides a dramatic frame for the staircase, the approach to which contains slim jib doors on either side to conceal the entrances to a bathroom and the kitchen.

As we mount the stairs we can look down from the half-landing into the breakfast room, ingeniously contrived out of little more than the space provided by a massive semicircular bay window on the east front. This kind of spatial complexity is unusual in modern classical houses, yet it is here that we should recall the comparatively modest dimensions of Ashfold. Simpson explains that, "Smallness of size tends to concentrate the mind to some extent." He believes that, "On a big building, there would have been less justification for playing the kind of tricks we did at Ashfold." One of the most thrilling of the "tricks" at Ashfold is the way in which space flows in all directions from galleries round the upper storey of the hall. Here, each side of the gallery features in its lower part a bookcase disguised on its outer front as a sarcophagus with inverted Michelangelesque volutes, flanked by Soanean piers surmounted by acroteria. Above these we can look out to the pastoral Sussex landscape in which the house is set. Simpson explains, "I wanted to build up a series of views within the house to add to the illusion of space." In fact, he developed the techniques of Regency Picturesque architects who planned the interiors of a house in the same way as landscape designers might plan the surrounding park. That this was Soane's practice is confirmed by the fact that his friend, John Britton, perceptively prefaced the book which he published in 1827 on Soane's house and museum in Lincoln's Inn Fields with the advice on garden

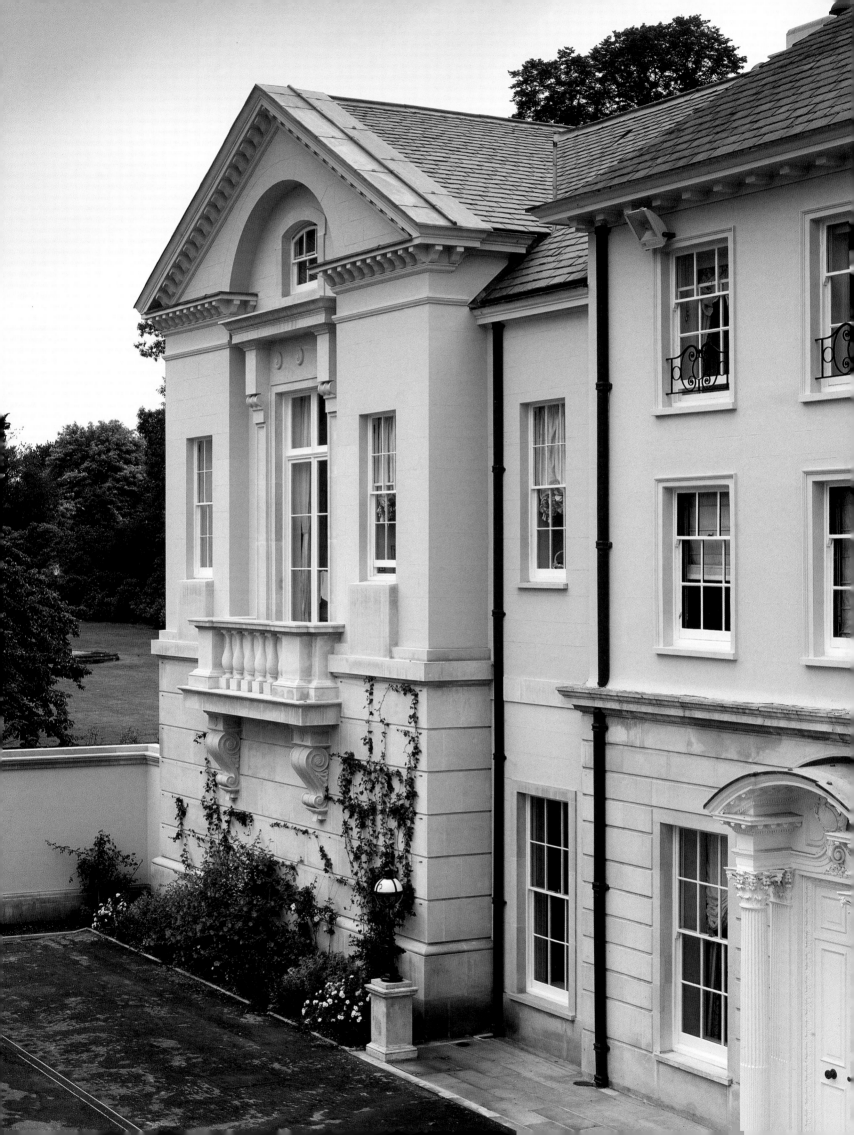

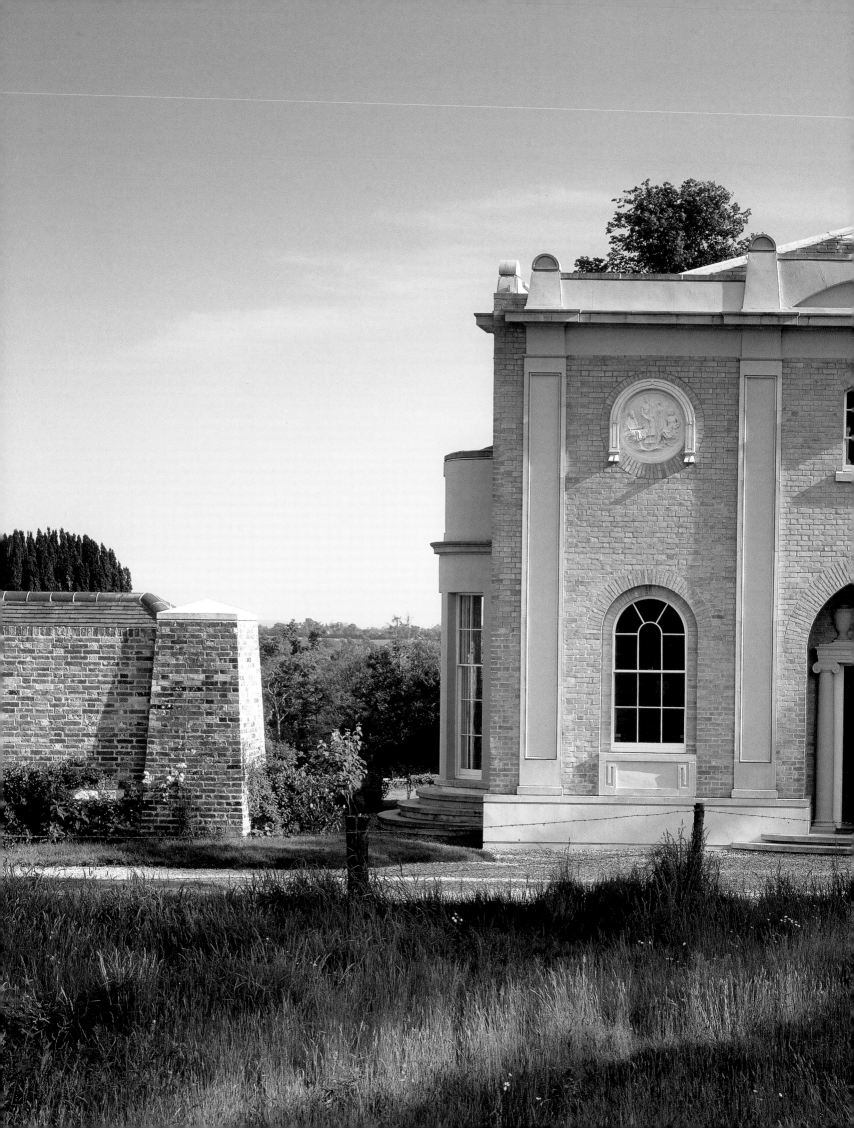

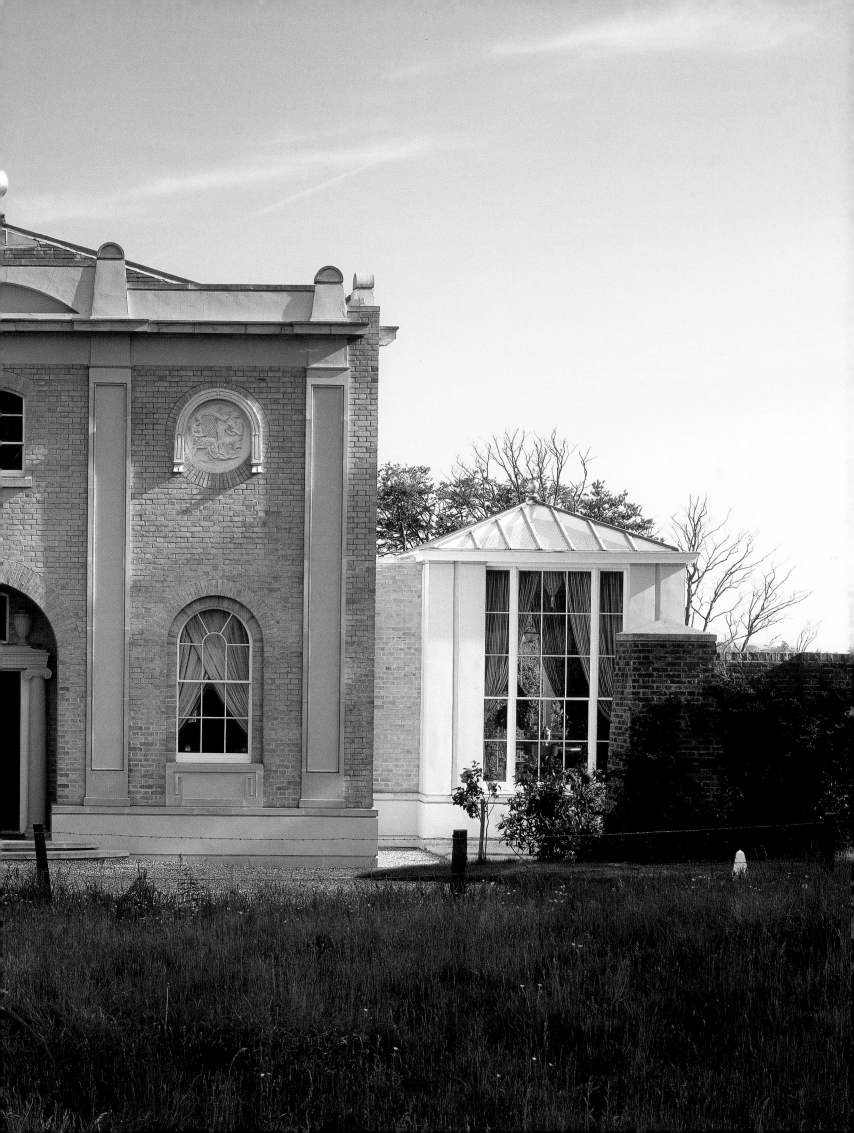

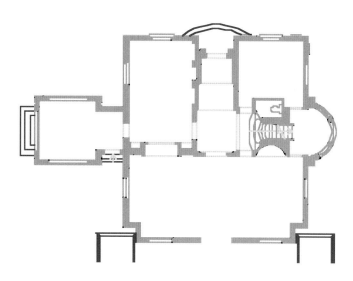

Ground floor plan of Ashfold
Right: View looking into hall from library at first floor level
Overleaf left: Staircase up to first floor
Overleaf right: View looking across upper level of hall into library on first floor

design that Alexander Pope gave to Lord Burlington: "Let not each beauty ev'rywhere be spied when half the skill is decently to hide. He gains all points who pleasingly confounds, surprises, varies and conceals the bounds."

The views throughout this house do, indeed, provide endless unexpected surprises and contrasts. From the front door, an arch frames the hall up a short flight of steps, while a further arch leads axially to the drawing room, its own arched windows leading to the garden: all this can be comprehended from the moment we enter the house. The axis at right angles contains the staircase which leads to the gallery from which can be approached a bedroom in each corner of the house. At every level the various parts of the house fit satisfyingly together like the most skilful piece of clockwork.

The drawing room, occupying the whole of the south front on the ground floor, is flooded with light from windows on three sides, those on the garden front featuring the arched forms which recur throughout the house. Ceilings, so often forgotten by modern architects, are everywhere worthy of attention at Ashfold. Here, the cornice, made up in situ like those throughout the house, consists of the running beads, seemingly invented by Soane in the drawing room of his house in 12, Lincoln's Fields, in 1792. The large size of the Ashfold drawing room enables it to fill several functions so that it is divided into three areas, each appropriately emphasised by the ceiling mouldings At the end nearest to the kitchen is a dining table; a sofa and chaise longue occupy the centre; while a grand piano faces the door to the sitting room.

Simpson explains that modern heating arrangements make more practical the Regency love of windows that reach down to the

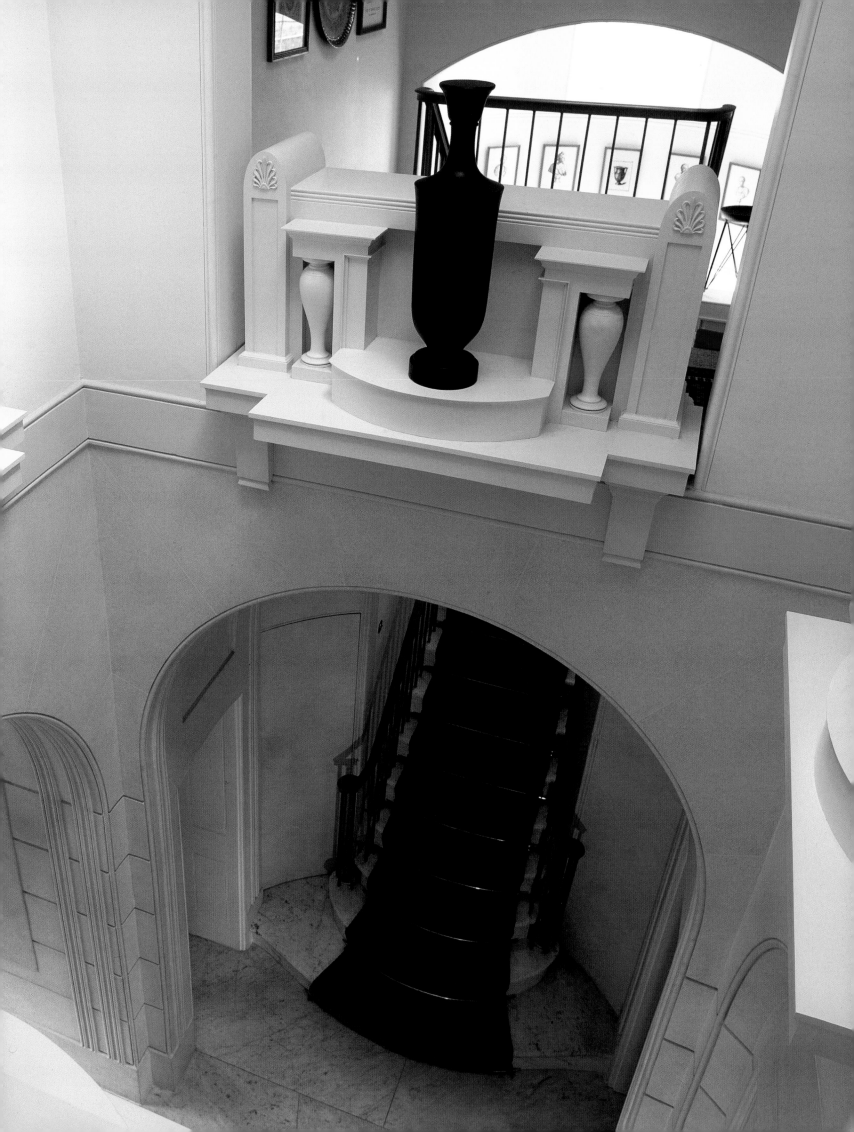

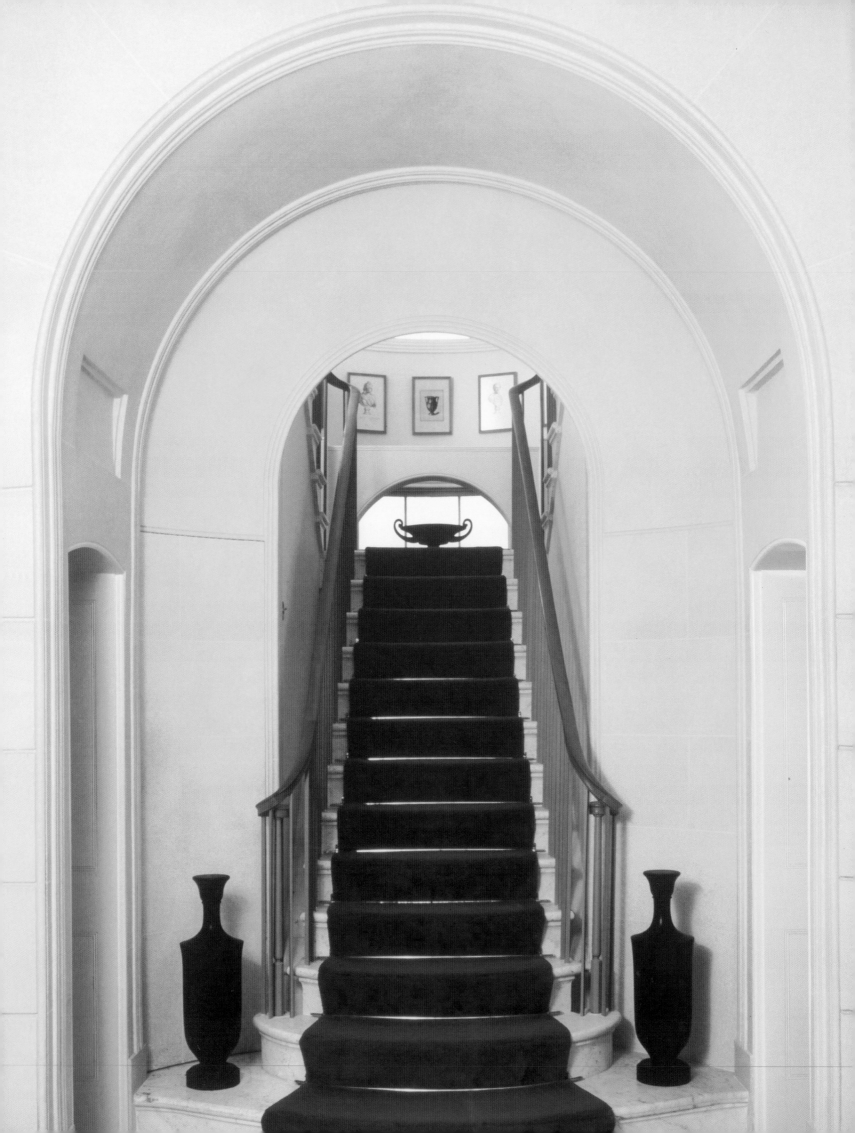

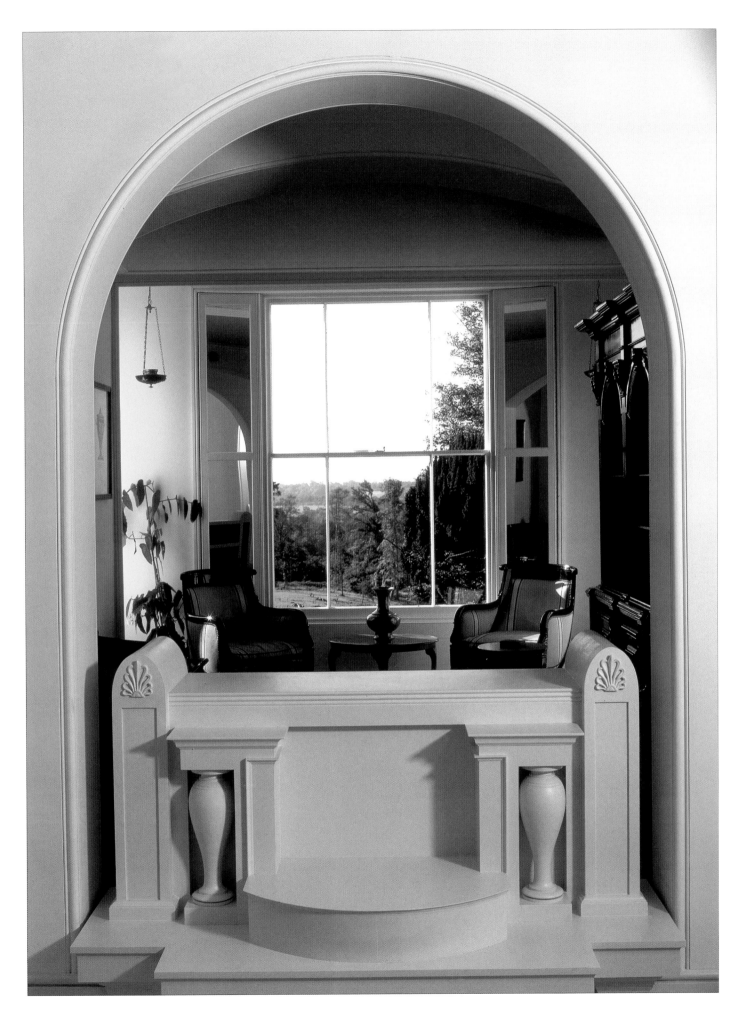

floor. The shutters in the drawing room fold back not into the window embrasure, as in conventional shutters, but into the wall on either side of the window. The side curtains are actually attached to the shutters and move with them. Further ingenuity appears in the sitting room where the handsome chimney piece is flanked by sarcophagus-like cupboards which contain video and television equipment. Even in the kitchen, all the labour-saving high-tech devices are concealed within massive handsome cupboards, articulated with Doric columns.

The house is built throughout from soft ochre handmade bricks from Lincolnshire, with each of the four facades treated differently. This variety is a Picturesque practice as exploited, for example, by James Wyatt at Dodington Park, near Bath, in 1798-1813. The north front has the triumphal arch theme of Pitzhanger; the east front is dominated by a commanding, centrally-placed glazed bow; the south front breaks forward in a slight projection which is faced in stucco stencilled with polychromatic classical decorations; while from the west front projects a large conservatory containing handsome furniture designed by Simpson along lines inspired by Thomas Hope. Since Simpson gave the detailing of the interiors a pared-down character similar to much of the work of Soane, he felt that classical furniture of a fairly emphatic quality would be required. As he could find nothing quite appropriate in shops, he became a furniture designer himself. He recalled that, "It required an entirely different range of knowledge, but once I'd crashed through that barrier I found it immensely rewarding to extend myself beyond the field of architecture."

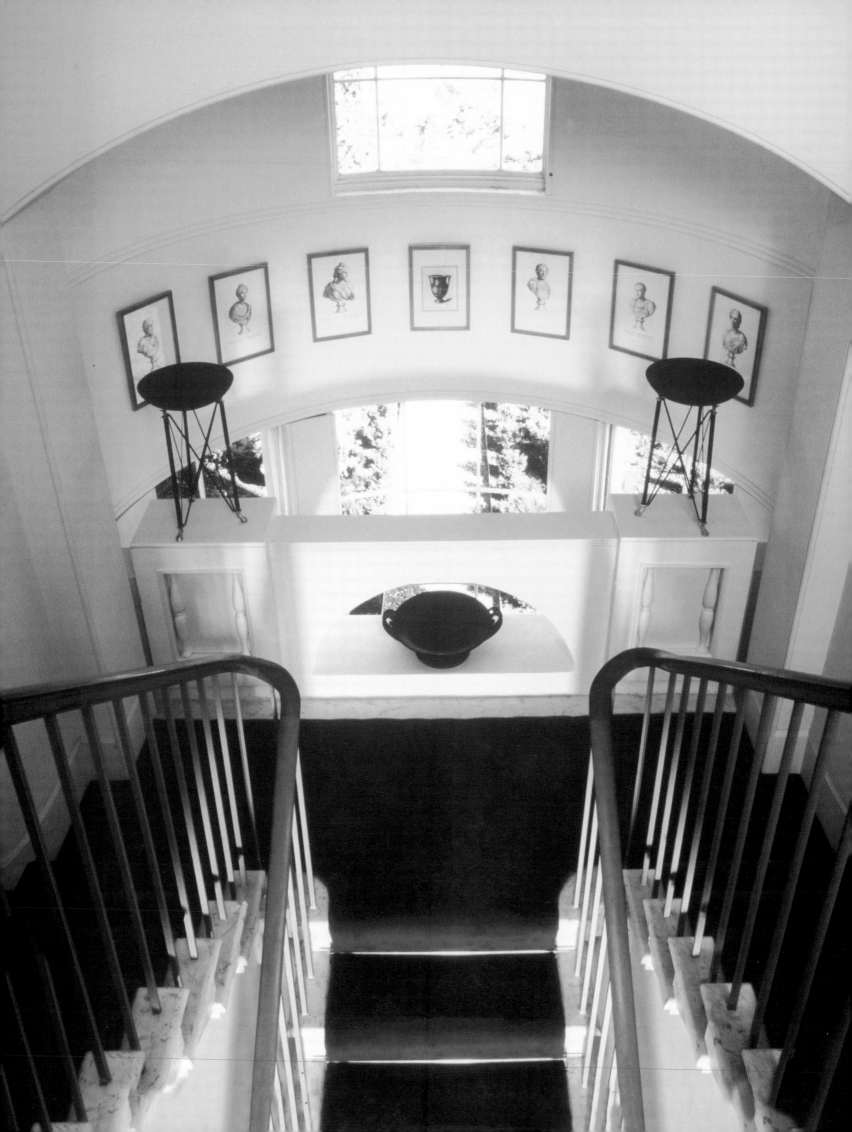

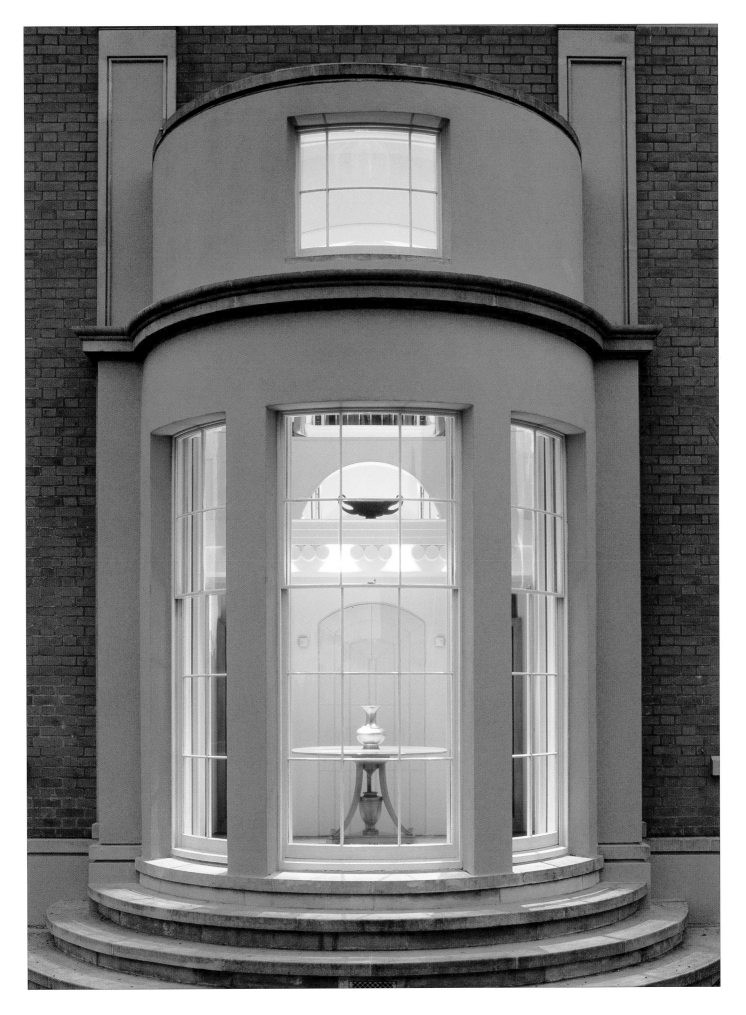

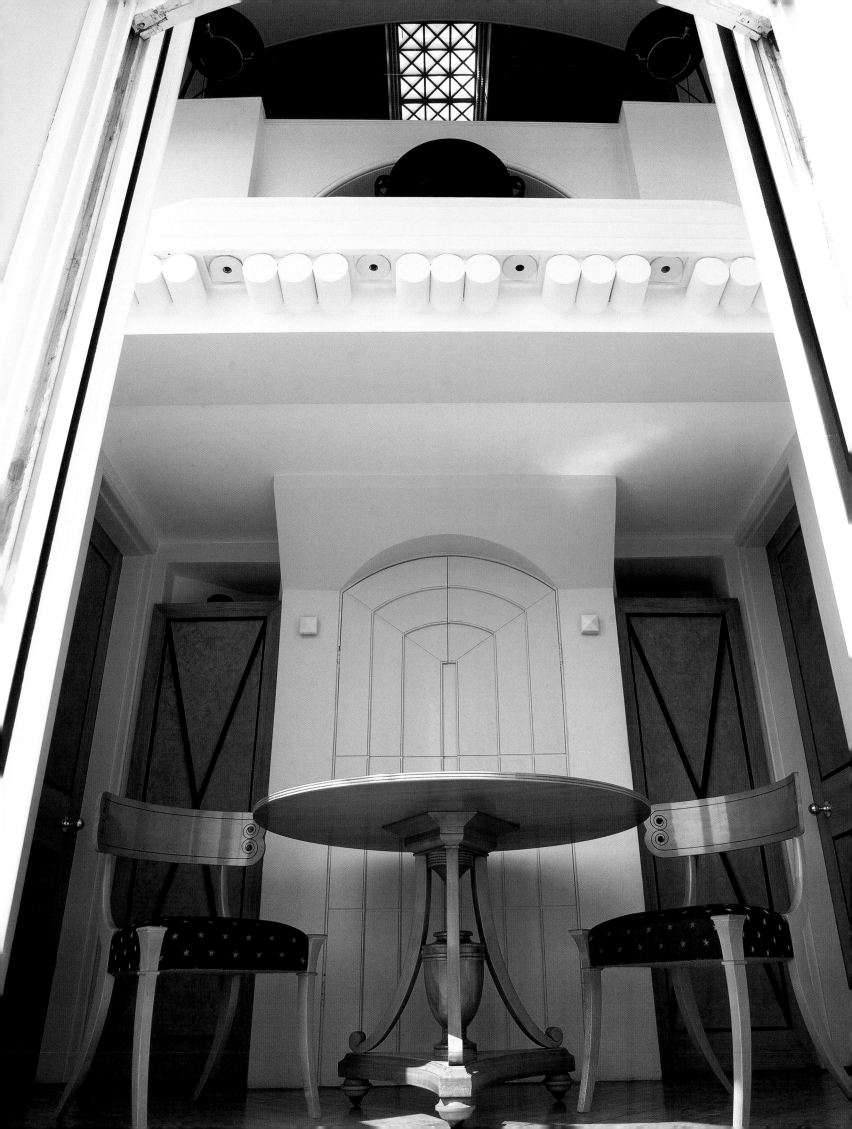

INTERIORS AND FURNITURE

Ceiling detail Ashfold
Left: Chairs and table designed for the breakfast room at Ashfold

In the history of western architecture few architects have paid as much attention to the design of furniture and interior fittings for their buildings as to the buildings themselves. In the eighteenth century one thinks of Robert Adam, every aspect of whose interiors, from the simplest hall chair to the carpet for a long gallery, is imbued with his distinctive and much-aped style. In the twentieth century Frank Lloyd Wright would often design furniture and stained glass according to the same geometrical module as the whole building, as in his hexagonally-inspired Hanna Residence in Palo Alto, California. Today architects who have the ability and dedication to create such *Gesamtkunstwerke* are indeed rare, but Simpson belongs to this elite group on account of the painstaking care with which he designs every last detail of a commission. No object or function is too humble or insignificant for his attention, the focus of which ranges from light switches and motion sensors to passenger lifts.

In designing interiors Simpson employs to the full the special capacity of the classical tradition to accommodate new technology in forms dating back millennia. Thus all the industrially-designed paraphernalia that threatens to submerge the modern interior can be incorporated harmoniously into the overall design, so that, for instance, exit signs and smoke detectors can be concealed behind guilloche panels and in elegant wall sconces. It would be too simple, however, to suggest that Simpson's artistry is solely concerned with concealment, because in many ways he is celebrating these technological devices by giving them proper architectural form. Certainly anyone who has felt the joy and exhilaration of travelling a Simpson-designed lift will wonder why every other lift is no more than a banal industrial product to be used but not enjoyed.

Perhaps the most unusual example of his celebration of the mundane is the hot food serving counter in the Fellows' Dining Room at Caius College, Cambridge. Here Simpson sets the heated unit within a Corian carapace which is inspired by the ancient Roman sarcophagus of L. Cornelius Scipio Barbatus, discovered on the Appian Way in 1782 and removed to the Vatican. The Dupont Company, the makers of Corian, believe this to be one of the most ambitious architectural applications of their product and have had the piece specially photographed. This interior, as has already been described, includes other unusual examples of the classical tradition applied to objects normally given no consideration

by architects. A screen which allows the serving area to be divided off from the main room is given the form of a Roman transenna, each vertical panel being separated from the next by a bundle of rods enclosing a spear, a variation on the Fasces, the ancient Roman symbol of authority. In this room we also find an updated form of one of the most distinctive pieces of furniture from antiquity, the ancient Greek Klismos chair, familiar from innumerable vase paintings and surviving marble examples in theatres. To enable the room to be reconfigured for a variety of events Simpson developed a unique stackable version of the Klismos chair, proving that functionality and beauty need not be incompatible.

Simpson's ability to work at every imaginable scale means that even a small residential extension is given a nobility which belies its size. In Doughty Street, Bloomsbury, he added a single-storey pavilion to the rear of an eighteenth-century terraced house to extend the kitchen with a conservatory and create a garden room. The addition, which stretches the whole width of the house, is mostly glazed. The large wooden beams supporting the glass roof rest on simple square piers with polychromatic capitals so that the whole reads as an interpretation of the primitive hut, the notional origin of a trabeated architecture. In contrast to the massive framework , Simpson uses exquisitely turned colonettes and delicate classical details for the kitchen cabinets as he had done at Ashfold.

The application of architectural forms to cabinet work can also be seen in commercial projects. The proprietors of an optician's shop, Hawkes and Wainer, in Leadenhall Market saw a proposal by Simpson for a large-scale development adjacent to the market and were so impressed that they commissioned him to redesign the interior of their shop in a classical idiom. In consideration of the shop's location in the City, Simpson chose a dark mahogany for the joinery in reference to the paneled interiors of the local livery halls and City churches. However, for the design of the cabinet work, he turned not to an English model, but to France of the Napoleonic period and in particular to the strikingly architectural furniture designs of Percier and Fontaine. Thus the main space of the shop is flanked on either side by a sequence of architectural display cases terminated by small glazed pavilions, reminiscent of Giles Gilbert Scott's telephone kiosks. These cases are capped by an entablature carried not by conventional columns but by a series of paired herms that also support the shelves on which spectacles are displayed. The pairs of herms are placed back to back perpendicularly to the shelves so that one faces into the shop and the other faces out through the window. At intervals there are mirrors framed by slender colonnettes. At the rear of the shop running its full width is a mahogany serving counter flanked at either end by large inverted consoles. Behind this rises a large, freestanding

View looking through the archway between the drawing room and dining room at Belsize Park, London

rusticated arch with a cornice. Here, Simpson employs his usual sleight of hand to take advantage of the double height space of the shop and conceal within the upper portion of the arch a mezzanine floor containing a small office for accounts and record storage. Below, within the deep arch itself there are rows of small drawers following the pattern of the rustication. The overall result of designing all the disparate parts of the brief as freestanding architectural elements rather than the conventional solution of dividing up the space with partitions, is that it remains a light and spacious environment where the full height of the interior can be appreciated. In contrast to the high seriousness of the empire style, Simpson indulges in a little humour with a niche which can be seen through the shop window from outside: framed within is a single Ionic column where the volutes of the capital have been replaced by a pair of spectacles. This figural transformation, though in jest, has distinguished precedents in the ammonite Ionic capitals of Amon Henry Wilds at Brighton in the 1820s, and the tobacco leaf Corinthian capitals of Benjamin Latrobe at the Capitol, Washington, of 1815.

HOUSE IN BELSIZE PARK
LONDON

John Simpson and his wife Erica bought an apartment occupying the piano nobile of this nineteenth-century semi-detached house in January 1989. While the principal floor was of noble proportions, its interiors had been subjected to the typical modern flat conversion in which all decorative features and cornices were removed. The main reception spaces had been further degraded by being divided up into smaller rooms. However, Simpson's inventive ability to manipulate space enabled him to reinstate the two principal rooms while at the same time carving out between them a two-storey transversely-arranged functional spine housing kitchen, bathroom, closet and mezzanine study-bedroom all entered through concealed gib doors. The creation of this double-storey arrangement was handled particularly cleverly by dovetailing the kitchen, closet and mezzanine study-bedroom together, so that the platform for the bed and the built-in desk were above full-height spaces below. The wardrobe features an electric rotating clothes rail so that its contents can be accessed without walking in thus allowing a low ceiling and enabling the bedroom above to have a full-height ceiling where needed. This creative use of borrowed space, reminiscent of the sandwiched layout of experimental apartments in Tokyo, should be more widely imitated for it contains more elegant and functional space than at first seems possible.

As at Ashfold, the ugliness of conventional wall-mounted radiators is everywhere avoided. Here they are concealed in both the

View showing sofa and cabinets designed for the drawing room at Belsize Park, London

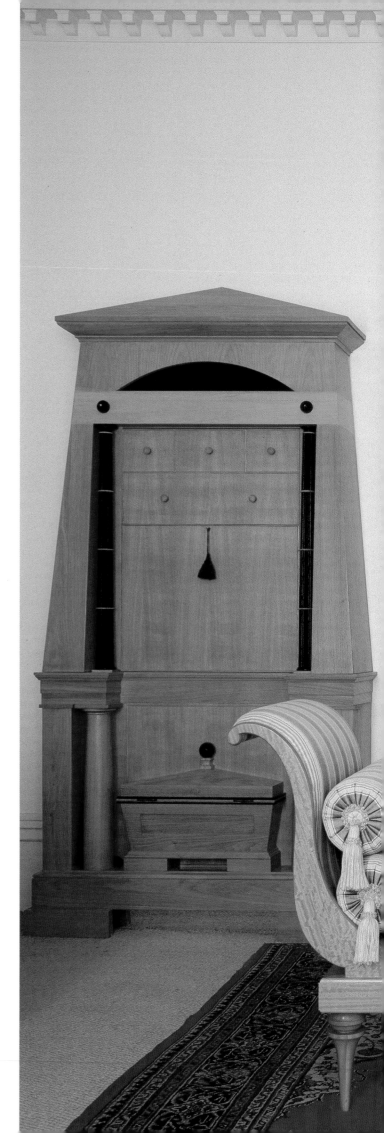

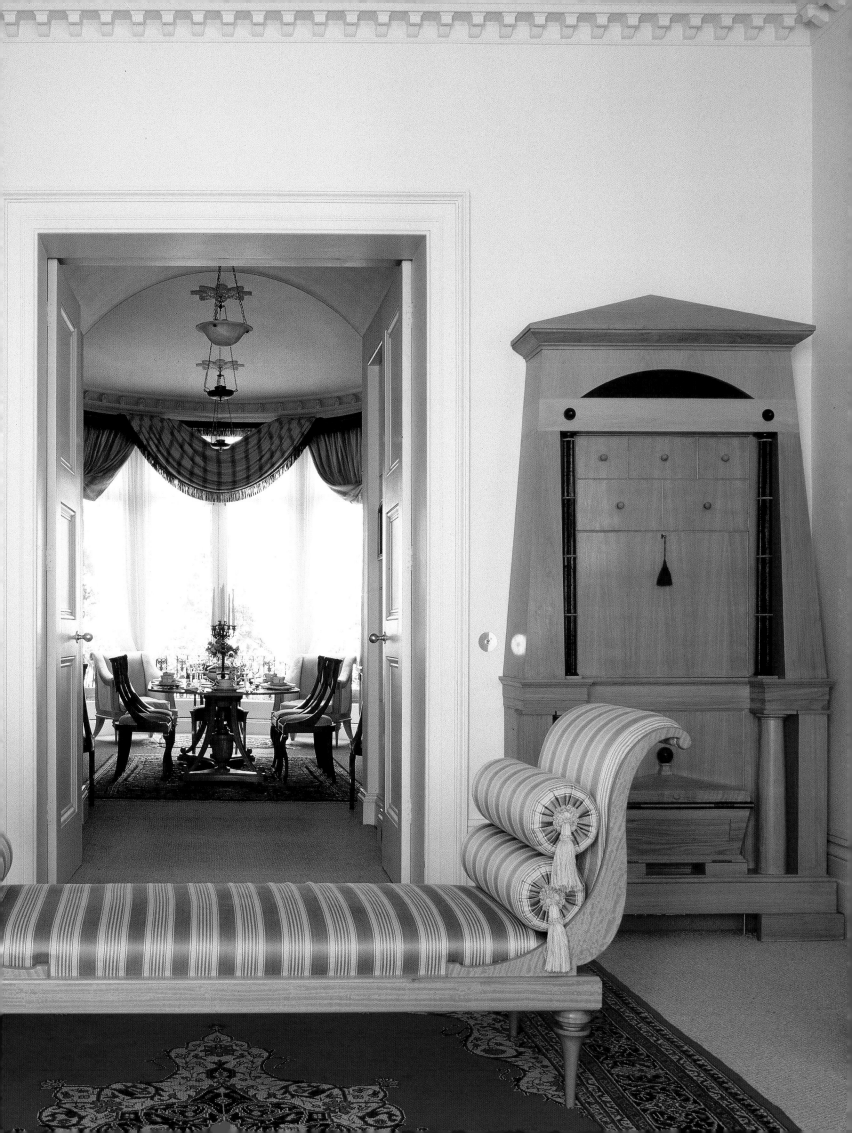

Top left: Welsh Dresser designed for the kitchen at Ashfold House,
Top right: Furniture details of sofa and side table at Belsize Park, London
Bottom left: Stacking Klismos chairs designed for the Fellows' dining room at Gonville and Caius College, Cambridge
Bottom right: Chair back and bronze bust details of table leg in the Fellows' dining room at Gonville and Caius College, Cambridge
Left: Bed designed for guest bedroom at Ashfold House, Sussex

Above and right: Cabinet, armchair, table and carpet designed for the Lord Colyton Room at Gonville and Caius College, Cambridge
Overleaf left: Display cabinets at Hawkes and Wainer Opticians, London
Overleaf right: View of the counter and arch with mezzaine level above, at Hawkes and Wainer Opticians, London

reception rooms within free-standing pedestals on which stand handsome neo-antique tripods which serve to deflect the warm air outwards into the room as it rises. The fire-alarm sensors are cunningly concealed within elegant lamps on either side of the main window. Even more ingenious are the multi-functional pair of Biedermeier-inspired oak cabinets that appear to be "secrétaires à abattant." One in fact conceals a hatch into the kitchen behind its fall-front upper panel, and unexpectedly accommodates a dishwasher in its base. The other contains a drinks cabinet above and a china cupboard below. Both contain a secret compartment in the sarcophagus-shaped base and are crowned by an arched lunette containing a loudspeaker. The stereo equipment for this is concealed in yet another ambitious cupboard in the dining room which also serves as desk and drawers. This is flanked by Doric columns and is surmounted by a pediment, while the drawers are treated as horizontally-channelled rustication, so that it is one of the most powerful and architecturally conceived pieces of modern furniture. The concealment of these functions has a precedent in Georgian dining room furniture where elaborate urns on pedestals, while appearing purely decorative would often be ingeniously

functional, hiding knife boxes, plate warming compartments, and even water dispensing devices to allow cutlery to be rinsed without returning to the kitchen. The architectural theme of this cabinet is continued in the dining room by Simpson's striking serving table of birds-eye maple, flanked by ebonized Ionic columns with sides forming arches which frame ebonized urns.

In the drawing room, also from Simpson's design. are the Recamier sofas and a handsome chimney-piece of Sicilian marble flanked by his favourite Michelangelesque consoles. Tall corner cupboards in the principal bedroom also serve a double purpose, since warm air emerges from the Diocletian window openings which surmount them. The small entrance hall is rendered powerful through its rusticated walls and Doric bucrania frieze, concealing cupboards.

The lesson of these delightful and entertaining interiors is that the classical language, far from being a hindrance to functional and economical design, as modernists have long argued, offers many practical devices for the manipulation of confined spaces on a budget so as to produce beauty, dignity, and charm, with the ungainliness of necessary technology cunningly concealed.

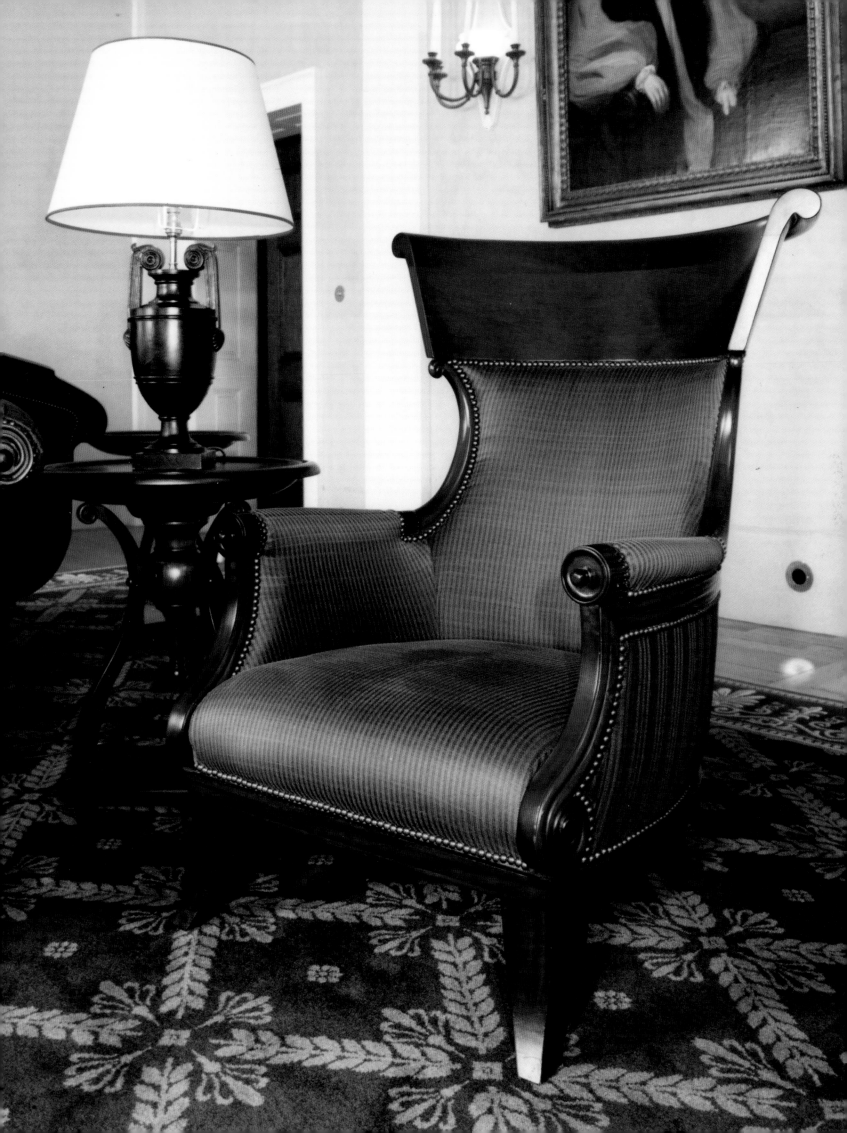

TEACHING

Frontispiece of Marc Antoine Laugier, Essai sur l'architecture, *Paris 1755*
Left: The Pipistrelle Pavilion, Barnes, London

For several years during the 1990s Simpson was one of the primary guest tutors at a short-lived but influential architectural school set up by the Prince of Wales. During its heyday the curriculum of the Prince of Wales's Institute of Architecture uniquely combined an Arts and Crafts-based approach with the rigorous teaching of classicism. In 1995 Simpson was able to bring these two threads together in a single exercise: the annual "design and build" project in which students on the school's Foundation course would develop a design for a small timber structure and then construct it themselves.

THE PIPISTRELLE PAVILION
LONDON

Under Simpson's direction they created an enchanting Doric pavilion on the edge of a pond at the site of a former waterworks at Barn Elms, just south of Hammersmith Bridge. This was built by students in the space of a month. The combination of fantasy and efficiency, with its royal flavour, recalls the construction in just sixty-four days in 1777 of the château of Bagatelle in the Bois de

Boulogne in Paris, as the result of a celebrated wager between the Comte d'Artois and his sister-in-law, Marie-Antoinette.

As a pleasure pavilion, or garden folly, the Barn Elms pavilion is an intriguing combination of light-heartedness and seriousness, for the brief given to the students was to "develop an appreciation of the relationship between construction and architectural detail, using the project to investigate the origin of the European classical tradition in architecture." The implication of this rather cryptic phrase was that the students were expected to explore the practical ramifications of Vitruvius's claim that the stone or marble forms of the Doric order derived from timber construction.

The students were confronted with yet another unusual task. This was to provide a structure roofed in such a way as to provide a shelter for a local colony of Pipistrelle bats. The reason for this is that the pond at Barnes is part of an SSSI (Site of Special Scientific Interest) with unusual ecological value as a habitat for flora and fauna. There was evidence, in particular, that the bat colony had made its home in the nearby Primary Filter Building, which was to be demolished as part of a residential development to the north of the site. The pavilion was itself to be in harmony with nature in

that its materials were to originate in, or be recycled from, environmentally sustainable sources, with its timber being carefully chosen to ensure that harmful chemicals would not leach into the pond. The students were also told that the pavilion would act as a viewing platform for the wider landscape of an associated "Wildlife Corridor" at the heart of which would be a hundred-acre conservation area to the south of the pond. Its design would thus need to anticipate those works as well as relate in size and scale to the proposed new houses to the north of the pond. These houses were to be built by Berkeley Homes (Thames Valley) Ltd., from designs by John Thompson & Partners.

The origin of this unusual project for a pond-side pavilion lay with Berkeley Homes who provided the timber sections from which the pavilion is constructed, and gave the students a list of the sizes of timber available. They recommended the use of all-timber jointing as well as the use of hemp rope as binding or as part of the detailing. The building was to incorporate a roof using slates salvaged from the demolished Primary Filter Building. The Bat Conservation Trust provided the students with detailed notes on the requirements of the Pipistrelle bat, such as the need for insulation, and on the placing of access holes to the loft. These should not be placed in sight of street-lights or house lights; nor should they be near doors and windows since droppings accumulate below access points. Bats, but not birds, the students were told, will go through a U-shaped tube.

The pavilion was to be constructed during March, since that month falls between the hibernation period of the bat and the breeding period which runs from April to September. The students at the Prince of Wales's Institute of Architecture were introduced to the task on 27 February in a lecture by John Simpson who directed the project throughout. Beginning the task of designing the pavilion on the same day, the twenty students worked day and night until each had produced a scale model of his or her project by 6 March. On that day the students presented their schemes at a "design crit" to a jury of sixteen which included not only Dr Richard John, the Director of the Prince of Wales's Institute of Architecture, but also outside representatives from Berkeley Homes, John Thompson & Partners, Cobham Resources Consultants, the Bat Conservation Trust, the Wildfowl and Wetlands Trust, and Dr David Watkin from Cambridge University. Despite their wide variety of backgrounds, the members of the jury were unanimous in preferring the solution proposed in two similar schemes by Tamsin Ford and Cosimo Sesti.

In their unusual information pack, the students not only found instructions from Berkeley Homes and the Bat Conservation Trust, but three pages from Vitruvius's *Ten Books on Architecture*, the only architectural treatise to survive from the ancient world. Vitruvius described how the main roof beams rest on columns, pilasters and antae, with tie-beams and rafters incorporated into the framing. Summing up the relation of roof tiles, rafters, and purlins, he boasted that "Each and every detail has a place, origin and order of its own." He claimed that carpenters in the earliest periods of the history of temple construction had fastened boards on to the ends of the beams in order to tidy them up after they had been sawn off. He went on to suggest that these boards were the origin of the stone triglyphs in the frieze of the Doric order. Similarly, the mutules in the Doric order represented, for Vitruvius, the projections of the principal rafters. All of these ideas were incorporated by the students in their detailing of the final design.

This extended passage in Vitruvius has fascinated architects and architectural theorists since the Renaissance. The Abbé Laugier in his influential book of 1753, *Essai sur l'architecture*, devised a whole programme for architectural reform based on his ideal vision of a primitive hut as the origin of all architecture. Sir John Soane, who shared the Enlightenment preoccupation with the return to first principles and primary causes, was greatly influenced by Laugier's reductionist theories and developed the analogy further in 1807 when, seeing reeds growing near Stowe, tied together with strings, it occurred to him that here was the origin of the column. He also wondered whether these strings found an echo in stone in the incised lines or grooves, known as the hypotrachelium, which feature below the capital in the Greek Doric column.

Aware of this suggestive passage in Soane's unpublished papers, Simpson passed the concept on to the students, so that it emerged clearly in the chosen designs. Thus, the wooden columns are composed of thin round poles encircling a solid core so as to resemble bundles of reeds. Reeds also seemed appropriate for a building that projects out, on a platform, over a body of water. Between the columns a low protective screen was designed from panels of woven hemp rope. This practice accords with the theories of the German architect, Gottfried Semper (1803-79), for whom weaving, moulding, building in stone and building in timber, formed the four elements of the original house. The wall was thus in origin a woven bamboo mat or fence serving as a space divider or wall.

The Barn Elms pavilion embodied many of the ideals of the Prince of Wales's Institute of Architecture: it was visually beautiful and intellectually satisfying; it was in harmony with its setting, and environmentally appropriate. Though modern, it had historical resonances, for it served aesthetic and well as functional purposes. It was also the perfect expression of the dictum of Léon Krier, master-planner of Poundbury, that "Architecture can express nothing else but its own constructive logic; meaning its origin in the laws of nature and human labour and intelligence."

Right: Detail showing rope column capitals and timber entablature with pegged timber joints

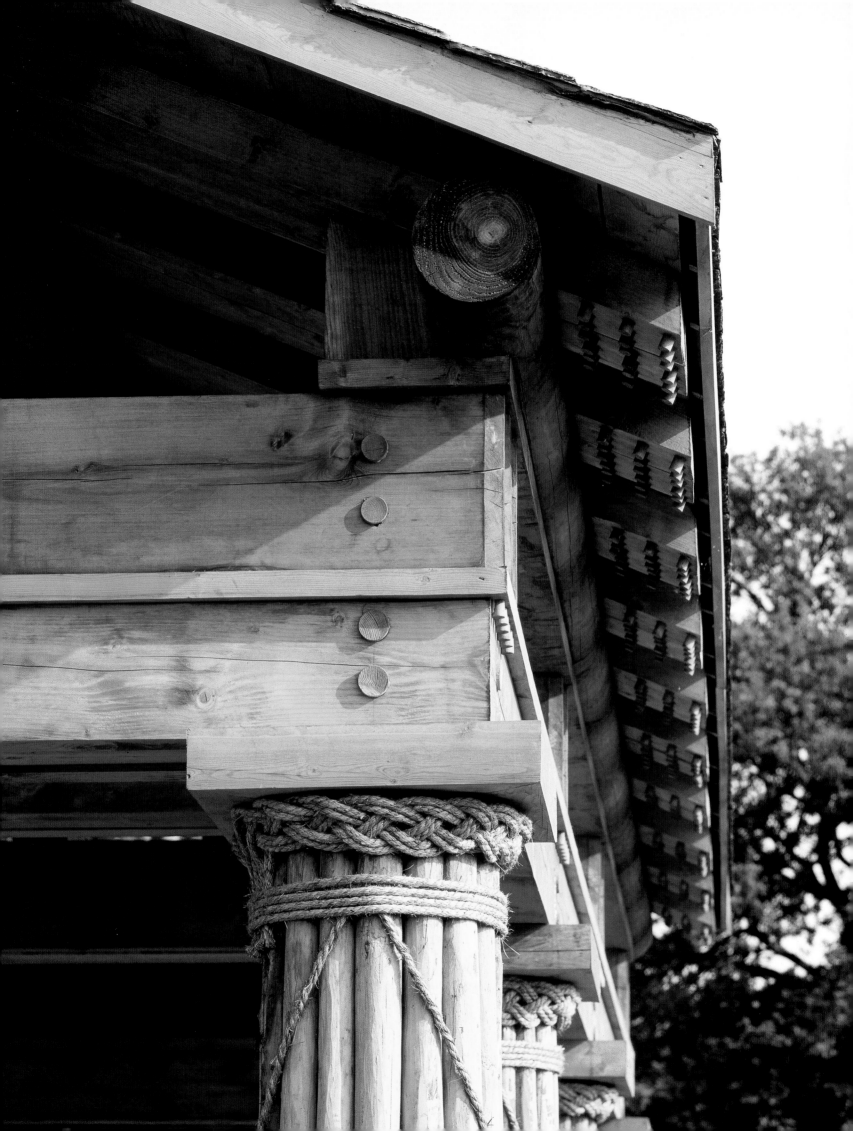

BIBLIOGRAPHY

Amery, Colin, "In the shadow of St Paul's," (Paternoster Square), *Financial Times* (London), June 13, 1988, p. 21.

Aslet, Clive, "Re-thinking the Village," (Coldharbour Farm), *Country Life* (London), August 25, 1988, pp. 102-103.

Aslet, Clive, "Ashfold House, West Sussex," *Country Life* (London), November 7, 1991, pp. 42-5.

Binney, Marcus, "Hooked on Classics," (Ashfold House), *The Times Magazine* (London), January 28, 1995, pp. 22-6.

Binney, Marcus, "Temple of Learning will dine in classical style", (Gonville and Caius College, Cambridge), *The Times* (London), December 27, 1996, p. 6.

Black, Brinsley, "St Pauls: Classicism versus the rest," *House and Garden* (London), October, 1988, p 194.

Bridges, John, "Four-square Classicism," *House and Garden* (London), January, 1987, pp. 56-7.

Brooke, Christopher, Hugh Richmond, and David Watkin, "The Master's Lodge, Gonville and Caius College, Cambridge," *The Caian* (Cambridge), November 1999, pp. 110-25

Bussel, Abbey, "London Bridge City: Venice on the Thames," *Progressive Architecture* (New York), June, 1990, pp. 23-4.

Casey, John, "Classics at Cambridge," (Gonville and Caius College), *The Daily Telegraph*, 12 March 1998, p. 22.

"Coldharbour Farm Development," in *Architecture in Arcadia*, Architectural Design Profile 103, Academy Editions (London), 1993, pp. 70-3.

Contemporary British Architects, Royal Academy of Arts, Prestel Verlag (Munich, New York), 1994, pp. 148-9.

Cruickshank, Dan, "Classicism and Commerce", (Paternoster Square), *Architects Journal* (London), November 15, 1989, pp. 28-31.

Doordan, Dennis, "The Paternoster Square Debate," in *Twentieth Century Architecture*, Laurence King (London), 2001, pp. 249-50.

Economakis, Richard, *Building Classical*, Ernst & Sohn (London), 1993, pp. 86-93, 138, 170-1.

Howard, Henrietta, "Modern Classic," (Ashfold House), *House and Garden* (London), September 1993, pp. 69-74.

Jencks, Charles, "The Prince Versus the Architects," *The Observer* (London), June 12, 1988, pp. 33-4.

Jenkins, Simon, "A Second Chance to Choose Cinderella" (Paternoster Square), *The Sunday Times* (London), June 26, 1988.

"John Simpson and Partners Limited, Londra," *Parametro*, Vol. 236, *Gruppo Editoriale Faenza Editrice SPA (Italy)*, Nov.-Dec. 2001, pp. 128-39.

Knevitt, Charles, "The Classical Revivalists stand up to be counted," (Classical Survival, Classical Revival), *The Times* (London), August 29, 1984, p. 10.

Krier, Leon, "God Save the Prince," (Paternoster Square), *Modern Painters* (London), Vol. 1, No. 2, Summer 1988, pp. 23-5.

Lyall, Sutherland, "Forging Ahead Backwards," (Real Architecture), *Building* (London), April 3, 1987.

"The Master Plan," in *Paternoster Square*, Paternoster Associates (London), 1998, pp. 23-5.
Paternoster Square and the New Classical Tradition, Architectural Design Profile 97, *Academy Editions* (London), 1992.

"Paternoster Square Redevelopment Project," in *Architectural Design*, Vol. 58, Academy Editions (London), 1988, pp. VII-XII.

Powell, Kenneth, "Enduring Charm of Classisim," *The Daily Telegraph* (London), March 19, 1987, p. 15.

Powell, Kenneth, "A Paternoster for the Prince," *Country Life* (London), December 17, 1987, pp. 52-3.

Powell, Kenneth, "The Saga of Paternoster Square," *The Daily Telegraph* (London), June 1988, p. 20.

Powell, Kenneth, "A New Venice on the Thames," *The Daily Telegraph* (London), January 7, 1989, p. XV.

Powell, Kenneth, "The Minister Must Decide," (London Bridge City), *Country Life* (London), March 2, 1989, p. 111.

Powell, Kenneth, "The Shape of Country Houses to Come," *The Daily Telegraph* (London), November 9, 1991, Weekend p. XVII.

Powell, Kenneth, "Classicism's Finest Hour," *The Daily Telegraph* (London), October 22, 1992, p. 15.

Powell, Kenneth, "Some Fizz for Bucks," (Coldharbour Farm Development), *The Daily Telegraph* (London), November 9, 1994, p. 38.

"The Reconstruction of the area around St Paul's Cathedral in the City of London," in *Interventions in Historic Centres*, Architectural Design, Academy Editions (London), pp. 76-85.

Richmond, Hugh; Christopher Brooke and David Watkin, "The Master's Lodge, Gonville and Caius College, Cambridge," *The Caian* (Cambridge), November 1999, pp. 110-25.

Simpson, John, "Canaletto," *Modern Painters* (London), Vol. 2, No. 40, Winter 1989-90, pp. 76-7.

Simpson, John, "The West Range of Gonville Court, Past and Future," *The Caian*, November 1996, pp. 110-25.

Stamp, Gavin, "Public Airing for Paternoster Square Proposals," *The Independent* (London), June 14, 1988, p. 5.

Steiner, Wendy, "Venice on Thames," *Independent on Sunday* (London), February 4, 1990, p. 31.

Watkin, David, "Paternoster Square," *City Journal*, Vol. 6, No. 1 (New York), Winter 1996, pp. 14-27.

Watkin, David, "Rooms that Speak of Memory," (Gonville and Caius College, Cambridge), *Country Life* (London), 2 April 1998, pp. 48-53.

Watkin, David, "The Master's Lodge," (Gonville and Caius College, Cambridge), *Country Life*, 24 September 1998, pp. 22-7.

Watkin, David, "Soane and Simpson," *The Caian*, November 1998, pp. 55-64.

Watkin, David; Hugh Richmond, and Christopher Brooke, "The Master's Lodge, Gonville and Caius College, Cambridge," *The Caian* (Cambridge), November 1999, pp. 110-25.

Watkin, David, "The Queen's Gallery, Buckingham Palace," *Country Life* (London), 28 January 1999, pp. 48-51.

Watkin, David, "Painter's Yard, Chelsea," *Country Life* (London), 16 September 1999, pp. 120-4.

Watkin, David, "The New Queen's Gallery," in *Royal Treasures: A Golden Jubilee Celebration*, The Royal Collection, 2002, pp. 61-4.

White, Roger, "Classical Manipulation," (50 Belsize Park), *House and Garden*, pp. 94-9.

PHOTOGRAPHIC ACKNOWLEDGMENTS

We would like to thank

Country Life, F L Estates, Taskcastle, and Stevensons

and the following photographers

for permission to use their photographs:

June Buck

Andreas von Einsiedel

John Critchley

Alexandra Papadakis